Peter Dormer
was a writer and exhibition organizer
specializing in twentieth-century design and applied art. His
previous books include *The Meanings of Modern Design*
(1990), *The New Ceramics* (1986) and *The New Furniture*
(1987), all published by Thames and Hudson. He studied at
the Bath Academy of Art, Corsham, the University of
Bristol and the Royal College of Art, London, where he
was awarded a Ph.D in 1992 for his thesis on practical and
conceptual skills in designing and making.
He died in 1996.

WORLD OF ART

This famous series
provides the widest available
range of illustrated books on art in all its aspects.
If you would like to receive a complete list
of titles in print please write to:
THAMES AND HUDSON
30 Bloomsbury Street, London WC1B 3QP
In the United States please write to:
THAMES AND HUDSON INC.
500 Fifth Avenue, New York, New York 10110

Printed in Singapore

PETER DORMER

DESIGN SINCE 1945

170 illustrations, 25 in color

THAMES AND HUDSON

All the cover illustrations appear inside the book.

Any copy of this book issued by the publisher as a
paperback is sold subject to the condition that it shall
not by way of trade or otherwise be lent, resold, hired
out or otherwise circulated without the publisher's
prior consent in any form of binding or cover other
than that in which it is published and without a
similar condition including these words being
imposed on a subsequent purchaser.

© 1993 Thames and Hudson Ltd, London

First published in the United States of America in
1993 by Thames and Hudson Inc., 500 Fifth Avenue,
New York, New York 10110
Reprinted 1998

Library of Congress Catalog Card Number 92-80335
ISBN 0-500-20261-3

Printed and bound in Singapore

Contents

Preface

The design profession has grown rapidly since 1945, primarily because the opportunities have been considerable. At every turn in the history of the postwar world of technology and manufacturing the designer finds he or she has a niche. Whenever the marketplace changes – as it has in Europe, for example, from black austerity to green concern – then the designer changes with it. The designer is a chameleon: he or she can, as needed, be a stylist, a corporate image strategist, an ergonomist or an environmentalist.

Not all designers like to be institutionalized as professional servants in this way. Some have become designer-craftspeople – designing and making only those things that they want to create. Their clients are the very rich or collectors and museums.

Some designers, especially in Italy, work as straight product designers for corporations while at the same time experimenting, playing and philosophizing with like-minded friends in short-lived associations or studios, the most famous of which was Memphis of Milan.

Many more designers like to claim that they are in some sense concerned with 'art'. In so far as they often have to create styles that capture our imagination and so become desirable to us, there is some truth in this.

However, this book offers a viewpoint that is based on an understanding of the designer as a member of a team. Design, subservient to manufacturing, the market and the consumer, is seen as an evolutionary process rather than a series of inspirations. This is not to deny the role of the individual as a driving force in design, but it is to dilute the importance of 'self-expression'.

Tacitly, this book is about consumers; and it is written in the belief that good designers know that consumers are neither passive, nor easily deceived.

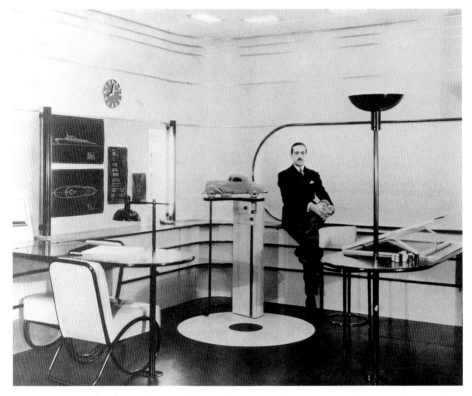

1 In his day Raymond Loewy (1893–1956) was the most famous designer-stylist in the world; he acted like a movie star, and was treated like a movie star. Here Loewy is seen in a mock-up of his office created by the Metropolitan Museum of Art, New York in 1934.

What is a Designer?

Since 1945 designing has become a profession in its own right. Gradually at first, but then more quickly (especially as Japan emerged in the 1960s as a trading competitor of formidable ingenuity), governments and large corporations became convinced that design was 'a good thing'. Design was seen to have two separate but related functions: it could be used strategically by a corporation to help plan its manufacturing and shape its marketing; and it had a more obvious role in making individual products attractive to consumers.

Designing is not a new activity. All ascendant civilizations have used it. The essential shape, form and structure of many artefacts, such as containers, tools, clothes and decorations, were fixed ten, twenty or even one hundred generations ago.

Even the professionalization of design is not 'new'. People have long specialized as potters or engineers, weavers or masons, and they often designed what they made. Moreover, old industries, such as textiles and pottery, differentiated between designers and makers – those who designed textiles in the 14th century were paid more than those who wove them.

Designers do not manufacture things. They think, they analyse, they may model or draw, and they specify. Some designers become involved in making their own prototypes. All good designers ask questions of their client and spend time helping the client to clarify what he or she really wants. Designing is about planning and making ideas explicit: if the product is to be made to the designer's specifications, then the designer must ensure that the factory has the tools and the intelligence and that each element specified is practicable. On complex jobs several product engineers will be involved, today with computer-aided software packages, to help to realize a design precisely. The greatest difference between the designer and the single independent craftsperson is that the craftsperson does not have the problem of communicating his or her intentions to others for translation into objects. The designer, however, must make

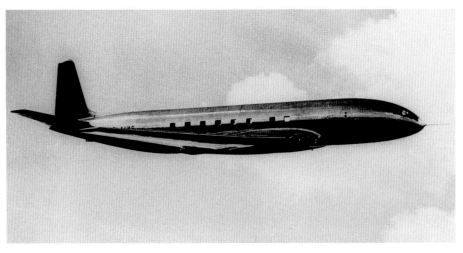

2 The square windows of the first de Havilland Comet were a fatal design flaw.

his or her intentions explicit – communication is at the heart of industrial design.

The trend that began in the USA between the two World Wars, for designers to offer their services to industry as outside consultants, became a flood in Western Europe, Scandinavia and the USA after 1945. Since the early 1950s, the activity of designing has been the subject of systematic and scientific analysis, it has been codified into set procedures, and it has become institutionalized by manufacturing corporations (Philips, Olivetti and IBM, for example) as part of the overall identity of the company. Designing the way a company looks and presents itself, and giving a 'family' look to the design of the company's products, is an intricate and serious business. Designers visualize a company's ideology and their visualizations communicate that ideology to the world. Designers provide the heraldry for the corporate baronage.

But design has not been thoroughly institutionalized. Design has also been claimed as art. Or, as Ettore Sottsass (Italy, b. 1917), a designer of enormous influence, has said: 'To me design . . . is a way of discussing life. It is a way of discussing society, politics, eroticism, food and even design. At the end, it is a way of building up a possible figurative utopia or metaphor about life. Certainly to me design is not restricted to the necessity of giving form to a more or less stupid product for a more or less sophisticated industry.'

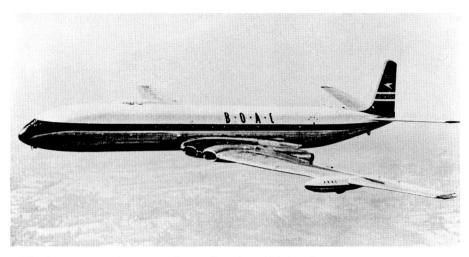

3 The Comet 4, 1958: by now a safe as well as a beautiful aircraft.

So what is the proper role of a designer?

Some have suggested that designers differ from engineers in that an engineer, although he or she might proceed intuitively, prefers to test and test, whereas an industrial designer is entirely happy with intuitive judgments. But, unlike an engineer, a designer is not responsible for the structural failure of the product. Or, to put the matter more graphically, in 1949 one of the most beautiful aircraft ever designed flew for the first time – the de Havilland Comet, the world's first jet airliner. Stylistically it looked right *at the time* but, in a cruel reversal of the designerly homily that 'if it looks right, it is right', it began crashing in service (1953–54). To modern eyes, the first Comets do not look right – they have square windows, and square holes are fatal design features in pressurized hulls because stress builds up at the corners, cracks occur and catastrophe follows.

This is not to imply that only design-engineers have responsibility for malfunction. Designers have a share of responsibility, especially in the design of the 'human/machine interface' – can this machine be operated safely at all times, are the switches, dials, levers or handles in the right place for a human to use effortlessly? The disciplines of ergonomics and product semantics are the disciplines of the designer's responsibility to the user.

The design-to-manufacture-to-sales-to-user process is a continuum. Between 'a designer' and 'a production line' there are many

interpreters – artisans, craftspeople, product engineers and materials specialists. These individuals (and their computers), together with other specialists such as marketing experts, exist to get an idea into reality and also to filter out as many uncertainties as possible before a design goes into production. Each person contributes to a design and although a designer may provide an important stylistic signature it is important not to confuse the idea of 'the designer' with that of 'the fine artist'.

Many modern designs, especially if we consider domestic consumer goods, office equipment, power tools, automobiles and aircraft, are *not* the fruits of one individual's mind, even if – for reasons discussed below – it can be beneficial from a marketing point of view to play up a single designer's name as a signature that gives a product a provenance in the same way that a painter signs his or her canvas. In relatively simple, fabricated, non-mechanical objects, such as printed textiles or tableware, or furniture, a single designer can claim responsibility for the design of the whole product. However, even here, it is possible that others will interpret the designer's design so that it can be manufactured more easily.

The first generation of modern designers who came to maturity in the late 1930s in the USA saw themselves as capable of turning a hand to anything, irrespective of whether it was a casing for a locomotive or a box for an iced cake.

A fine example of this breed of 'designer as stylist' is Raymond Loewy (1893–1986). Born in France, in 1919 he emigrated to the USA, where he began as a fashion illustrator before, in the late 1920s, becoming a pioneer of the putative industrial design profession. The key characteristic of the profession in its modern form was the emergence of the designer as a freelancer and then as a consultant with his or her own studio staffed with assistants.

Loewy styled several of the prewar American locomotives, including the million-pound monster S-1 steam engine (1937) and the lovely, sleek Greyhound buses of the 1940s. Loewy is also well known for the Lucky Strike cigarette pack, and for food and soft-drinks packaging.

He described design in pithy terms that manufacturers could understand. He said products were bedevilled by four parasites which the designer had always to eliminate: 'noise, vibration, air or water resistance and villainous smells'.

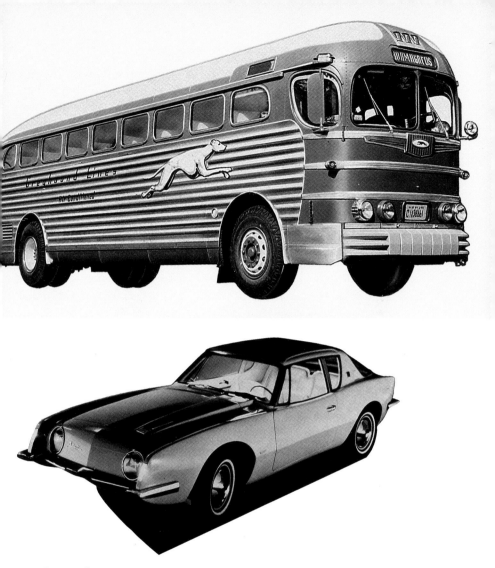

4, 5 Raymond Loewy style. *Top* Silversides Greyhound motor coach, 1940–54, an early example of design enhancing corporate image. *Above* Avanti automobile for Studebaker, 1962.

The artist rather than the engineer provided the benchmark for Loewy, who said he designed the S-1 on the back of an envelope; his Avanti Studebaker car (1962), described (he said) by the chief

engineer of Porsche as almost perfect in its streamlining, was (he claimed) the result of 'design intuition'. It suited Loewy's public image to suppress the back-up teams of structural engineers and draughtsmen who turned his intuitions into mechanically sound reality.

In 1949 Loewy was on the cover of *Time* magazine, which tagged his portrait with 'Designer Raymond Loewy – he streamlines the sale curve'. In 1960, he entered into Camelot itself and came to sprawl on the floor of the Oval Office where, with coloured papers and scissors, he and President John F. Kennedy redesigned the livery of Airforce One, then a Boeing 707.

The lesson that Loewy and his peers learned and then taught to the rest of the modern world was that manufacturers could be convinced that good style sells more products. This belief in the consultant designer's ability to style the sales curve upwards was the first and most formidable weapon in the new design profession's armoury.

It was not enough. After the Second World War, the global ambitions of larger corporations, running hand in hand with the aspirations of consumers, meant that industrial and manufacturing expansion occurred rapidly. Companies manufacturing consumer goods developed new marketing techniques and increased their production, their workforces, their outlets and their advertising. If designers were to have a role, they needed to be able to justify their proposals for design. Their arguments needed strengthening in order to convince other, competitive elements within corporate organizations – production, finance and marketing – that design had more to add than an attractive casing.

Designers themselves perceived that one approach was to put design on a quasi-scientific basis. The sort of designer emerging in the early 1950s in North America and in parts of northwest Europe and Scandinavia was not without intuition – the ability to have creative insight and suggest new solutions or new products was and remains an essential ingredient in design. However, possible solutions had to be tested, justified and modified. Set procedures, a methodology and some science seemed to be needed – and, accordingly, were created.

A good example of human engineering applied in the relatively simple context of designing hand-held power tools occurred in the 1950s. Zdenek Kovar (b. 1917), a sculptor and industrial designer at the Zdenek Nejedly School of Industrial Art in Czechoslovakia,

6 The handles of Zdenek Kovar's scissors (1952) describe their movements through their forms.

7 Human engineering applied in the simplest of contexts – Olaf Backstrom, O-Series scissors for Fiskars, Finland, 1960.

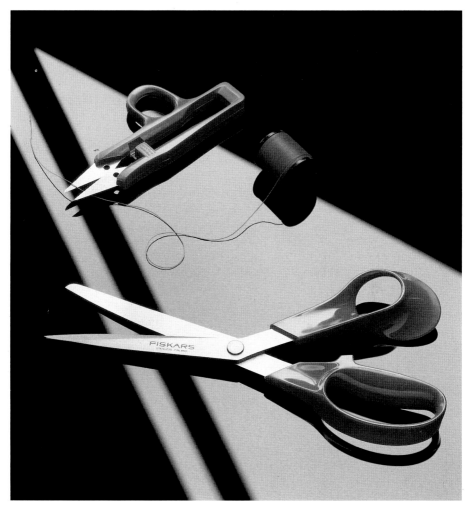

worked on the ergonomics of hand tools. His designs for scissor handles in 1952 anticipated similarly designed products produced in the West, such as Olaf Backstrom's (Finland, b. 1922) excellent scissors (1960), produced by Fiskars in 1967.

Kovar was interested in the causes of calluses, blisters and cuts on factory workers' hands. He set up trials with workers using existing tools (hammers, pneumatic drills and the like) with soft plaster wrapping on them. From the impressions left by their hands he developed new handles and grips which looked intensely organic, sculptural and humanoid.

In the decade or so immediately after the Second World War, a number of European and North American designers probably overweighted their interests towards ergonomics and empirical research into function, in the reasonable belief that a thing that is nice to handle contributes to general well-being.

Certainly several design magazines and institutions in the early 1950s were uneasy that the designer might be seen as a flippant creature. The search for a rationalist approach to designing has several roots. Many of them are German and include the pioneering work of artist and designer Peter Behrens (Germany, 1868–1940) as well as early 20th-century design 'guilds' such as the Deutscher Werkbund. One of them is in the most famous of all 20th-century art and design schools – the German Bauhaus (1919–33). Some of the ideas discussed and experimented with at the Bauhaus (such as modular design for furniture in interiors, the elimination of extraneous decoration, the prototyping of simple designs for mass production) were reborn with great vigour in the almost as famous postwar design school, the German Hochschule für Gestaltung at Ulm (1955–68). This was established to pursue a rationalist approach to design and although its curriculum included fine art when it formally opened, with the arrival of new director, Tomas Maldonado (Argentina, b. 1922), fine art was replaced by quite different subjects: mathematics, sociology, ergonomics and economics.

Ulm tried to exorcize capriciousness from design and, in the pursuit of 'correct' solutions, sought to establish standard working methods for a designer. Unlike the Bauhaus which, despite the ambitions of its teachers, failed to connect itself with industry, Ulm found a conduit for its design methodology in Braun, the German electronics company.

Braun AG, established in 1921 in Frankfurt as a radio manufactory, was rebuilt in 1945. Artur and Erwin Braun, the founder's sons, took the company forward in the 1950s. In 1960 the Braun product line was divided into four product categories, each headed by a senior designer. These were Dieter Rams, radio and hi-fi; Reinhold Weiss, household and personal care appliances; Richard Fischer, shavers; and Robert Oberheim, photographic equipment. Clocks, watches, lighters and calculators were added in 1966.

Rams is the best-known figure associated with Braun, but several talented designers contributed substantially. Weiss and Fischer, graduates of Ulm, worked in-house at Braun from the late 1950s. Weiss's Coffee Grinder KMM1 (1964), a functional and stylistic classic, is still in production. The teachings of the Ulm school were thus disseminated via its students and reach down to us through products such as the KMM1. Dr Fritz Eichler, appointed to the board in 1954, was the architect of the company's corporate design philosophy. Meanwhile, Hans Gugelot (teacher at Ulm and consultant to Braun) worked with Rams and Eichler upon radio and hi-fi.

Ulm was not unique in Germany in searching for scientific approaches to designing. Nigel Cross (*Engineering Design Methods*, 1989) notes that work has continued in Germany on rationalizing the design process. He cites the professional engineers' body Verein Deutscher Ingenieure, amongst whose published guidelines is one which states: 'The design process, as part of product creation, is subdivided into general working stages, making the design approach transparent, rational and independent of a specific branch of industry.'

In the United States the concept of scientific design procedures was developed pragmatically and effectively. One of the earliest demonstrations of the practicality of proceeding with a sound programme of analysis and empirical testing occurred in the USA with the interior design of the Boeing 707. Designed first as a tanker refuelling aircraft for the USAF it was bought in its civilian mode by Pan American World Airways in 1955, and went on to establish the standard for commercial flying for the postwar period.

Walter Dorwin Teague (USA, 1883–1960) and his deputy Frank de Giudice worked on the interior design of the 707. Their method, which cost Boeing half a million dollars, resulted in a full-scale mock-up with dozens of 'pretend flights' to test the seating, the galleys and other ergonomic factors. Their use of plastic panelling, recessed lights,

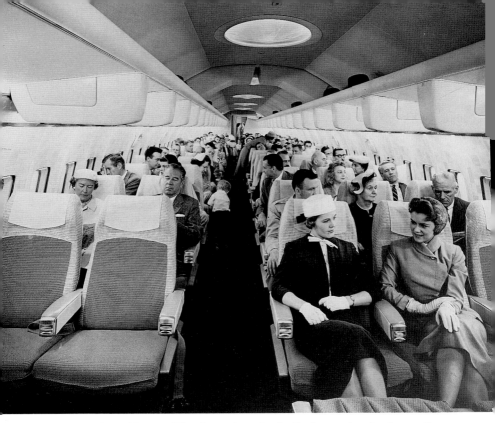

8 W.D. Teague, full-scale mock-up for the Boeing 707 interior (1955–56).
9 Henry Dreyfuss examined the demands of human size and proportions on design.

high, contoured seats, integrated customer-service units and a coherent, calming colour scheme established the basic design strategy from which airlines have yet to deviate. Aviation companies are not blind to the role of beauty in selling their products; the exterior of the 707 also received some product styling from de Giudice, who designed the shape of the fuselage nose, the tail fin and the engine housings.

The 707, bought by so many airlines, has since had several important designers work on its interior. American Airlines commissioned Henry Dreyfuss (USA, 1903–72) to design the interior of its 707s. Dreyfuss was a datum collector par excellence and ergonomic data provided the subtext for his famous book, *Designing for People* (1955). In 1960 he published a series of charts, *The Measure of Man*.

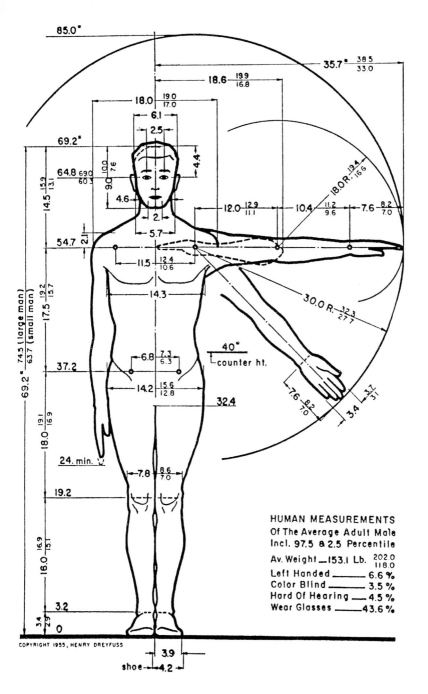

HUMAN MEASUREMENTS
Of The Average Adult Male
Incl. 97.5 & 2.5 Percentile

Av. Weight ___ 153.1 Lb. $\frac{202.0}{118.0}$
Left Handed _____ 6.6 %
Color Blind _____ 3.5 %
Hard Of Hearing ___ 4.5 %
Wear Glasses _____ 43.6 %

COPYRIGHT 1955, HENRY DREYFUSS

19

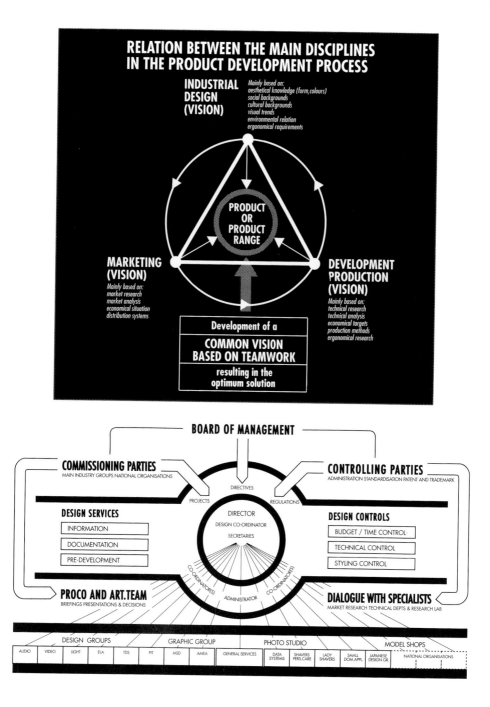

0	1	2	3	4	5	6
IDEA REQUEST	AIMS REGULATIONS	RESEARCH INFORMATION	SKETCHES RENDERINGS	MODELWORK PRE-SELECTION	DECISIONS CONTROLS	APPEARANCE CONTROL SALES REPORTS
PROJECT	BRIEFING	CREATING	DESIGNING	PRESENTING	DRAWING	FOLLOW-UP
COMMISSION PLANNING	CHARACTERISTICS SPECIFICATIONS	STUDIES LAY-OUTS	DIALOGUES PRECALCULATIONS	PREFERENCES MODIFICATIONS	DELIVERY TESTINGS	DOCUMENTATION PROMOTION

After the Second World War major manufacturers began to integrate design and designers into their institutional organization. These examples are from Philips.
10 Industrial design was given the same status as, for example, marketing, 1984.
11 Designers were given clearly defined roles and thus a degree of credibility in arguing with other company departments, 1969.
12 The Philips design track: design for problem-solving.

For Dreyfuss, as for many American designers, there was no conflict between the market-orientated and sales-dominated consumerism and design that has been achieved rationally and which performs properly. (Nevertheless, a generation of products that have emerged since Dreyfuss's death look nice but are difficult to use – computer printers, automatic ticket machines and video recorders are among them. Such ergonomic failures indicate that good performance remains more elusive than good looks.)

Most of the world's leading corporations illustrate how the functions of the designer and the role of design have evolved since 1945. The Dutch electrical manufacturing company Philips is an example whose design strategy has been well described by John Heskett in his book, *Philips: a study of the corporate management of design* (1989). Founded in 1891, Philips is one of the largest companies in the world and it operates across the world. Before 1950 its design strategy, though not exactly ad hoc, was not clearly set out. Changes occurred when architect Rein Veersema was appointed to head up the design of radios, televisions, record players and shavers. Over the course of fourteen years, Veersema introduced the disciplines of ergonomics and costing into design – giving designers something with which to defend their designs against other opinions in the company. He also pursued the idea that all Philips products should have a family identity.

Veersema's deputy, Frans van der Put, who took over from him for a year as caretaker head of design in 1965, carried the baton of belief that design should 'prove itself by its works'. In 1966, van der Put was replaced by a Norwegian designer, Knut Yran, who said. 'Design is a technical profession with a marketing function' and 'a designer must

realize the concern's intentions before he realizes those of his own'. Yran believed in systematic planning, and masterminded Philips' first House style manual (1973), which sought to give consistency to all aspects of the company's presentation. House style manuals, which became a commonplace in corporations worldwide in the 1970s, also became part of many public sector services and government departments.

Like a number of European-based manufacturing companies, Philips – as Heskett describes it – was worried in the early 1970s by the quality of the design and manufacture characterizing Japanese goods. Moreover, the success of Japanese products worldwide meant that the old idea that a manufacturer had to tailor all products to suit individual national tastes was not necessarily true. Sony, for example, was proving that world products sold. This realization helped influence Philips in deciding to appoint Robert Blaich as Yran's replacement in 1980.

Blaich, an American architect and industrial designer, had worked for Herman Miller Inc., one of the USA's leading office furniture companies – and one of the very few that has been design-led since the war. He espoused 'global design'; like many other designers he was impressed by the success of the Sony Walkman.

Blaich got industrial designers and engineers talking to one another and understanding one another's procedures. As Heskett explains it, he clarified the broader roles of both the product engineers and the product designers, with the designers being concerned with the systems of graphics, packaging, marketing and, 'above all, the mechanics of operations by users and groups of users'. He also became one of the loudest champions of 'product semantics', which attempts to make the meaning of a product an explicit part of the product's function. If you can see what a thing 'means', then you can more readily grasp how to use it.

Heskett's book is part of a self-reflexive literature which has emerged, some of it written by engineers and designers, about the nature of 'designing'. Since 1945, as the responsibilities of the designer have grown, designing itself has fragmented into specialisms and designers are generating principles to guide their work.

Nigel Cross suggests that a designer sets out with a goal, some constraints, and some criteria by which the result may be judged a success or failure. This description, although it might coincide with

13 The need to maintain a coherent design image across a diverse and scattered industrial empire led to the development of house style manuals – Philips published its first in 1973.

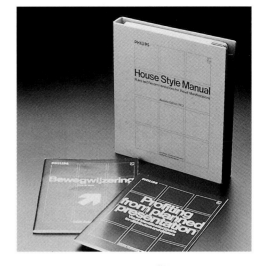

14 During the 1980s Philips, like its competitors, began targeting niches of consumerism. The Moving Sound range of cassette and disc players was aimed at the urban teenager.

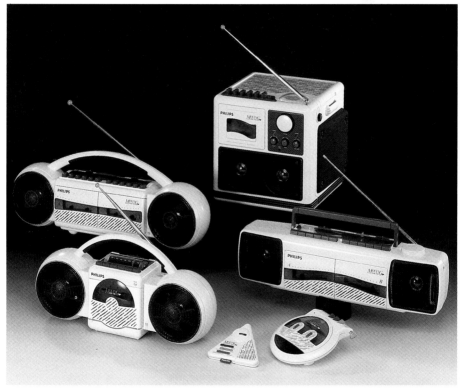

the working practice of an Italian Renaissance artist, is quite different from that of a contemporary fine artist who is likely to argue that he or she has rejected all constraints and that he or she alone determines the criteria for success or failure.

A designer given the goal of designing a new range of lamps understands that the constraints upon the design will be related to what the market is perceived to need, what the factory is capable of making and how much profit the company wants as a return on its investment. Some criteria for success will be relatively easy to fix but some, such as whether the product will capture the imagination of the marketplace, remain a limited gamble. Cross notes that the central feature of design work, however, is that it is 'solution led'. And here the first generation of industrial designers like Loewy may be right with their stories about dashing off a drawing on the back of an envelope. Cross says the designer's traditional approach to solving problems, especially if they are ill defined (as a great many necessarily are at the outset of a project), is to move fairly quickly to a potential solution. Even if the solution does not fit, it reveals further aspects of the problem and hence clarifies it for another attempt at a solution.

It should be noted, however, that although design as methodology and design as research are practical concepts, they are also (or were also) a part of a fashion, and part of a general *Zeitgeist* fascination with logic, science and problem solving. The art world was similar. For by the middle 1960s art schools in western Europe and some in North America were referring to art as 'research'; students and their tutors did not talk about subject matter so much as problems and projects. This fashion went hand in hand with the conceptual and other minimalist art movements that peaked in the late 1970s.

In Italy the practice of design as *research* has been successfully juggled with the idea of the designer as an artist. The spirit of design has remained closer to the spirit of design-as-art, maintained partly by the training of designers as architects and partly because there is a strong avant garde design movement in Italy in which ideas tapping into politics, sociology, fine art, architecture, film and music are explored, played with and sometimes used as the starting point for actual designs.

The atmosphere surrounding design is different in Italy than in Germany or North America. Whilst Olivetti, for example, shares similar concerns about global products, marketing and family

15 Although Olivetti is an advanced, technology-led company, it has caught the imagination of educated purchasers by tempering the culture of science with that of art. The objective is achieved by using high-profile artist-designers and through the sponsorship of major exhibitions.

Sculptures and paintings relating to the origins and the glory of the Horses of San Marco in Venice.

The Horses of San Marco

A Royal Academy exhibition presented by Olivetti

Royal Academy of Arts
Piccadilly London W1

8 Sept - 28 Oct 1979 10-6 Daily. Late evening Wednesdays until 8

Admission £1.40 (Half price students & pensioners and Sundays until 1.45)

identity, claims made about how design is managed in this successful Italian company differ considerably from those of Philips or a North American company such as Ford or Pepsi-Cola. Whether the substance of the management process is very different is a moot point.

In the sister book to John Heskett's on Philips, Sibylle Kicherer's *Olivetti* (1990), we learn that 'drama' is considered to be an integral part of the design process. Italian designers generally train first as architects and tend to be more assertive of their role as individual artists. Kicherer describes the atmosphere of designing for Olivetti:

25

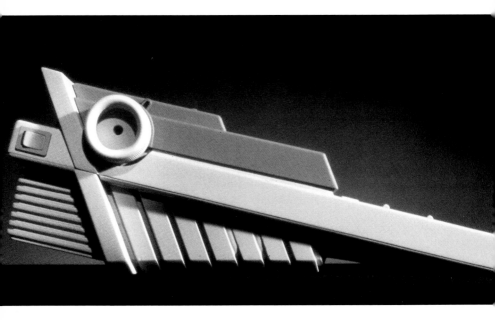

16,17 A portable electronic typewriter that is light, easy to use and has a high printing speed. Designed for Olivetti by Mario Bellini and Alessandro Chiarato, 1985–86.

'An important factor here is what can be called the "Italian drama" – the consciously created and accepted chaos that is caused by the reinforcement of different approaches, overlapping competences and extreme time pressure, all of which results in apparent confusion and explosive personal interactions. Design managers and designers see such confrontations as a challenge, even as a necessary way towards achieving excellence.'

Designers like Sottsass are given retainer fees by companies such as Olivetti. This gives a designer security and freedom to create and experiment. In the long run, the company, so it is argued, benefits from the creativity of these experimental, 'artistic' activities that have no apparent, direct connection with the mainstream work of the company.

Olivetti is not a chaotic company, but it allows its designers unique freedoms. Although the designer is treated like 'an artist', the model of artist presented is one of the Italian Renaissance where artists (including those we most admire today) created within a well-defined brief.

The stages in design at Olivetti can be summarized as follows: managers decide that a new product or range of products is required; researchers are then commissioned to collect information about market and technical aspects; specifications are worked out that can form the brief to both the designers and the development engineers. At this stage, the department responsible for the corporate image of the company is brought in, and the designers, too, are involved in initial discussions. Once all the commercial requirements have been sorted out, then the designers begin to work on the design concept.

Designing is a noisier business in Italy than almost anywhere else in the world. The atmosphere is heady, loud, colourful and as non-bureaucratic as possible; but the underlying process of design is in principle compatible with that found in Germany, Britain, Scandinavia, Holland and North America – as well as Japan.

Italian companies, as well as priding themselves on finding and encouraging new design talents, have also benefitted from the peculiarly Italian 'radical design' movement which has centred on a series of design studios, loose associations of like-minded designers, which began emerging in the mid 1960s. The leading studios were Archizoom Associati (founded Florence 1966), Superstudio (Florence 1966), Alchymia (Milan 1976) and Memphis (Milan 1981). Their

work is part philosophy, part art, and part manufacturing. They share several of the same designers and each of them has been interested in innovative design, in interpreting mass culture, and in ideas about planning and architecture. Their research was of a 'brainstorming' kind in which the results were more usually presented as prototype objects (furniture and lamps) or montages, collages and film sets to explore ideas in housing, urban planning and the future of 'the city'.

Andrea Branzi (Italy, b. 1938) – designer, philosopher and habitué of most of the Italian postwar avant garde design groups and author of the definitive book on Italian postwar design called *The Hot House* (1984) – wrote in 1983 that the New Design espoused by the Studios (see also Chapters 3 and 4) sought to recover 'a system of ties and functions' between the objects in the home and the families who live with them; one that 'cannot be explained in purely ergonomic or functional terms, that involve man in his relationship to his domestic habitat from a wider cultural and expressive point of view.' He theorizes what most non-designers already know: that we buy and acquire things for all kinds of reasons, influenced by our memories and associations, our aspirations and our friends, as well as what we see on television or in museums.

By no means all the developed, industrialized nations of the world possess a fully fledged industrial design profession. It is ironic that France, who gave us Raymond Loewy, has rather few industrial designers – only about 300 in 1987, for example. In 1983 the very word 'design' was banned from the French language as a part of the campaign to keep the French vocabulary pure of English words. It was replaced with the inadequate expression *la stylique*, which did not delight the small band of French industrial designers who protested that their work has meant more than deciding on the colour of the casing. Commentators pointed out that this linguistic confusion was revealing about the French attitude which saw design as merely styling. This has meant that designing – in the holistic sense that emerged in companies such as Philips or in the broad intellectual sense that is alive in Italy – does not exist in France. Yet France has made an impression, in public transport and in public architecture especially, with its spectacular town planning projects, such as La Défense in Paris.

France has continued its tradition of producing star quality designers in couture fashion and French furniture has recaptured the

verve and design intelligence that characterized that industry during the 1920s and 1930s. However, high-quality consumer product design is surprisingly scarce. There are exceptions, such as the Citroën DS 19 motor car (1955), and some domestic kitchen electrical equipment. But designers have yet to be viewed generally in French industry as part of the team that has a role in planning the strategy of a company. In France the designer is still a stylist, rather than the logician-artist-engineer-stylist that he or she is expected to be elsewhere in the industrial world.

In the Scandinavian countries of Denmark, Sweden and Finland (and, to a lesser extent, Norway and Iceland) design has tended towards a mixture of hand craft ideas with industrial design. In part this was because the strength of Scandinavian industry lay in furniture, ceramics, lighting and textiles – all areas with long roots in the decorative arts. In the 1950s the craft/design-based 'Scandinavian look' was a marketable commodity (and remained so through much of the 1960s). It meant simple, well-made shapes and forms with a gentle geometry. Natural materials were favoured, as were light colours, and the appeal was middleclass but democratic.

Although a crafts-based aesthetic shaped the style of furniture and ceramics, factory production made and makes full use of machines – it was a crafts influenced industry, not crafts based. The specialist industrial designer was a rarity for a while (although in companies such as Sweden's Saab there were notable exceptions).

But partly as a consequence of the economic slump in the late 1970s and early 1980s and also as a result of diversification into high technology industries (with the impact of new electronics technology and materials – see Chapter 2), the Scandinavian industrial designer has emerged with a function similar to that of his or her German, Dutch or North American counterpart. This trend is confirmed by educational changes, which show that training for industrial designers has become separated from training in the crafts and decorative arts. As is the case elsewhere in northwest Europe, in Italy (also increasingly in Spain) and in North America, there has been a steady growth in the role of consultant design studios as well as in the development by individual companies of their own corporate design studios.

Japan learned very quickly that design was a tool for marketing products and modelled many of its design procedures on information

gleaned from tours of North American corporate design departments in the 1950s and 1960s. Never mind that in the 1950s Japan had a reputation as a mass producer of rather poor quality goods, by the early 1970s European and American manufacturers were gloomily analysing Japanese tape recorders, hi-fis, radios, televisions, cameras and motorcycles, not only for the quality of their manufacture and detailing but also for their style. But designers had to be 'company men': the freelance consultant designer is less important in Japan than the company design studio.

The style and psychology of Japanese design is unique (see Chapter 3), but the guiding principles of design are similar to those of corporate design strategies elsewhere in the world. In Japan the designer tends to be anonymous as far as the public is concerned. None the less, companies repay loyalty by actually producing many more of their designers' ideas than would happen in Europe or America. Designers are also encouraged to produce a considerable range of prototypes and ideas. There are signs that younger Japanese designers, those who have travelled to the West or trained in British or North American colleges, are beginning to gain more autonomy for themselves as free creative spirits but the orthodoxy is to submit to the anonymity of the company's demands.

However, in most countries, although a review of the way the job of the designer has developed since 1945 shows an emphasis upon methodologies, research, marketing and planning, there is much that remains whimsical or even arbitrary about the way designs catch on. The ideology of the designer as a planner rather than an artist has served companies well, but the ideology has not been monolithic. The existence of individual design studios throughout the West, together with a marked interest and demand for variety, pluralism and, indeed, democracy, is reshaping the role of the designer. And much depends upon how designers want to see themselves. It suited the postwar generation to become company men. It may not (and probably will not) suit their children.

And finally, a caveat. There is a danger of distorting the role of designers if we draw too strong a distinction between them and 'us' – the consumers. Analyses of the relationship between designers and consumers veer towards unrealistic extremes. On the one hand it is possible to see the relationship as adversarial or manipulative – one in which designers side with manufacturers and retailers to dupe, harass

or seduce us into buying what they want to make and sell. This caricature is manifestly false. And it is false because the other caricature commonly drawn – that consumers are passive and will accept whatever is put in front of them – is also false. We forget the enormous quantities of products (and producers) that fail.

Perhaps the most interesting aspect of design and the way it has developed since the Second World War as a profession is the manner in which it has sought to get design right. Journalist Pamela Johnson's article 'Shock of the Newborn', for the British magazine *Issue* (May, 1991), details how successive designers had developed and modified a range of products for babies, young children and their parents by listening to consumer feedback. She notes that, with regard to the foldaway baby buggy designed in Britain in the mid-1960s, 'Designers have responded almost annually to parental requests: more back support, a place to put shopping, balloon tyres, swivel wheels, five-point harness, multiposition seats, linked braking system and protective rain hoods.' Designers respond to their own needs because their needs coincide with ours. Few of us are iconoclasts; even fewer iconoclasts are successful designers.

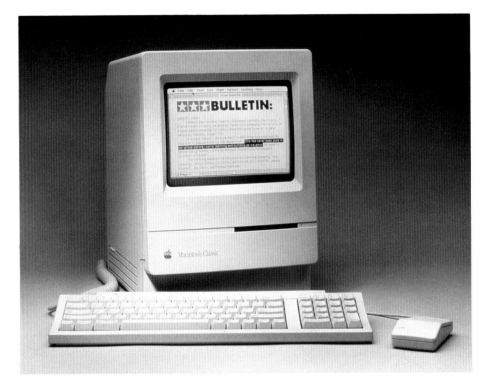

18 Making the computer 'user friendly' has been a key target of recent years. The Apple Mac quickly established itself in the 1980s and new models, including the Classic, above, continued into the 1990s.

Industrial and Product Design

The relationship between design and technology is not one sided. Technological developments do not determine what the manufacturer wants to produce, nor do they rigidly determine the shapes a designer creates. The fetters on form, style and function have been loosened by new electronics and new materials. This chapter offers a brief overview of these changes and how they have affected product designers and shaped style since 1945.

The tags we have given to the decades since the Second World War show the richness of modern technology: the atomic age, the jet age, the television age, the space age and the age of automation. Less tangible descriptions have also been applied, such as the era of information, the age of post-Fordism and the twilight years of industrialization. The state-of-the-art technology as we move into the 21st century will probably be biological. One theme, however, has been constant since 1945 – the liberating impact of the miniaturization of mechanisms – accompanied by a new lightness and refinement of the casings that house them.

One need look no further than light bulbs. Over the last fifty years we have moved from the big tungsten-filament light bulb, swelling out like a pumpkin, to the fluorescent tube (General Electric, USA, 1938), to a new generation of mini-fluorescent tubes that emerged in the early 1980s, which can be fitted into small domestic products. A rival lighting source, tungsten-halogen lamps, appeared in the 1960s and, in the 1980s, were revolutionized by the introduction of small transformers permitting low voltage lamps which offered delicate, pin-beam precision lighting to homes, offices and shops.

A second constant theme has been development in the scale and the nature of 'mass' production. The introduction of computer-driven tools has meant that shorter production runs and different runs of similar but not identical products can be produced economically. This has encouraged niche marketing and has dented the monolithic concept of mass manufacturing and mass marketing.

33

19 Calder Hall, Britain's and the world's first industrial-scale nuclear power station, was opened in 1956.

20 Throughout the West the 1950s became the 'TV decade'. In the USA figurative and exotic TV lamps added colour to the cathode ray tube's grey flickerings.

21 Artificial satellites have transformed world communications and research into the weather, environmental change and the search for scarce resources.

22 Automated manufacturing and the development of computerized 'expert systems' are a postwar technological success.

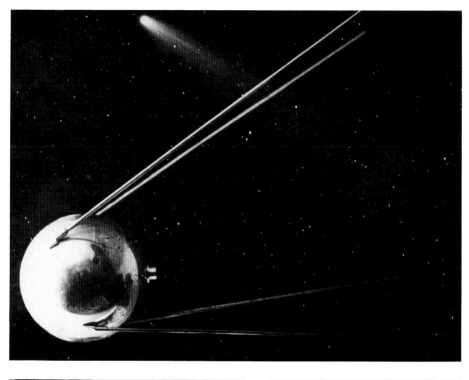

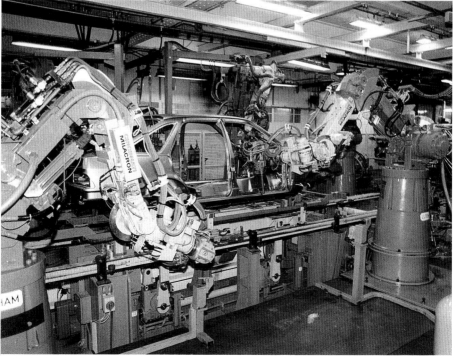

But a full assessment of the impact of modern technology on design, especially computerization, is elusive. The wider implications of the revolution in personal computers that occurred in the 1980s, for example, cannot be assessed because they have barely been exploited. We can all recognize the obvious: in the factory the computer has transformed engineering design and manufacturing; in the office it has speeded the exchange of information and provided us with desktop publishing; it has also entered the home to an extent.

But will the personal computer (PC) transform individual lives in the same way that the motor car has done? The motor car had major consequences: it transformed the environment of the countryside and the town, and it liberated individuals who took off in their cars in their millions.

In principle, one can take off with the computer. Steve Jobs, co-founder of the Apple Computer Company, hoped that his innovative Apple Macintosh computer would do to computers what the Model T Ford did for cars. Jobs also compared the personal computer as a mind-expanding tool to the invention of printing.

The first electronic digital computer was built in 1945 at the University of Pennsylvania. This thirty-ton machine contained thousands of thermionic vacuum tubes (similar to the old glass radio valves) and it was programmed laboriously with punch cards. Such machines were large but not very powerful. Computers, like all electronic machines, were transformed by the transistor.

The transistor was created in the USA's Bell Telephone laboratory during the years 1947 to 1951. Made from silicon, it requires a low voltage and is thus very efficient. By the end of the 1950s, radios, hi-fis and, of course, computers, were transistorized. Other forms of transistor were developed for use in electric ovens, washing machines and other domestic appliances such as coffee grinders, food mixers and freezers.

Computers came of age in the 1960s and were something of a status symbol for corporations. The market was dominated by IBM but one of the first mini-computers was designed in 1968 by Digital Equipment Corporation (DEC), making use of the 'microchip' invented ten years earlier. For in 1957, whilst the American government panicked at the news that the USSR had launched an artificial satellite into space (Sputnik 1), most US Senators were unaware that the USA had stolen a more significant lead back on earth

23 The first transistors, assembled by their inventors at the Bell Telephone laboratory, USA, on 23 December 1947, look primitive; but they revolutionized the electronics industry and changed our way of life. The transistors amplified electrical signals by passing them through germanium, a solid semiconductor material.

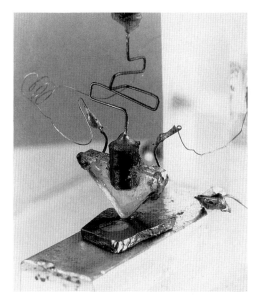

24 A photomicrograph of a computer memory chip developed by IBM which achieves a memory array of 5 million bits per square inch. Other achievements in electronic miniaturization include the UK's INMOS transputer (1987) – the world's first computer on a chip. Each transputer has 200,000 transistors on 1 square mm of silicon.

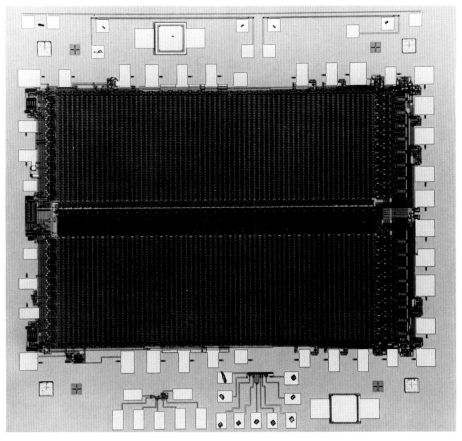

– American Jack Kilby produced the first working microchip – the semiconductor integrated circuit. This invention was the foundation of micro-electronics.

In 1971 the Intel Corporation (USA) introduced the microprocessor, which is basically a form of electronic calculator on a single silicon chip. Its first consequence was a commercially viable generation of small, then very small pocket calculators. The digital watch followed. Less visible applications of the microprocessor were in the creation of early forms of 'thinking' washing machines, automobiles, sewing machines, toasters and electric ovens. The microprocessor provides a memory and provides control. It enables a washing machine to have dozens of different programmes or an automobile to perform rapid calculations that adjust the brakes or suspension automatically to prevent the driver losing control when cornering or braking sharply. It does away with a mass of space-consuming mechanisms.

The designer has been affected by micro-electronics in three ways. Miniaturization of working parts has meant that an object can become smaller or that it can be turned into an object of curiosity – the external form no longer having to follow the dictates of the internal workings. Miniaturization has also, in some instances, 'devalued' the currency of certain goods – thus cheap, small radios and cheap, even smaller pocket calculators are approaching the status of the ballpoint pen in terms of availability and disposability. The designer is therefore no longer working on a precious object. The third impact is upon the designer personally – the computing power of the new computers is challenging his or her skills. The influence of computer-aided design, computer-aided manufacture (CAD-CAM) is getting stronger by the year. One of the most interesting developments is computer animation which, when added to computer simulation programmes, allows a designer-engineer to see what the effects of wear and tear and time will have on a design.

After the Second World War, the established first generation of designers in the USA (men such as Raymond Loewy, Walter Dorwin Teague and Henry Dreyfuss) and then the new generation emerging in Europe (especially Germany and Italy) began treating the design of consumer products with two characteristics in mind. Whatever style they chose emphasized clean lines and orderly presentation of functional parts – knobs, switches, dials and levers. They also focused on precision. Whatever the materials – wood, pressed steel, spun

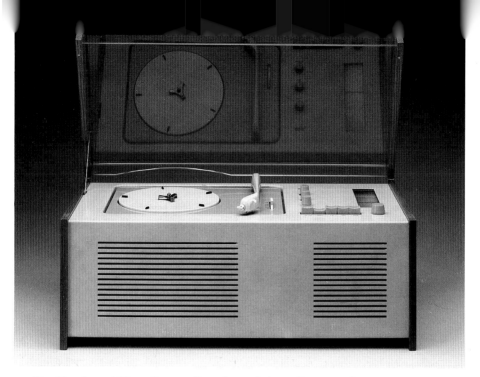

25 Hans Gugelot and Dieter Rams, radio and record player, Braun, 1956.

aluminium and then plastics – designers and product engineers demanded neat fixings and casings, and more refinement generally in the assembly of mass-produced goods. But the ultimate refinement, that of getting rid of bulk, eluded them. (Indeed, sometimes designers were out of step with consumers in this quest. Bulk can express largesse, pomp, luxury – in big refrigerators and big cars for example. Big cars – such as the German Mercedes and BMW – still demonstrate that bulk can be much favoured by the discerning wealthy.)

For years the possibilities for miniaturization were limited (although electrical motors were getting smaller, a process that had been in train since the 1920s). The main design options centred upon the casings.

Making static, bulky objects less obtrusive was instrumental in determining the shape of Braun's Snow White's Coffin (1956), the SK4 combined radio and record player. Designed by Dieter Rams and Hans Gugelot, Snow White's Coffin was on the cusp of the 'age of the transistor'. By giving the phonograph a perspex cover, with a light-

coloured wood cabinet and white-painted metal, Rams and Gugelot had gone as far as it was possible to go in the pursuit of design quietism using old-fashioned technology. Three years later, in another combined radio and record player, Rams took his quietism further; the pocket-sized radio could be separated from the phonograph and the two together were barely bigger than a woman's slimline handbag. In the same year, 1959, Sony introduced the world's first fully transistorized television set. 'Reduced to essentials of tube and battery pack tightly sheathed in a metal cabinet, and with handle, knobs, antenna and stand arranged as function dictated, this boldly reduced eight-inch screen model was at the time considered amazingly light, weighing only thirteen pounds.'

It would be misleading to suggest that the major thrust in 1950s design can be characterized by the spare design championed by Braun or the Sony Corporation. Then, as now, there was a variety of styles and, in the USA especially, most consumer products, aside from such goods as refrigerators, were colourful and flamboyant.

Designers tend to take each new development in technology on its own merits. They then temper the technology with ideas of their own or from the past, partly in response to public reaction. This is illustrated in the development of the digital quartz watch industry that erupted in the 1970s. It threatened to do away with the analogue watch face, partly because the novelty of having numbers flickering away on red Liquid Electronic Display (LED) crystals became exceedingly fashionable, and partly because digital watches were easier to manufacture. But analogue watches are easier to read and appealed as classic objects, prompting a switch in the early 1980s to combining the old look with new technology.

Small electrical components enable designers to design complex things to be held in the hand. Gadgets thus become toylike. But the mildly derogatory way in which cameras, calculators, electric shavers, radios, televisions and portable telephones are dismissed as toys ironically hits upon an important point: adult humans share with their children a basic animal pleasure in handling small, comfortable and comforting objects that have 'kind' forms and pleasant textures. If the functional aspects are well designed, if – for example – the buttons depress with just the right resistance to the finger tips, then the object is desirable. Braun capitalized on this instinctive pleasure by miniaturizing and refining its products to a jewel-like quality.

40

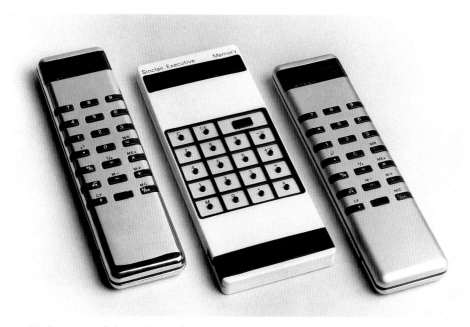

26 Sinclair range of electronic calculators, 1972: technology encourages a logic for a new style.

In Deyan Sudjic's instructive book, *Cult Objects* (1985), the Braun ET22 electronic calculator is cited as providing the definitive answer to what a calculator should look like. Designed by Dieter Rams (1977), it is not the smallest possible calculator or the thinnest (in the 1990s some calculators are anorexic – so small that they are virtually useless).

Rams's creation owed much to the work of Clive (UK, b. 1940) and Iain Sinclair (UK, b. 1943), who designed and manufactured the world's first pocket calculator (1972). It was only a centimetre thick and twelve centimetres long. The most complex calculator of its time, it possessed a 7,000-transistor integrated circuit, and was the first to be powered by a wafer-thin battery.

Clive Sinclair, inventor and entrepreneur, also had a share in pioneering the personal computer. His ZX Spectrum and ZX 81 computers, introduced in the early 1980s, brought inexpensive computing to hundreds of thousands of homes throughout the world. The ZXs were black, practically seamless little boxes. Not even the keyboard stood proud of the surface, for the keys were just printed

onto the rubbery exterior. But the keys had an unpleasant squidgy feel to them, were difficult to hit precisely, and were thus an ergonomic mistake that Braun would never have made.

Such a failure of ergonomics was a design failure of a particularly important kind – the failure to recognize that between the black box and the user a conduit of understanding had to be designed. This was where the Apple company came into its own.

By the late 1970s there were several kinds of personal computer available but they required hours of learning to use them. Steve Jobs and his partner Steve Wozniak wanted a computer which anyone could start up and use – hence the Macintosh project.

The design features of the Macintosh all emanate from Jobs's determination to put the user rather than the technology at the centre of the design. Of course, without the technology, the possibilities for use could not arise, but the designers of the 'Apple Mac' were not to be driven by the technology.

One important aspect of the Apple Mac was the 'mouse' – the hand-held controlling device that is pushed around like a toy motor car. To Jobs this replicated gesture and hand movements: the user pushed the mouse to make an arrow point on the screen to select the service wanted. Its other major feature was the user-friendly graphics, using words and pictures that related to the tasks and objects of an ordinary office.

The strategy behind this design was therefore to use the 'familiar' as a conduit of understanding between the user and the computer. Sinclair's mistake had been to offer the user no familiar footpath to the inner secrets of his magic black box.

When the Apple Mac was being designed, in the early 1980s, the memory chips used by the computer were expensive, thus limiting the size of memory that was possible. Consequently, software designers had to design their programmes with an elegance bordering upon poetry in order not to use all the memory power of the computer on user-friendly appeal. Aesthetics – in the sense of a pursuit of refinement – help at all levels of design.

The physical styling of the Apple Mac box was influenced by Jobs's love of the Mercedes car. He said to John Sculley, a colleague at Apple, 'Look at the Mercedes styling, the proportion of sharp detail to flowing lines. Over the years they've made the lines softer but the details starker. That's what we have to do with the Mac.'

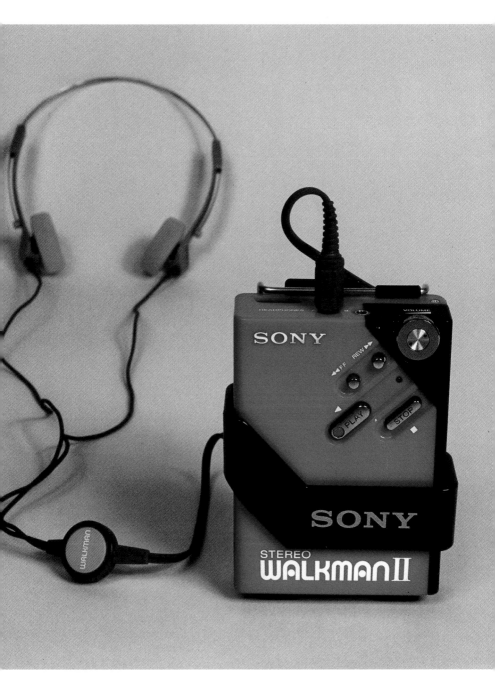

27 The Sony Walkman, introduced in 1978: a styling concept that used existing technology.

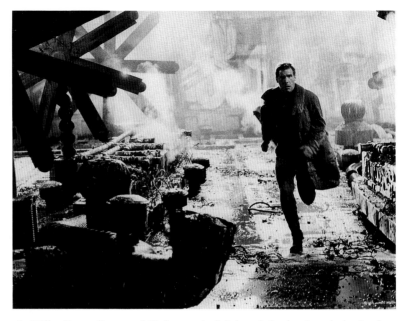

28 Ridley Scott, director of *Bladerunner* (1982), later helped to launch the Apple Mac.

It was launched in 1984, with a bold television commercial that emphasized a connection between the Apple Mac and freedom. Ridley Scott, the film-maker famous for such films as *Alien* and *Bladerunner*, made the commercial, which identified all other user-friendly computers with George Orwell's *1984* vision of thought control. The Apple Mac, of course, was presented as the liberating force of individuality.

Weight for weight, modern computers, radios, hi-fi systems, or electronically regulated auto engines, deliver much more than their ancestors of twenty years ago. This has been the electronic technologist's great gift to designers – the means to create working icons of personal freedom through greatly enhanced power and portability – the now classic example of this being the Sony Walkman cassette tape player.

The introduction of the Walkman in 1978 was a watershed in Japanese design. During the 1950s and, to some extent the 1960s, Japanese industry was succeeding by responding quickly with new products based on new developments in technology. It had hardly to bother about styling – at least not in the sense of style adding value or

44

meaning to a product. However, with the Walkman, styling was important – indeed, the whole notion of a personal stereo was a styling concept, as with a piece of personal clothing. It was a way of recycling an existing piece of technology (transistor, solid-state electronics) into a second generation of product – and profit.

The early small cassette recorders produced by Sony in the 1970s had aluminium cases but, by the mid 1980s, as with most consumer products including high-value cameras, plastic became the norm. This gave the advantage of lightness as well as economy.

However, for at least a decade after the Second World War, the design of consumer goods such as typewriters, radios, refrigerators and televisions was greatly restricted by the size of the internal mechanisms, the limitations of the casing material and the process of fabrication. Many 'classics' of design in the period 1930 to 1955 have a close family resemblance because designers were stuck with the fabrication techniques of the age, which allowed manufacturers to press and bend metal sheet economically only if they allowed for shallow rather than sharp curves.

But the limitations of a manufacturing technology had to be sold to the consumer. Thus the designer had to elaborate upon a virtue of the style that factory machines could deliver. Rounded, shallow curves were organized into a style – streamlining – which became a metaphor for some of the values of the age. It went out of fashion when other fabrication methods became available.

The metal-bashing techniques that produce the rounded, organic sheet-metal forms were styled into some notable classics of design. Marcello Nizzoli (Italy, 1887–1969) designed for Olivetti the Lexicon 80 typewriter (1948); the Vespa scooter, designed by Corradino

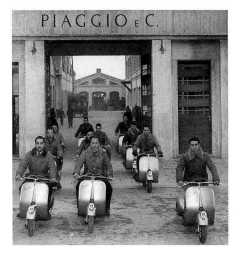

29 Corradino d'Ascanio's innovative design for the Vespa scooter, 1946, provided cheap, reliable individual transport at a time when most workers were too poor to buy a car.

d'Ascanio (Italy, 1891–1981) and produced by the Piaggio company in 1946, was rivalled by the Lambretta, which appeared in 1947.

Manufacturers sought economy of manufacturing from designers and product engineers. The American designer Harold van Doren (USA, 1895–1957) explained in *Industrial Design* (1949) how some of the archetypes of postwar American design were determined almost wholly by their production methods. He took the electric toaster as an example: 'Several postwar models have appeared on a phenolic plastic base on which the heating elements, thermostat, and mechanical parts are mounted, then covered with a single inverted dome of deep-drawn steel.'

Metal, however, is being replaced by the ever-widening family of polymer-based materials. Pioneering work in plastics was done before the Second World War and Bakelite was used for radio casings in the late 1920s. After the war, the demands of competitive mass manufacturing, together with the esoteric needs of the defence industries, impelled the creation of new polymer-based composite materials. These have replaced metal fabrication substantially across a wide range of household goods, and are now substituting for metal components in automobiles and aircraft.

The cost of casting metal has increased sharply since the war, while developments in polymer science have meant that plastics can be shaped into complex forms relatively cheaply. There are broadly two classes of 'plastic' – thermoplastics, which are made tractable by heating, and thermosetting plastics, where a chemical reaction is involved in the moulding and setting of the form. Modern versions of this category of plastics are used in designs where fire resistance is important.

One advance made since 1945 is the development of foam plastics, whereby fibres and gases are added to a polymer to create a thick but rigid plastic that has a good weight-to-strength ratio: automobile steering wheels are an example of their use. Perhaps the most flamboyant use of foam plastic was when Gaetano Pesce (Italy, b. 1939) designed his Dalila chairs (1980) in rigid polyurethane foam – they look as if they were arrested between the acts of melting away or warming up into life.

The basic process for manufacturing articles in plastic involves softening the polymer material by heating it, and then forcing it into a metal mould and cooling it. The material is squeezed or forced out

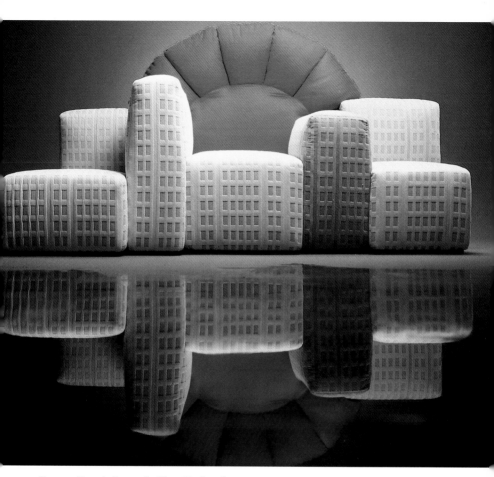

30 Gaetano Pesce's Sunset in New York sofa, 1980.

through a shaped nozzle or die (extrusion) or pulled (pultrusion), spun, sprayed, compressed or injected into a mould.

One stylistic consequence of the growth of plastics (which, in volume use, now exceed that of metal) is that most forms are rounded and organic but, as standards of production have increased, the detailing has become sharper and much cleaner. This has enabled product designers to introduce a level of refinement by specifying a ridge, a sharp surface pattern, or a clean change of level, so that they can approach the creation of an object much as an architect does a building – thinking in terms of defining and enlivening its surface and

47

form by creating features to catch the light and create shadows. Much of the incidental moulding on the casing of a personal computer, portable stereo system or pocket calculator is stylistic, not structural – usually there to give form by moulding the light that reveals form.

Some grades of plastic have a high impact-tolerance (they can be bashed, knocked or scratched with little damage); others can tolerate very high temperatures. With careful engineering design, complex mouldings, including features such as hidden, integrated hinges or locking systems, can be produced with great accuracy and finesse. One of the most practical plastics now in use is called acrylonitrile-butadene-styrene (ABS). It has a high gloss, is rigid and is used as a replacement for metal in the housings for radios, calculators, telephones and computers.

Plastics challenge the designer because their innate and very useful properties remain hidden unless revealed by the efforts of the designer (unlike wood, whose grain is apparent, metals which age gently with a gathering patina, or metals which offer glossy shines or deep reflections).

An early success in exploiting some of the virtues of plastics was achieved by the American manufacturer Earl S. Tupper, who used polyethylene to produce food containers – Tupperware. Critical to the success of these inexpensive, attractive, lightweight containers was the sealing enclosure, patented by Tupper in 1949, and described as: 'a sealing enclosure for containers in the form of a hollow finger-engageable stopper having elasticity and flexibility with a slow rate of recovery to provide a non-snapping and noiseless type of cover which is applicable to the top of a container by hand conformation and removable therefore by a peeling-off type of procedure.'

The design of Tupperware, in terms of the relationship between volume and proportion, is as good as can be found in classically-designed vessels produced in the traditional materials of clay or glass.

Plastics developed since 1945 can be used in hot environments and where particular mechanical properties are required (such as in handles on tools), or where electrical insulation, or resistance to chemicals, oil, cooking fat or abrasives is needed. The ordinary plastic kitchen kettle has several of these virtues.

A commonplace kitchen design of the early 1980s that would have astonished a product designer of the 1950s is the injection-moulded plastic (acetal copolymer) jug electric kettle – a design rapidly

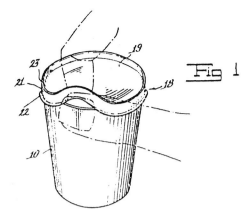

31 Earl S. Tupper, patented design for the push-down seal in the lid of his Tupperware, 1949.

replacing metal kettles. As product engineers explain in *Plastic Materials* (1988), whereas a metal-bodied kettle requires several manufacturing procedures, plastic has the advantage that it can be moulded in one piece 'to provide features to which to attach the electrical element and socket, and provide a colourful finish, at a cost considerably less than that of the metal part.'

Among the variety of polymers are the clear acrylics such as Perspex (1936), which have attracted designers who want to reveal the internal components of a gadget as a means of decoration. Franco Albini (Italy, 1905–77) designed a glass radio in 1938, but a number of radios and televisions were made (in limited quantities) with transparent acrylic casings after the Second World War. In 1968, Leonardo Fiori designed an elegant chest of drawers in clear plastic. And among the most sought after of the Swatch all-plastic watches that became popular during the 1980s are the transparent ones showing the innards. But it is in the vast field of food and retail packaging that clear plastics have revolutionized design. The 'blister' pack for example, is used for packaging and presenting a huge range of small objects, from radio batteries to earrings.

A consensus often develops among designers and manufacturers about the appropriate uses for a new material – orthodoxies arise surprisingly quickly so that, for example, the 'blister pack' becomes the conventional way of packaging and marketing particular

32 The Swatch watches, like pocket calculators and radios, seem almost as disposable as ballpoint pens – an attitude that ecological concern has now begun to question. Disposability has turned the notion of innate value upside down. But if quality of manufacture and performance are guaranteed, interest in the product has consistently to be renewed by new styling.

products. Fortunately, there is generally a handful of designers around who take a new orthodoxy and make a lateral move with it. Daniel Weil (Argentina, b. 1953), now Professor of Industrial Design at the Royal College of Art, London, started putting radios and clocks in plastic bags. He dispensed with hard, opaque casings and made a kind of electronic jewelry out of the components, which remained protected by the soft, pliable and transparent (but dust-and-waterproof) bag. He had other ideas about using transparency as an added functional element and as both a decorative and didactic device. For example, he suggested that plumbing should be transparent; one could see where things were blocked and/or one could make an anarchic decoration of the waste and water as it travelled around, through and out of the house.

The development of composite materials has yielded a new generation of lightweight, yet immensely strong, structural materials, which became widely used in civilian manufacturing in the late 1980s. A composite material combines the properties of two or more materials bonded together. (Concrete, for example, is a composite of gravel, sand and cement). The new polymer-based composites are polymer resins mixed with fibres – different kinds and lengths of fibres are used according to the engineering requirements that are to be made of the material. Carbon fibres are stiff; glass fibre is flexible. Crash helmets, tennis rackets and all manner of sports goods rely on composite materials.

Advanced composite materials were developed by the defence industries to meet the needs of air forces who wanted aircraft that could fly higher, with greater range, more payloads, and with greater manoeuvrability than existing metal or wood structures could cope with. A high-performance carbon-reinforced composite is, weight for weight, six times stronger than steel.

Metal has not been entirely left behind. Quite apart from the still-considerable range of primary structural uses for steel, there are also developments in steel-composite and aluminium materials. These metal-composites are of less relevance to the packaging of consumer goods than they are to the construction of automobiles, aircraft and public transport systems. However, even in gadgets in the home or the office, a metal finish, a metal trim or a metal casing adds élan to a product. And among the advances made in plastics technology during the 1980s were new methods in the metallization of plastic surfaces –

33 Ceramic tiles for insulation of NASA space shuttles: craft production applied to advanced technology.

an ironic turnabout – the surrogate material imitating the one it has replaced.

New technology and its materials are like clay. Clay is a hugely malleable, versatile media – it can be sculpted, thrown on the wheel, dried into dust and force-blown into moulds by automated equipment, press moulded and, in its new forms, used for the blades of knives, the heat shields of space-shuttles or the components of an automobile. In short, it can take any form required of it. A lot of new technology is similar in its freedoms; high technology can be dressed, not in new design but in old. Technology gives designers the freedom to rework past styles ad infinitum – that is why it does not dictate its own aesthetic.

34 The new technology of 'Virtual Reality' may transform education, designing and the leisure industries.

New technology muddled the arguments of the old arts and crafts movements – arguments that still had some currency among designers in the 1950s – concerning truth to materials and the integrity of design. The old framework – of honesty, not forcing materials into unsuitable forms, not packaging a functional item in an apparently non-functional package – collapsed. Modernists had hung an ethical as well as an aesthetic ideology on the old framework; when technology knocked the framework down, it demolished Modernism's materialist ethics at the same time.

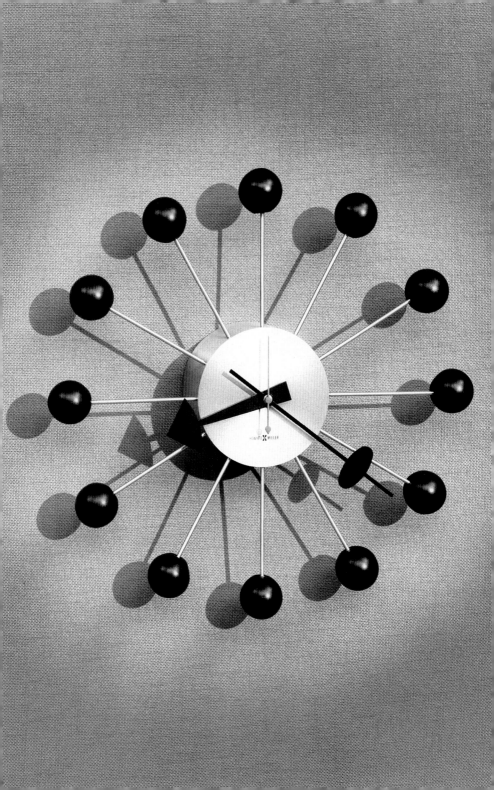

The Style of Product Design

Product shape is influenced by production technology. But it is also affected by law and bureaucracy. The telephone is a good example. In countries with a monopoly private or government-run telephone service, the design of the handsets has remained constant for decades. However, when deregulation allows competitors to emerge, a plethora of designs emerges as well.

One may assume that what the product does will determine its appearance. Use does influence shape – a kettle needs a handle, a spout and a vessel to contain the water. A hairdryer needs to expel warm/ cold air, have a handle and be light enough to hold over one's head. Many basic tools are determined in their form by the narrow function they have to perform – cutting, slicing, grinding, bashing and ripping are functions which determine specific shapes, forms and material requirements.

The claim that use influences the shape and form of a product is not the same as the claim that use determines the final design. And yet, from time to time, in an effort to ground design in a framework of objective principles, the theory of 'functionalism' becomes fashionable with some designers and critics. There is no coherent theory of functionalism, but in her excellent essay, *Design Since 1945* (1983), Kathryn B. Hiesinger defines functionalism as the idea 'that beauty in useful objects is defined by their utility and honesty to materials and structure.'

In the years immediately after the Second World War, some North American and European designers found the idea of functionalism useful as post hoc justification of a style which appealed to them – and which was developed through the stringent necessities of military and engineering design. Functionalism became useful as a theory because it made sense of a predilection they had anyway.

Esther McCoy, designer and historian, points to the fascination several American product designers had with designing products whose function was measurement. In her article, 'The Rationalist

55

35 George Nelson, Ball and Spoke clock, USA, 1950s: imagery for the atomic age.

Period' (1985), she cites George Nelson (1907–86) and his brushed-aluminium circular electric desk clocks (1955), and Walter Dorwin Teague's glass-housed barometer (1949). Raymond Loewy, the most prolific product designer in the world at that time, designed a series of radios for the Hallicrafter company in 1949 – using black-on-white instead of gilt and gold fabric; making the switches and knobs 'mechanically convincing' so that the radio had the no-nonsense look of the kind of equipment found in a military aircraft.

But many other designers did not adopt the 'functionalist look'. For while the period between 1945 and *c.* 1960 can be described as the period of rationalism and/or functionalism in design, it does depend where one looks. In American automobile design, functionalism did not determine the shapes of the cars. Moreover, the variety of furniture, lighting, decorative textiles and wall finishes of the same period in North America, Britain and northwest Europe express design that is eccentric, jazzy, neurotic, brash and discordant. One could just as easily describe this age as being 'irrational'.

Some designers sought guidance in the rubric that function determines form and leads to 'natural' beauty. Designers, design colleges and some 'design-led' companies often went to great lengths to enlarge the rubric into a theory grounded in the science of ergonomics.

Functionalism is an idea that can be seen to make sense. Examples abound (both in our century and from previous centuries) of useful objects that were also beautiful, but whose beauty appeared to be an incidental by-product of their function. Such objects seldom had the name of a single designer, architect, engineer or craftsperson attached to them.

Architects, most famously Le Corbusier (Switzerland/France, 1887–1965), were prone to 'discovering' the beauty of such structures as grain silos or warehouses, or the utilitarian designs for bridges, tunnels, viaducts, mooring posts, sluice gates and lock systems that emerged in the 18th-century English canal system. Steam railways yielded another source of examples which show how building-for-use seemed to produce beauty as a by-product.

One of the ironies, however, about a 'form follows function leads to beauty' argument, especially one based on the evidence of anonymous, utilitarian objects from the past, is elitism. When intelligent designers of the late 19th or early 20th century looked at

36 Raymond Loewy, fantasy radio, USA, 1947. In this prescient design Loewy anticipated by two decades the idea that technology could be used as a styling device to attract domestic consumers – a lesson that he himself had already put to use in the styling of heavy engineering projects, such as locomotives, and that the Japanese exploited in the design of hi-fi and other electrical goods in the 1970s.

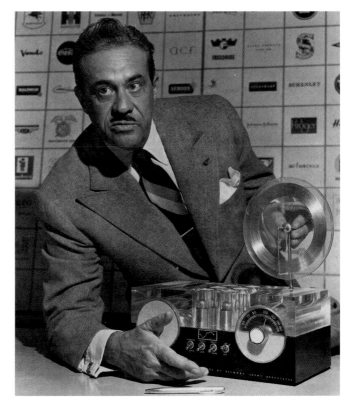

37 Walter Dorwin Teague, glass-housed barometer, USA, 1949. Designer and historian Esther McCoy cites this and other examples as evidence of the American postwar design preoccupation with rationalism, accuracy and measurement.

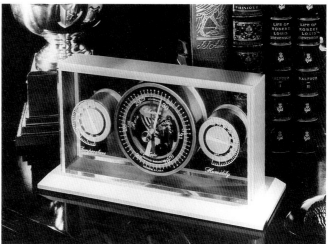

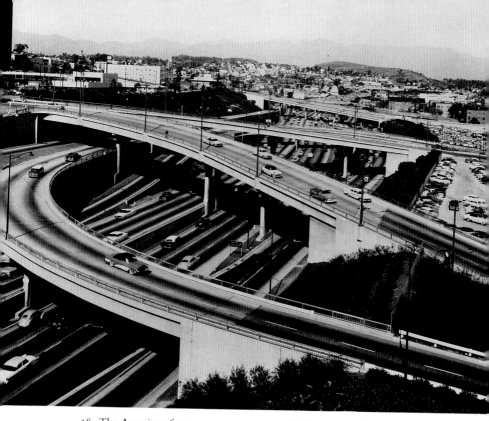

38 The American freeway system: sensuous fluidity or ugly functionalism?

the anonymous artefacts of 18th- and 19th-century industrialization, they saw great beauty in the simple, engineered structures, and set about trying to divine general causal principles between function and beauty. However, the artisans and engineers who designed and built the structures were ignored. It was assumed that function could determine its own aesthetic – an assumption that overlooked the contribution of the anonymous artisans. It was forgotten that beauty is the consequence of deliberate choices by individuals.

Function does not necessarily lead to beauty: most of the urban freeways and motorways in North and South America are functional but, to most eyes, quite ugly. (This is not to say that urban highways are ugly per se.) As an 'ism', functionalism sought principles that would guide design independent of the designer or maker. It was a false trail.

Functionalism shows how theory often follows practice. Design did not evolve a theory of functionalism first; conversely, a style developed in reaction to decorated and elaborate styles such as Art Nouveau and was later justified by an evolving theory. The same is true of Postmodernism. Designers and architects experimented with different styles because the geometry of the International Style was played out. As practical experiments with Neoclassicism, pattern, and bright colour advanced, the theory began to evolve to justify them.

Braun manufactures designs that look functional and do work well, but the company's carefully evolved philosophy of design has also resulted in several generations of beautiful objects. There is no formula or equation that gives neat causal connections between, say, the function of a hand-held electronic calculator and its form. (A hand-held electronic calculator can take the form of a precious tablet *à la* Braun, but could just as easily be in the form of a plastic banana.)

Underlying Braun's design renaissance was the thinking of the Swiss-born architect, designer, painter, sculptor and theorist, Max Bill (b. 1908). In Germany during the 1950s he had a major role in shaping postwar German design. He had trained at the Bauhaus (1927–29) and when he co-founded the Hochschule für Gestaltung in Ulm (1950), he was keen to uphold Bauhaus ideals of design that put function first in an orderly aesthetic. It was Bill, if anyone, who offered the most coherent explanation of the aesthetic we call functionalist. In 1949 he wrote, 'Examining critically the shapes of objects in daily use, we invariably take as a criterion the form of such an object, as a "harmonious expression of the sum of its function". This does not mean an artificial simplification or an anti-functional streamlining. What we specifically perceive as form, and therefore as beauty, is the natural, self evident, and functional appearance.'

The emphasis placed on 'natural' beauty is revealing. For although Bill was one of those designers who believed that mathematics should be as much a part of the designer's talents as drawing, in the end he too must rely on some generalized feeling as to what 'looks right'. This 'looking right', which designers and architects have claimed is the essence of so much anonymous, artisanal design of previous centuries, remains at the heart of functionalism – that and, as Bill later said, not allowing the pursuit of beauty to overwhelm functional criteria in design. In 1983, he confirmed his view that 'functional design considers the visual aspect, that is, the beauty, of an object as a

component of its function, but not one that overwhelms its other primary functions.

Bill's apparently cautious inclusion of beauty as a part of function should not be read as either mean-spirited or as overly puritanical. He was arguing always for balance, and balance in design is achieved not by becoming obsessive about one element, but by searching for a solution in which ease of manufacture, reliability and ease of use, and satisfaction to the senses are all present. This sounds an obvious goal for designers, but it is not. Sometimes designers exaggerate an aspect of their design for one reason or another, often with detrimental effects upon the object's overall performance. This is true of some motor cars, pocket calculators, fashion-led kettles and tableware, and over-designed magazines or video films.

Currently, the academic orthodoxy in design history is to play down the role of the individual designer and to play up the role of the prevailing culture. But it is in the interplay of the far-sighted individual with her or his culture that the secrets of change are discerned.

In the first ten years after the Second World War it was the 'prewar' generation of designers who carried the baton of product and industrial design forward into the second half of the century. Marcello Nizzoli, Max Bill, Henry Dreyfuss, Raymond Loewy, Walter Dorwin Teague, Hans Gugelot and Gio Ponti are among them. They carried forward, particularly in the USA, a vision of what modern designed things should look like.

This vision had been distilled in the USA just before the War at the World's Fair, New York (1939), and was transmitted around the world via magazines and cinema news reels. Billed as showing 'the world of tomorrow', the fair treated visitors to such excitements as Henry Dreyfuss's Democracity diorama and, the biggest attraction of all, Norman Bel Geddes's (USA, 1893–1958) Futurama exhibit. Futurama showed Americans a redesigned America filled with super highways and an advanced super-technological utopia in which everything was clean, streamlined and scientific. Observers were transported around the display on a moving train of chairs, to view the unfolding landscape as though flying across it. The stylistic ingredients of slippery forms and clean looks with everything mechanical sheathed in white or metal casings evoked a sense of a smooth future.

39 Henry Dreyfuss designed the Democracity diorama for the 1939 World's Fair,
New York.

40 The Norman Bel Geddes Futurama exhibit at the 1939 World's Fair, New York.

Bel Geddes had, through his book *Horizons* (1932), done much to increase American public awareness of 'design' and 'designing'. He also helped to popularize streamlined, organic forms as revealed in his drawings for aircraft, ships and automobiles. And with the introduction in the 1930s of the metal-skinned Douglas airliners showing that the slippery-sheathed future was just around the corner, the public hungry for a glistening, chromed present was prepared to gorge just as soon as the country settled down after the Second World War.

American design and styling in the decade or so after the War grew in a climate different to that of northwest Europe. In both Britain and West Germany, as well as the social democratic countries of Scandinavia, there was a political will to plan for a better future and direct it with high-minded policies. The remit of the British Design Council from the 1940s through to the late 1960s included an

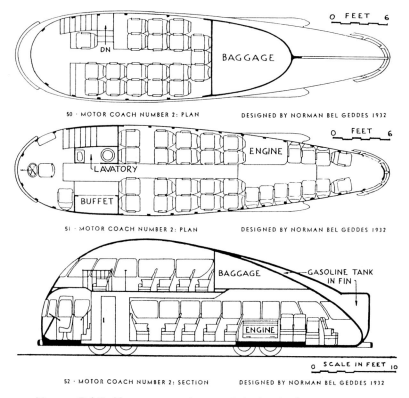

50 · MOTOR COACH NUMBER 2: PLAN DESIGNED BY NORMAN BEL GEDDES 1932

51 · MOTOR COACH NUMBER 2: PLAN DESIGNED BY NORMAN BEL GEDDES 1932

52 · MOTOR COACH NUMBER 2: SECTION DESIGNED BY NORMAN BEL GEDDES 1932

41 Norman Bel Geddes, motor coach, 1932: designing the future.

emphasis upon educating and leading the public into an appreciation of good taste and design. (However, this leadership was faltering by the end of the 1960s when it became clear that there was no agreement on what was 'good' taste and when it seemed everyone in the Pop music, film, fashion, magazine and giftware industries were getting extremely rich breaking every canon of Arts and Crafts or Modernist good taste. Even Victorian Gothic, long despised by intellectuals, was creeping back into favour.)

In the USA, planning and design was left to market forces and independent institutions, such as the Museum of Modern Art, New York, to seek to 'lay down the law on *good* design'. MOMA did its best to be high-minded in the face of American excess. It never pretended to be neutral. It was not an institution to show the plurality of arguments and examples of what good design could be. It took a

narrow, quasi-Bauhaus, quasi-Scandinavian line. (In the 1980s MOMA flirted with Postmodernism and the more intellectually opaque 'deconstructivism' – a literary discipline that was clumsily transposed into architecture and, to a lesser extent, industrial design.)

The USA was the first country to experience the phenomenon of the 'throw away' consumer society based on the notion that yesterday's style was no good and that it was more fun to have a new look every year. Manufacturers capitalized on the idea that it was cheaper to throw away broken goods rather than repair them.

However, this exchange-and-throw-away attitude did not operate in all sectors of American design. Setting aside the automobile industry, which was in some respects a scandal, one of the characteristics of the American consumer boom after the war (and a facet of American commerce generally since the mid 19th century), was the production of similar goods in varying standards of quality, in order to satisfy all classes of people. That not all consumer goods appear to have been badly made may be gauged by the fact that there are numerous collectors of American 1950s design whose 1950s refrigerators and electric stoves are functioning well after three or four decades. The standard of such items as cooking utensils and kitchenware was generally very good, although, as always, one tended to get what one paid for.

An example of quality American production and design is provided by the Ekco Products company. Kathryn Hiesinger explains that when Ekco decided around 1944 to upgrade the look and quality of its products, it had no designer and turned to its engineers, mouldmakers and marketing personnel for ideas. Ekco's Flint kitchen tools range (1946) introduced flat shafts, riveted, black plastic handles and polished surfaces, which, Hiesinger says, 'must stand as an example par excellence of successful design by committee.' The company went on to prosper.

Changes in technology increased the speed of product obsolescence in North America (and later in Europe), especially in the late 1950s electrical goods sector. With the introduction of transistorized components, the switch to printed circuit boards changed the assembly of electrical goods, making it easier to throw away whole sections of a faulty radio or TV rather than repair it. This was a logical, economic consequence for the low price, competitive end of the market, particularly in irons, kettles or vacuum cleaners, in which the

42 Ekco Flint kitchen tools, USA, 1946: good product design by an inhouse committee.

most expensive element is the heating element or electric motor. To an extent, the 'throw away' society reflected not so much decadence as the largely unforeseen consequence of manufacturers trying to sell goods to every level of society.

However, the American automobile of the 1950s has been unfairly held up as condemning the American 1950s as a decade of decadent design. In Europe, apart from utilitarian small cars such as the Volkswagen Beetle, the Fiat 1100 and the Morris 1000, a succession of clean-lined automobiles were produced that resembled smooth, organic, abstract sculptures. These included Pininfarina's Cisitalia

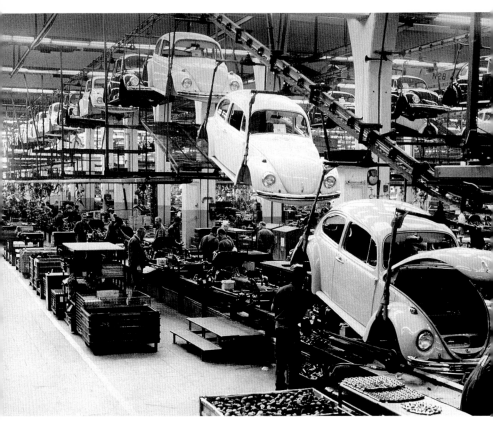

43, 44 The prewar design for the Volkswagen Beetle and the 1955 French
Citroën DS 19 are European examples of national style.

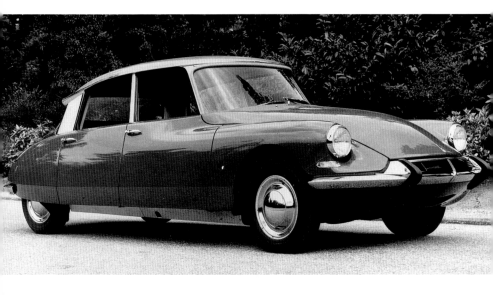

Coupé in Italy (1947), the Porsche 356 in West Germany (1949), the Saab 92 in Sweden (1950) and the Citroën DS in France (1955).

European car designers produced blobular forms, dictated by the metal-bashing technology at their disposal, and influenced by some aspects of wind-tunnel testing, salted with a few stylistic ideas taken from the USA. In France and Britain, for example, the late 1940s introduced the rounded, 'poached egg' designs in Peugeot's Simca 6 (1949) and the Morris 1000 (1948). Widespread discussion greeted France's Citroën DS 19 (1955); the London *Times* called it the greatest piece of adventurousness since the war. The DS 19 appeared to offer a radical, alternative aesthetic that was specifically European, but in truth it shared ingredients already exploited in the USA, such as the full wrap-round windscreen and the elimination of side struts (except for a central pillar) to the side windows. (The American Buick of the same year had windows with very thin frames that wound down with the windows, and no central strut at all.) The DS 19 was also a European bid to catch up with the USA in creating 'effortless driving'; it was not a car of the future but an attempt to put many state-of-the-art ideas about motor engineering into one mass-production vehicle. Hydraulic suspension gave it a very comfortable ride. Citroën thus directly challenged American manufacturers, especially Packard, who had just introduced their 'Torsion-ride'. The DS 19 was acclaimed as 'sculpture'; but some critics pointed out that the body of the car was less refined in its construction than American autos – *Design* magazine (London, 1955) noted: 'On American cars, panel joints are carefully positioned so that the joint lines help the appearance, but there is no such refinement in the Citroën.' Internally, the DS 19 was novel; its futuristic steering wheel had just one strut (at a time when most steering wheels looked as though they had come off a cargo ship). Subsequent versions were improved, and its many modern features made it a symbol of the new France. Senior French politicians made it their official car.

The styling of private transport was especially important to consumers in the early years of the postwar peace. Scooters, motorcycles and cars were the most expensive purchases most people made and, after their clothing, the most visible.

Transport generated symbols of prosperity: the German Volks-wagen Beetle (a prewar design), the Italian Vespa scooter, the Fiat 1100 and 500, and the French Citroën DS 19. In Britain, perhaps one

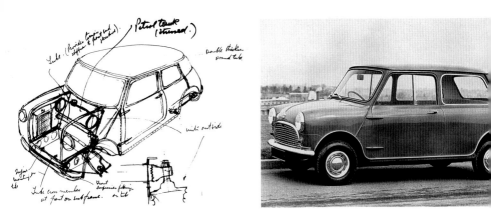

of the best postwar examples of industrial design was Austin Rover's Mini (1959), which became the motor car of the 1960s.

Designed by Alec Issigonis (Turkey, 1906–88), the Mini introduced front-wheel drive, audacious handling and high speed to the mass market; it was fun to drive and it was clearly a 'clever piece of design', for it offered a lot of room in a very small space (it is less than four metres long). It was considered to be 'classless' – an unusual quality in British motoring in those days. Appearances, however, were deceptive. Surveys revealed that few blue-collar workers bought the vehicle; it was favoured by the young middle-class first-time buyer or as a middle-class 'second car'.

No blue-collar worker in the USA in the 1950s would have considered a Mini as fit for anything other than a child's toy. A succession of Ford and General Motors automobiles, restyled year by year, led to the average American automobile looking like an elaborately chromed soap dish featuring 'Flight Sweep Styling' – a style owing nothing to the science of streamlining which European designers were using in their work.

The Swedish Saab 92 motor car, designed by Sixten Sason (Sweden, 1912–69), was the first car to be undershielded. Covering the underside of a motor vehicle helped the passage of the car through the air (a German discovery made in 1940).

Undershielding is not visually exciting, and Harley Earl (USA, 1893–1969), Vice President of General Motors in charge of styling, thought a more theatrical design would sell. From 1949 to 1957, his automobile designs became longer, lower and more chrome-laden, with fins and wrap-round windscreens. Stephen Bayley, author of two books on Earl, says: 'When Harley Earl used a word like

45, 46 The revolutionary Mini, designed by
Alec Issigonis, was lauched in the UK in 1959. It
possessed a remarkable power/weight ratio and a
low centre of gravity contributed to by its 25 cm
wheels.
47 Harley Earl's Cadillac Eldorado Brougham
Town Car, General Motors, 1955. With
hindsight this design condemns itself through its
wastefulness and its unsafe form (the fenders,
though pure ornament, were probably
dangerous in collisions with pedestrians). At the
time, people bought such style by the millions.
48 Lavish Earl interior (1954).

"streamline", no matter how many syllables he got into it, he knew
that it was a commodity which meant the odd Joe on the street had his
life as a consumer enhanced.'

The marketing strategy of the American automobile industry – of
bringing out modified styles every year – was alleged to make con-
sumers feel that their car was out of date the year after they bought it.

Not all American designers deplored this strategy as wasteful and
some, like George Nelson, were sanguine. In 1957 he wrote that the
concept of built-in obsolescence was neither as catastrophic nor as
clear cut as was claimed. He argued that automobile changes were
introduced gradually, in order to protect trade-in values and not
infuriate last year's customers; that a 1957 model did not instantly
render obsolete the model of 1956. He also maintained that the 'trade-
in' structure, so important in the manufacture and selling of
automobiles, was not a feature of other consumer goods such as

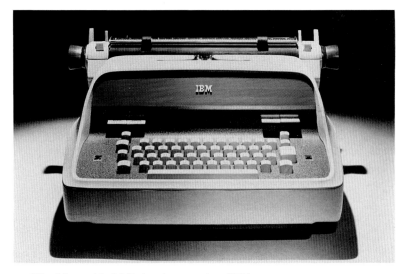

49 Eliot Noyes, Model B electric typewriter, IBM, 1959.

washing machines and refrigerators which, because they did not have wheels, were physically less easy to trade in.

Other designers, including Teague and Dreyfuss, explored a more rationalist approach in their work – partly a function of the things they were designing, such as aircraft interiors. The twin criteria of safety and lightness created a discipline that forced designers to pare their designs and justify them to structural engineers.

One of the most influential American designers of the anti-Earl camp was Eliot Noyes (USA, 1910–77), whose thinking had more in common with European designers such as Hans Gugelot and Dieter Rams. Noyes became the consultant director of design for IBM in 1956. He had trained as an architect and worked with the designer Marcel Breuer (Hungary, 1902–81), who had taught at the Bauhaus. He had also worked with another émigré, the former head of the Bauhaus, Walter Gropius (Germany, 1883–1969). Gropius suggested that Noyes should become Director of the department of Industrial Design at the Museum of Modern Art, New York.

After the Second World War, Noyes worked for Norman Bel Geddes, and then opened his own design office in 1947. He designed electric typewriters for IBM – the Executive (1959) and the Selectric (1961). Both stand comparison with the classics in typewriter design established by Nizzoli and Olivetti in the 1950s. The similarity of

50 Eliot Noyes, Selectric typewriter, IBM, 1961.

design is accounted for by similar production and assembly methods for the casings, and also the European roots (via Breuer and Gropius) of Noyes's design and architecture education.

Noyes's influence at IBM became immense, for he was also responsible for the general corporate design and presentation of IBM itself, and hired men like his mentor Marcel Breuer to design buildings. It is interesting, as Stephen Bayley has pointed out, that two of the biggest American Corporations – IBM on the one hand, General Motors on the other – had such radically different design approaches. This difference can be accounted for as a mixture of two things: the intellectual and aesthetic predispositions of the two leading designers, and the different consumer markets in which the two companies operated. Market forces shape design ideologies. Noyes said 'I prefer neatness', but it was valuable to IBM only because the corporate, institutional, scientific and general office market in which IBM sold its products also preferred neatness.

The 'European influence' on American design came in several waves. The Scandinavian influence was established before and after the Second World War with a succession of touring exhibitions. Colleges such as the Cranbrook Academy of Art and Design became host to émigrés who were especially influential in furniture and textile design. And the Museum of Modern Art, New York, became a

conduit for the new Europeanism in design while, in another department, MOMA was relishing the demise of the European influence in American painting and championing home-grown talents such as Jackson Pollock. In the early 1950s, the Director of MOMA, Edgar Kaufmann Junior, organized a series of exhibitions about 'good taste' in design (intended to be instructive to both industry and the American consumer), including an exhibition called 'Olivetti: Design in Industry' (1952).

It ought to be noted that while European design was enjoying critical success in the USA, all manner of things American were being received with joy by the youth in Europe, in Britain, Italy and West Germany. It is also true that in graphic design American designers were regarded as more modern, adventurous and creative than many of their European counterparts.

An important caveat regarding American design from around 1945 to around the early 1960s relates to the American economy. Analysts are now beginning to argue that the years of economic growth and the consumer paradise that characterized the 1950s and early 1960s were an aberration in American economics. The USA's industrial plant in the wake of the Second World War was more-or-less unscathed, and much improved technically and logistically by the necessities of war; there was also a pent up demand for consumerist goods (the Depression, followed by the war, gave people a taste for buying as soon as the opportunity arose). Thus, for the fifteen to twenty years after 1945, the USA was ahead economically with a running start before other economies could catch up. Though the design and manufacturing community was open to some stylistic influences from abroad, the average American home was essentially all American. It had no Japanese, German, French, or British imports. American consumers consumed only American design. Foreign was only chic to a small percentage of consumers – upper class, rich, educated and self-consciously 'liberal'. As a survey in *The Economist* (26 October, 1991) put it: 'America in the postwar years really was a self-contained economy that could provide its unquestionably American people with virtually everything they wanted.' In the 1990s not even Japan could match that achievement.

In 1950s Europe, a barrage of campaigning came through international exhibitions, magazines and conferences for the so-called 'functional' style. The style was illustrated by favoured examples. If

51 Olivetti has used top designers for decades. Mario Bellini, Lettera 25 typewriter, designed 1972, produced from 1974.

Scandinavia was most often cited for excellence in furnishings, then Italy, and later Germany, were hailed as the centres for industrial and product design.

Italy's influence was established through the quality of products designed by men such as Marcello Nizzoli and Gio Ponti, companies such as Olivetti, and exhibitions and publications such as the design magazine *Domus* (founded in 1928). The most important European international exhibition was also Italian: the Milan Triennale.

Many influential product designs were the work of Nizzoli, who designed for Olivetti. His series of adding machines and calculators – the Summa 40 (1940), the Elettrosumma 14 (1946) and the Divisumma (1948) – were followed by the much-admired Lexicon 80 (1948) and Lettera 22 (1950) typewriters, which established the general form of the modern typewriter – a rounded, unadorned sheath, split into two or three sections for ease of maintenance and to protect the mechanical innards. Nizzoli also ran an independent studio. Among the examples of his private work the following stand out: the two sewing machines for Necchi – the Supernova (1954) and the Mirella (1957) – and cigarette lighters for Ronson.

Of equal influence was Gio Ponti (Italy, 1891–1979). He founded the magazine *Domus* and he was influential in re-establishing the Milan Triennale after the war. This international exhibition was the public venue used by countries such as Finland to promote themselves in the eyes of the industrial nations as centres of design excellence. The introduction of design awards at the Milan show, such as the Compasso d'Oro, encouraged particular approaches to design (such as Nizzoli's), and was a further impetus to the International or

Functionalist style. Modern design became a kind of international club. Good taste was what the 'functionalists' said it was. You were either 'in', like Noyes, or out, like Earl.

Ponti excelled in architecture as well as product design and collaborated in the design of the 1950s landmark of Internationalism in architecture – the Pirelli Tower, Milan (1956). (His co-partners in this project were Alberto Rosselli and Antonio Fornaroli.) Ponti's espresso-coffee machine for La Pavoni (1948) and his almost equally famous porcelain bathroom fittings for Ideal Standard (1953) are regarded as classics of this period.

The dominant style favoured by the institutions of good taste in most product design during the 1950s was organic in shape and form, notably reflecting the work of the favoured sculptors and painters of the period (such as Miró and Moore), who produced globular, swollen forms and images. When Le Corbusier was commissioned to create a building whose function was to be 'spiritual', he designed the boat-like chapel at Ronchamp – the pilgrimage church of Notre Dame-du-Haut (1950–54).

Establishing a parallel between product design and art does not explain why a particular look is popular for a period. The embracing of simple organic form in the period after the war can also be cast psychologically, as people, designers included, wanting to make objects that were 'kind' rather than agitated. Yet much of the decoration in this period and into the 1960s was very agitated. There is

52 Organic design reflected forms in sculpture (*left*, Henry Moore).
53 Gio Ponti, La Pavoni coffee machine, 1948.

54 Mario Bellini and Antonio Macchi Cassia, UMF 21 cash register for Olivetti, 1981–82.

no single dominant style across all design and art, only temporary styles dominant in sectors of design, and two sectors in the same period can look quite different.

An evolution rather than an upheaval in the styling of consumer electrical products began with the introduction of transistorized and micro-electronic technology in the 1960s. Shapes and forms became small and refined but remained essentially as boxes or sheaths around innards. More artistic approaches were possible, but would conflict with functional requirements. A product design has several lives before it reaches the consumer – it must be packed, stored, transported, displayed, sold and transported once more. It is therefore helpful if the product is either generally rectangular or generally round in form. The box appealed to some designers, who managed to refine it to the point of abstract art.

The best examples of slimline electronic boxes came from Bang and Olufsen (Denmark), who accomplished in the late 1960s and 1970s what Braun of West Germany had embarked upon in the 1950s. Both companies created a corporate identity through their products. Bang and Olufsen stereos, radios and televisions became exquisitely worked boxes with very neat graphic detail. They did away with knobs, replacing them, as far as possible, with buttons and sliding switches.

The B&O look was produced by Jakob Jensen (Denmark, b. 1926), who designed the Beosystems (stereo units) and the Beogram turntables in the years 1969–73. The combination of dark-grained wood veneer, satin aluminium and stainless steel provided subtle colouring and the right balance between the natural world, the machine world and 'art'. Although the designs were and remain discreet, they are also very noticeable. The Beogram 4000 turntable used a tangential pick-up arm which was taken up by other manufacturers.

The 'Danish look' differed from that developed by the Japanese. In the 1970s, several Japanese manufacturers were styling their products in an aggressive, military-style engineering garb – it apparently appealed to the young. Some of these designs were European in origin: for example, Mario Bellini (Italy, b. 1935) designed a militaristic-looking cassette-recording deck for Yamaha (1974), and the Italian designers Richard Sapper (Germany, b. 1932) and Marco Zanuso (Italy, b. 1915) had styled their Black 12 television for

55 The Danish Company Bang and Olufsen achieved a unique modern look for its range of domestic electronics products. Jakob Jensen, Beosystem 1200 hi-fi system, wood and aluminium, 1969. This system won the Danish ID prize for its balance between looking like 'apparatus' and 'furniture'.

56 Jakob Jensen, Beogram 4000 hi-fi system, wood, aluminium and stainless steel, designed for Bang and Olufsen, 1972. It features the tangential pick-up arm pioneered by B&O and much copied.

57 Yamaha Electronics was one of the first Japanese companies to use a European designer. This cassette-recording deck, the TC-800GL, was designed by Mario Bellini in 1974 and in production 1975–78.

58–60 'Kids' are a rich vein of consumerism. In 1988 Sanyo introduced ROBO, a robust range of cassette players and radios which are identified in a way that fits in with the branded shoes, sweat shirts, jackets and other niche-market items that the up-to-date child is encouraged to insist upon.

Brionvega which, in 1969, won several awards for its 'High Technology' styling. The Japanese, ever mindful of what appeared to go down well in Europe, saw a way forward for their own stylists.

Today, the B&O style continues to be that of ultra-slimline refinement, but the company is in danger of parodying itself. For although a single product can become a 'classic', admired long after its technology has become quaint, a style can be worn threadbare if it is constantly used and worked and recycled. Design is always an ephemeral activity and styles do become played out like clichés. Or it may be that consumers like change and every style needs to be rested (for rediscovery a generation or so later).

In the 1960s in office products, styles moved away from an overtly organic, naturalistic look. At Olivetti, as Sibylle Kicherer has noted, the effect of Nizzoli's designs was that of a single, sculptural form – like a Henry Moore sculpture with a keyboard. But Nizzoli's successors at Olivetti, such as Sottsass and Bellini, created designs that are no longer 'organic' but architectural – the machine is divided into separate volumes and planes. This, together with the use of textured plastics and colour, accounts for the stylistic changes between the early 1960s and the mid 1980s.

Designers have become especially fond of the computer because it is a machine with several distinct components, each of which can be isolated as a form of table sculpture. Olivetti has been credited with

61 The Olivetti M24 personal computer, featuring a flat, thin, detachable keyboard and launched in 1984. One of the contributors to its design was Ettore Sottsass.

62 The world's first mass-produced all-transistor radio, the TR 55, was Japanese, manufactured by Sony, and appeared in 1955.

some notable design innovations for the computer – both Sottsass and Bellini have contributed to the ergonomics of the design – by devising the flattened keyboard and by putting the monitor on an extending, moveable arm.

Along with European companies such as Philips, Olivetti and Braun, each of which has had an impact on styling in product design, the Japanese company Sony has also been influential.

In 1945, Sony, then called the Tokyo Tsuchin Kogyo Kabushikak-aika company, was set up. It produced the first Japanese tape recorder in 1950, and in 1955 manufactured the first successful transistor radio, using American patents for transistors. This radio, the TR 55, bore the name Sony. One of the company founders had learned that short names were reputed to sell products, and the word Sony evoked the Latin word for sound and the affectionate diminutive for son. In 1958 the company changed its name to Sony. Apart from continuing to provide the electronics world with 'firsts', such as its 1959 transistorized television, Sony proved adept, as Stephen Bayley has noted, at creating new products out of old ones – he cites the synthesis of the clock-radio as an example. Sony invented the satin anodized aluminium look for stereo units and paid exacting attention to details. It was swiftly copied by other Japanese companies.

In essence, Sony excelled at creating objects that were pleasant to touch as well as to look at. But, of course, this interest in the pleasure

element offered by machines, especially machines such as solid-state electronic gadgets, was not an exclusively Japanese phenomenon. Some companies and designers attempted to create a design ideology out of the tactile experience.

For example, Mario Bellini, Perry King (UK, b. 1938) and Santiago Miranda (Spain, b. 1947) have spent many years with Olivetti researching keyboard design (as have Dieter Rams and his design team at Braun). Bellini had experimented with the keyboard in the 1960s but his Divisumma 18 electronic calculator (1972) caught the attention of other designers with its continuous, flexible, rubber-skin keyboard. The catalogue accompanying the Bellini retrospective exhibition of 1987 at the Museum of Modern Art, New York, says: 'The skin, which protects the machine from dust, is anthropomorphi-cally suggestive. Articulated push-buttons, covered with soft rubber skin, are like nipples. Here, the emphasis is not on calculating and power, but on stimulating a sense of pleasure.' A sceptic might argue that the first duty of a calculator is to make it easy for the operator.

Olivetti, believing that the push-button as a surrogate nipple was a desirable styling element, encouraged King and Miranda to use it in the 1980s on such products as the DM range of electronic printers. But many people prefer non-membrane keys to press – a mechanical rather than a fleshy feedback not only feels more appropriate with a machine but is actually easier to use. Squidgy buttons feel inaccurate – and in a number-crunching machine such a feeling subverts the user's confidence.

After four decades of industrial design, decades predicated first on the ideology of 'functionalism' and then on the ideology of the 'human interface with the machine', it is remarkable that so many products defeat the consumer in use. The video-cassette player, for example, is notoriously difficult for people to use. On the other hand, some products of startling clarity and usefulness emerged: most notably the transistor radio, the Sony Walkman cassette player and the simpler forms of calculator and 35mm camera, as well as such clever products as the Polaroid instant print processing cameras (1947) invented by Edwin Land (USA, b. 1909). These products are each characterized by the single-goal nature of their design and the lack of thought or worry that the user expends in operating them.

The Sony Walkman cassette player, introduced in 1979, was a rapid success. Most people do not want to record tapes, they want to play

63 The Polaroid model 103 Land camera (this version was designed by Henry Dreyfuss), 1965–67.

music, and by dropping the recording facility, Sony created a one-functional, simple-to-use, convenient-to-wear product that, through its functional virtues, was 'emotionally rewarding'. Products such as the Walkman approach, for the user, the kind of obvious simplicity that traditional, anonymous designs like jugs, tea kettles, knives and ballpoint pens possess.

For some designers, however, the debate about use was bankrupt because it did not get to the heart of a problem that was beginning to excite some of the younger and left-wing designers and artists: wresting creative control back from industry and commerce.

The prime movers in the radical design movement were architects. In Italy, one of the centres of the movement, it was inevitable that the questioning would be by architects since all designers were architects

by training. But in any case the 'modern movement' in design that had emerged between the World Wars was led by architects just as the pre-First World War European arts and crafts movements were inspired by architects and architectural critics. Architecture has provided the thinkers for design throughout the 20th century.

Andrea Branzi, architect, designer, theorist and professional 'avant garde-ist', describes in his book *The Hot House* how radical architecture in Italy was born around 1968 as an instrument of 'struggle' as well as research. The notion of struggle was fashionable in the late 1960s – class struggle, struggle against commercial hegemonies, and, in Western Europe, a struggle against American-led capitalism.

Marxism had emerged as a respectable academic subject in West European universities, and its teachings provided a theoretical framework for the analysis of the fruits of capitalism. There was also a wider and quite genuine perplexity felt by 'ordinary' people in the face of the extraordinarily rapid changes that occurred in less than twenty years: there were simply many more things, more buildings, more travel, more roads, more cars, more advertising, more information and more activity. Change created uncertainty.

Such excess was good raw material for the art, film, theatre, exhibitions and debate which it inspired. The Italian radical design groups Archizoom Associati and Superstudio staged exhibitions and created models that examined the characteristics of the modern city, modern planning and modern consumerism, by taking ideas to their extreme and creating a parody of the real world. Archizoom devised a project in 1970 called No Stop City, a parody of Utopia based on the supermarket and the factory, designed to research and define the

64 No Stop City (1970): an investigation into modern urban life and forms.

65 Riccardo Dalisi was one of the leading designers in Global Tools, which began in Italy in 1973. One of his achievements was the creation of visually complex designs with low-cost materials and extremely simple construction – an ironic reworking of the modernist *bon mot*, 'less is more'.

characteristics of modern, urban, material life. Radical architecture criticized uniformity and attacked the idea of consensus – especially the consensus of consumption.

There was interest in Italy in the idea of giving back to people 'the right to design for themselves'. In 1973, a counter school of architecture and design called Global Tools emerged which, says Branzi, 'set out to bring together all the groups and individuals in Italy who represented the most advanced realms of radical architecture, under a unified programme of research . . . to channel the energies of the avant garde'

One of Global Tools' members, Riccardo Dalisi, carried out experiments in the teaching of street urchins in Naples ('poor, half wild, untouched by culture') whose creative responses were thought to be unspoiled and spontaneous.

In Britain, some of the thinking and experimentation in the fringes of Italian architecture and design had been anticipated by Archigram, a group established in 1960, which staged exhibitions and produced a publication (the first issue of *Archigram* appeared in 1961). Aided by the interest of writer and critic Reyner Banham, the group argued

that both the most sophisticated and the least sophisticated technologies should be available to people so that they could have the widest number of choices. Like their Italian counterparts, Archigram's main focus was the city, and their better-known projects are 'Plug-In City' (1963) and 'Instant City' (1968).

Ambivalence about technology and the desire to humanize did not have all its roots in the art-intellectual fringes; it flourished also in serious debate about the rights and needs of the consumer. And the USA led on proclaiming the rights of the consumer.

Through the adversarial nature of American democracy, a series of spokespersons emerged, castigating and criticizing design, designers and manufacturers. Ralph Nader, a member of the board of the Consumers' Union (USA, established 1935), published *Unsafe at Any Speed* (1965), an attack on the automobile industry; Victor Papanek launched a general attack on design and designers with his book *Design for the Real World* (1971). In 1980, the American designer Patricia Moore disguised herself as an old woman and wandered the streets of New York to find out what being weak and vulnerable was like. Her lectures, writing and television appearances added to the general re-orientation in American design around issues of 'use' and 'being practical'.

In many ways, despite the self-criticism and the waywardness of some sectors of American manufacturing (such as the automobile industry), American design in the 1960s showed that in some areas it had genuinely put people first. For although ergonomics and human-factors design were not widely discussed by American designers until the late 1970s, there is much evidence of sound, empirical industrial designing in public transport which extends far beyond mere styling, and which combines flair with a concern for the wider good.

For example, in 1965, the Federal Government authorized a proposal from the San Francisco Bay Area Rapid Transit District to design a mass transit system. Designed by Sundberg and Ferar, it became a study in ergonomics. The system went into operation in the early 1970s, and it became the model on which others were based. With the Boeing 747 (introduced throughout the world during the 1970s), the apotheosis of mass transport was reached – it transformed the economics of world travel.

But in America, as in Western Europe, new theories about the possibilities of styling were emerging – from the architects.

66 BART: a new standard in design for public transport.

Architect Robert Venturi (USA, b. 1925) wrote two influential books which legitimized theoretically what some designers were already doing practically. The problem was, as designers realized, styling is to some extent an arbitrary activity. Venturi's books, *Complexity and Contradiction in Architecture* (1966) and *Learning from Las Vegas* (1972), essentially pronounced that decoration was respectable, that one could be eclectic with integrity, and that the entire history of architecture and applied art was there to be drawn from.

This freeing up of attitudes within the fringes of the design and architectural worlds had its effects in the 1980s with the style that was named 'Postmodernism'. It opened up an opportunity for new designers to quote from Cubism, Mannerism, the Egyptians or the Amazonian Indians. It legitimized kitsch in the very sense that the American art critic Clement Greenberg had defined and condemned it (in 'Avant Garde and Kitsch', 1939) – for borrowing superficially from devices developed by mature cultures, and putting them together in a meretricious fashion. Old-fashioned prewar Modernists abhorred meretricious design. 1980s liberalism welcomed it.

A preoccupation with the notions of 'expression', 'simile' and 'metaphor' in a design also emerged. The *idée fixe* for the 1980s became a series of questions. 'Does this product express what it does?' 'Does it explore (as a sculpture might) the broader nuances of the use to which a product might be put?' 'Does it extend the imagination of the user?' 'Is it fun?' 'Does it put us in control over technology?'

Metaphors and similes engaged American designers particularly. The most famous design to represent their Postmodern interest in design-as-metaphor was created by Lisa Krohn (b. 1964), with the help of a colleague, Tucker Viemeister. This award-winning prototype telephone answering machine (1987) used the simile of the book to make the product 'user friendly'. Krohn said of her design: 'An integrated phone and answering machine, the Phonebook employs simile as both an appearance icon and a guide to its operation. Rigid plastic pages are turned to pass from the mode of making calls to the recording and replaying or printing of messages, just as flipping through a personal agenda turns up its different uses. In a way, Phonebook was a sugar coating on the pill of technology.'

The Phonebook is a good example of 'product semantics'. By establishing a visual simile with a familiar object, Krohn demonstrates a strategy for making a complex machine simple to use. One of the problems in modern design, especially with multi-functional electronic products, is that such machines, because they can do so many things, are demanding of our time and concentration. Anyone who has used a combined facsimile-and-answer-phone machine knows there are many different programmes available, and a slip of the finger will send the machine careering off into the wrong mode. On the whole, one wants a machine to disappear into the anonymity of its function – so that one can use it without thinking how to use it. Krohn's design exemplifies a fundamental strategy in making high-technology products genuinely useful.

Product design in the late 1980s was also orientated around the idea of making products feel more personal. Following the revolutionary Sony Walkman came a rush of consumer goods contoured and shaped to fit the human body as though we were to wear product design like clothing or jewelry.

The *International Design Yearbook 1989/1990*, for example, shows a pocket television by Philips and a rival from Matsushita of Japan which look very different, but both are contoured for the hand and

67 The Yashica Samurai X4.0 camera, first sold in the UK in 1989, is an example of styling as advertising – 'One look will tell you it's something different' In its form the camera is an adult toy: adults miss the toys of childhood, and this design, advertised as giving 'pure unadulterated fun', demands to be handled.

the lap, to lodge comfortably against you wherever you sprawl. In camera design, the Japanese have taken the hand-held camera both backwards and forwards in style history: Canon, Nikon and Kyocera have evolved cameras that look as if they have been grown biologically rather than fabricated. They could almost be implanted into the body rather than merely held in the hand.

Sony extended the idea that one can take one's personal products *everywhere* with the Shower radio (1989), a radio combined with a clock to take into the shower. Sony also introduced a children's range of 'toys' – radio, compact-disc player, cassette player and tape recorder coloured in bright reds, blues and yellows, and featuring extra-large buttons for small fingers and rubber trim for protection.

Kenneth Grange (UK, b. 1929) designed a range of containers, including gardening watering cans and electric kettles, that are practical improvements on their predecessors, and which also reiterate the body-hugging tendency.

Making designs that are comfortable and safe are two functional criteria that have become dominant in product design. There is, for any particular type of product, broad agreement on health and safety and comfort criteria. But the attempt to establish rules as to what a thing should look like has been abandoned – for the time being.

MILTON GLASER

Graphic Design

The roots of contemporary graphic design are centuries old. Military and royal regalia, national flags, heraldry, tapestries and stained-glass windows used symbols and pictures to assert authority and promote beliefs and ideologies.

However, since 1945, graphic design has expanded and diversified. Its products have altered radically the mental and imaginative life of everyone in the West and in Western-style cultures. The sophistication and proliferation of technology's media has made graphic design a powerful influence. Contemporary television and cinema advertising films are tightly edited visual dramas that convey a story by suggestion as much as by direct narrative in forty-five seconds. This signifies the sophistication of the designer and consumer: the person in the street has become adept at handling visual metaphors and graphic puns throughout the media of broadcasting, newsprint, magazines and advertising.

Advertising and persuasion apart, graphic design is also a discipline through which objective information can be enhanced and clarified. Some of the most challenging yet least glamorous problem solving is in signage for motorways, airports and hospitals where clarity, readability and succinctness are priorities.

Graphic design is driven by fashion, and successful designers are those who can respond to changes in technology and who have a 'nose' for what is in the air. Some fashions exist for obvious reasons: improved colour printing, together with a general desire throughout the West for gaiety, has meant that colour has dominated graphics (as it has other style-led design such as leisure wear – today even the middle-aged and the elderly wear day-glo jumpsuits and ebulliently striped high-tech footwear). But dominance is generally met by reaction, and during the 1980s there was a widespread fashion for black-and-white photography and grainy, fuzzy, nostalgic film advertisements.

91

68 Milton Glaser design for a Bob Dylan poster, Push Pin Studios, 1967.

Graphic designers manufacture fantasies. Tools such as the airbrush have abetted this: the airbrush, invented as long ago as 1893 by Charles Burdick in the USA, is like a pen in which compressed air drives out a fine spray of ink or paint and allows the designer, with the use of paper masks, to create finely graded tonal pictures of super-realist quality. The photographer's art has also become more deceptive. Elaborate stage management of photography and film has most recently been joined by the extraordinary manipulation and modelling of images made possible by computer-driven animation. Graphic design has surpassed Hollywood as the dream factory.

Technology – and consumer, corporate and institutional demand – have shaped late 20th-century graphic design. Yet many contemporary graphic design tactics and strategies are built upon early 20th-century art movements such as Cubism, Surrealism, Futurism, De Stijl and Constructivism.

Surrealism appeared in two forms before the Second World War: as constructions or assemblages of found objects tied together by a title or short description, and as very detailed fantasy pictures in which otherwise ordinary objects were made extraordinary by being shown in unusual combinations or settings. Photographers were drawn to Surrealism because it offered a strategy through which they could turn photography into art, and Surrealist art has become a mass art because of its use in photography by graphic designers. Surrealist photography was explored by, among others, Man Ray (USA, 1890–1977), Edward Weston (USA, 1886–1958) and Laśzló Moholy-Nagy (Hungary, 1895–1946).

Another important ingredient in contemporary graphic design is collage (and, in film, montage). The creative possibilities of this technique were explored in depth by the artist Kurt Schwitters (Germany, 1887–1948) who pioneered the art of cutting up printed material and photographic images and reassembling them into abstract, narrative or allusive collages.

Late 20th-century typographical and typeface design was shaped by early Modernist art innovations such as De Stijl and Constructivism. El Lissitzky (Russia, 1890–1941) designed aggressive, geometric images for the communists, including the famous propaganda poster 'Beat the Whites with the Red Wedge' (1919). Together with fellow Constructivist and propagandist Alexander Rodchenko (Russia, 1891–1956), he demonstrated the adrenalin-raising range offered by

stark, abstract geometric designs, spare colour palette and severe, agitated typography.

In Germany, one of the most important 20th-century designers was Herbert Bayer (Austria, 1900–85) who taught at the Bauhaus where, in 1925, he designed a pioneering, minimalist sans serif typeface called Universal. Bayer wanted to get rid of all capital letters – why, he asked, have two alphabets? This was an especially radical suggestion, given that the use of capital letters in German, where nouns are capitalized, is more pronounced than in most other languages.

John Lewis, typographer, in his book *Typography/Basic Principles* (1966), has summarized the constituents of what was called the New Typography: freedom from tradition; geometrical simplicity; contrast of typographical material; the exclusion of any ornament not functionally necessary; a preference for keeping within the range of type sizes that could be machine set; the use of photographs for illustrations; the use of primary colours; and the acceptance of the machine age and the utilitarian purpose of typography.

The lessons taught by the revolutionary avant garde in the 1920s were quickly put to commercial use in the 1930s. The Frenchman A.M. Cassandre (1901–68), designer of a series of now classic posters, shows the influence of Cubism, Surrealism and Constructivism in his work. But he added wit, and put it to work for clients such as Dubonnet, steamship companies and railway authorities. He designed several typefaces which, though sans serif and Modernist, were tempered in their angularity by echoes of more rounded, pen- or brush-designed alphabets of earlier centuries.

In Britain, the arts, crafts and handicrafts movements had generated their own form of Modernist typography which has remained infuential – Edward Johnston (1872–1944) designed a sans serif typeface for use by London Underground (1916); Eric Gill (1882–1940) designed his Gill Sans typeface for the Monotype Corporation in 1928. And Stanley Morison (1889–1967) designed Times New Roman in 1932 – probably the world's most widely used roman typeface.

Yet after the war, with a handful of British institutions excepted, British design ignored the New Typography and adopted whimsical lettering, woodblock illustrations and ornament, as well as pastel colours. Why this happened is unclear, especially since the 1950s was a decade when Britain was rivalling the USA in the non-whimsical

69 Abram Games design, 1942. Such posters were to influence postwar design.
70 Design by Milner Gray for the Festival of Britain, 1951.

technologies of aircraft building, computer design and the nuclear power industry. But nostalgia, and perhaps a desire for cosiness, prevailed in magazine, packaging and poster graphics. Whimsy was recognized officially by the organizers of the 1951 Festival of Britain as a dominant British trait and one of the pavilions ('The Lion and the Unicorn') was made over to a celebration of this characteristic.

The world 'leaders' in modern graphic design for the first decade or so after the Second World War were to be found in the USA, Switzerland and Germany. The USA and Switzerland had attracted refugees from Nazism. Piet Mondrian (Holland, 1872–1945), the painter at the heart of De Stijl, went to New York. Moholy-Nagy went to Chicago to found the New Bauhaus. Herbert Bayer went to New York. Two areas of American graphic design were especially strong during the 1950s – corporate design and identity, and magazine design. Both fields embraced the New Typography because it was an international style; with its emphasis upon machine setting, clean lines and photography it had a neutrality and a freedom from tradition and nationalism.

The International Style also became known as 'Swiss' style, which in the 1940s owed much to Jan Tschichold's (Germany, 1902–74) book, *Typographische Gestaltung*, published in Switzerland in 1935. Among those who fled to neutral Switzerland during the war were Bauhaus and De Stijl-influenced designers. In Zurich, Walter Herdeg (Switzerland, b. 1908) founded *Graphis* magazine (1944), which promoted a rationalist approach to graphic design: a strict use of grids and sans serif faces, injected with energy through the asymmetrical compositions of pictures or other visual elements. The play-off between symmetry and asymmetry remained a classic recipe of modern graphic designers throughout the 1950s, especially in the USA and northwest Europe.

Modern style in graphic design demanded sans serif letters, but many sans serif typefaces were difficult to read because individual letters were insufficiently differentiated from one another. In the 1950s, two sans serif typefaces came to dominate internationally on account of their legibility and readability: the Univers family (1954), and Helvetica (1957). Both were adopted for public signage throughout Europe and have remained in use, with variations, ever since.

In Germany during these early postwar years, the design school at Ulm was a centre of graphic design. Its Rector (until his resignation in 1956) was Max Bill. An architect in the Bauhaus tradition, Bill appointed tutors like Otl Aicher (Germany, b. 1922), a graphic designer who gave a contemporary articulation to Bauhaus ideals – notably that design should be seen for its social and not its commercial values. Aicher is an interesting example of how a designer can develop creatively within a relatively narrow vocabulary. During the 1950s he was a purist graphic designer, although he was already innovating with pictograms; from the mid 1950s onwards he was working on logos and trademarks for companies such as Braun and Lufthansa. In 1967 he was appointed as the consultant designer for the 1972 Munich Olympic Games, where his pictogram designs were much praised for their directness and their wit. Pictograms have become an important graphic art since 1945, because the surge in international travel, sporting and cultural events has demanded a graphic signing system that does not depend upon words, but which communicates by visual simile. Aicher developed his pictogram vocabulary to encourage tourism in the German Alpine town of Isny.

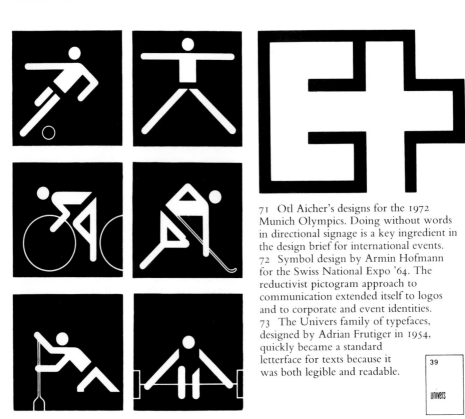

71 Otl Aicher's designs for the 1972 Munich Olympics. Doing without words in directional signage is a key ingredient in the design brief for international events.
72 Symbol design by Armin Hofmann for the Swiss National Expo '64. The reductivist pictogram approach to communication extended itself to logos and to corporate and event identities.
73 The Univers family of typefaces, designed by Adrian Frutiger in 1954, quickly became a standard letterface for texts because it was both legible and readable.

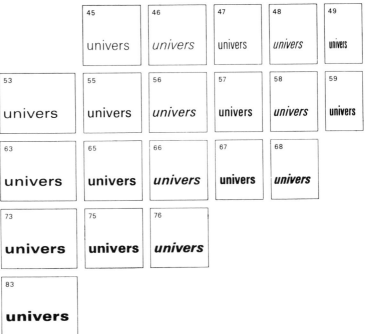

74 Helvetica, designed in 1957, became one of the main letterfaces for public signage throughout Europe.

ABCDEFGHIJKLMNOP
QRSTUVWXYZ abcdefg
hijklmnopqrstuvwxyz
1234567890
()[]&£$.,;:-!?''

75 Palatino was designed in 1949 by Herman Zapf.

ABCDEFGHIJKLMNOP
QRSTUVWXYZ abcdefg
hijklmnopqrstuvwxyz
1234567890 1234567890
ff fi fl ffi ffl ()[]&£$.,;:-!?''

76 Melior was designed in 1952 by Herman Zapf.

ABCDEFGHIJKLMNOP
QRSTUVWXYZ abcdefg
hijklmnopqrstuvwxyz
1234567890 1234567890
fi fl ()[]&£$.,;:-!?''

77 Optima has been much praised for its readability, the result of the 'character' of its individual letters. Designed in 1958 by Herman Zapf.

ABCDEFGHIJKLMNOP
QRSTUVWXYZ abcdefg
hijklmnopqrstuvwxyz
1234567890
ff fi fl ffi ffl ()[]&£$.,;:-!?''

Germany also generated several important typefaces. Herman Zapf (b. 1918) designed Palatino (1949), Melior (1952) and Optima (1958). Optima was praised for its readability, which was aided by the 'character' of individual letters. This character resides in the individual strokes making up the letter forms – each stroke has its own visual weight – as distinct from an alphabet in which every stroke of every letter is the same visual weight (which can be monotonous and tiring to read).

Holland's contribution to the first two decades of postwar graphic design built on its progressive design and art movements of the 1920s and 1930s. Prominent figures in the avant garde of the 1930s, such as Piet Zwart (1885–1977), passed the baton of De Stijl and its influences to subsequent generations of designers. Zwart combined De Stijl with Dada, a combination of the rational and the anti-rational to be seen in contemporary leaders of Dutch graphic design, such as Gert Dumbar (b. 1940) and Wim Crouwel (b. 1928). Crouwel set up his influential graphic design practice in 1952, and in 1963 was a founding member of Total Design, a company which has made its reputation for its support of Functionalism and the International typographic style, and for complex information design projects such as their award-winning signage for Schiphol Airport at Amsterdam.

Among those graphic designers in the USA most affected by European typographical design was Paul Rand (b. 1914), who began his career in 1937 as art director of *Esquire* and *Apparel Arts* magazines, and then joined the William H. Weintraub advertising agency in 1941 where he worked until 1954. During these years he began to specialize in corporate design, especially company logos and trademarks, and later worked on a new corporate identity programme for IBM. His approach was essentially typographical, although the prewar, self-conscious rationalism of the New Typography movement was tempered in the hands of men like Rand by the use of colour and by alphabets that, especially in the IBM packaging programme of 1960, had more than a hint of 19th-century wood-block lettering.

Although the typography and layout during the 1950s and early 1960s was Swiss/International at heart, the imagery was often loud – either creamily energetic (in the promotion of fashion clothes or luxury goods) or aggressively energetic, as in the promotion of cinema films. For example, the leading American graphic designer, Saul Bass (b. 1929), came to prominence in 1955 with his graphics and

78 Signage for Schipol Airport, Amsterdam, 1967, created by Total Design.
79 Saul Bass poster for *The Man with the Golden Arm*, 1955.

animated titles for Otto Preminger's film *The Man with the Golden Arm* – the main character was a heroin addict and Bass devised a single image of a jagged arm, which alone was used to advertise the film when it opened on Broadway.

Bass went on to do the title graphics and posters for many more films, including *West Side Story* (1961) and *A Walk on the Wild Side* (1962). He has also designed a variety of logos for corporations including Quaker Oats, AT&T and Exxon. Another American in a key position in graphic design was Henry Wolf (Austria/USA, b. 1925), who was designing and art directing in the International Style a succession of leading American magazines – *Esquire* (1952–58), *Harper's Bazaar* (1958–61) and *Show* (1961–66). Wolf favoured Surrealist-influenced photographic images.

The achilles heel of the International Style in graphic design lay in its recipes – it was an approach built on rules to be learned and applied – and so it became predictable.

The boredom was broken by Pop Art, which stirred first in Britain in the late 1950s and became the rage first in the USA and then Western Europe. Pop Art began in Britain when young British artists and designers visiting the USA returned with American magazines. They were excited not just by the glossy, modern style magazines such as *Esquire* but by pulp magazines and comic books, especially those filled with advertisements aimed at the well-off blue-collar workers. Pop Art began as a British artistic yearning for 'the American scene', for the depth and extent of American wealth. Using collage, photography, typography and found objects, it was, initially, a British appropriation of American images.

The landmark in graphic Pop Art imagery is Richard Hamilton's collage, *Just what is it that makes today's homes so different, so appealing?* (1956). Hamilton's visualization is about greed, consumption, excess, indulgence, advertising, sex and youth. His observation was of striking significance because it showed a set of values that graphic designers in places such as Ulm were trying to ignore or repudiate. It was also a satire on the gaps between consumer aspiration and reality, a joke about the silliness of consumerism itself.

The roughness of Pop Art, of pictures torn out of magazines and odd assemblages, also started a fashion for anti-design in graphics. An example of this was the launch in 1961 of Britain's satirical magazine *Private Eye*, which for thirty years has irritated people of wealth and authority. In 1992, *Private Eye* looked as it did in the 1960s – as if it had been hastily pushed together from typescripts pummelled out on old-fashioned manual typewriters, illustrated with grey photographs rescued from other people's wastepaper baskets. The unfinished look was all part of its anti-establishment image.

81 *Private Eye*, Britain's leading postwar satire and humour magazine.

In the USA, Pop Art painters such as Jasper Johns, Tom Wesselmann and Robert Rauschenberg made art by painting versions of packaging, advertisements and other graphic ephemera that the consumer culture had thrown up. Roy Lichtenstein began painting blow-up versions of romantic strip cartoons. This was both satire and celebration – satire because painting strip cartoon images by reproducing the printer's dots (the screen) by which such images are built up on the page was a rebuttal of the, until then, dominant trend in American painting – Abstract Expressionism, and its wide, long brush strokes. It was a celebration of the energy and unself-consciousness of mass culture.

For regardless of the influence of the International Style and the New Typography, there remained throughout the West a burgeoning commercial outflow of all kinds of populist, vulgar, fanciful and generally anonymous commercial graphic design. It was to this resource that artists and young graphic designers now looked for inspiration.

Pop artists were heavily influenced by the fact that in graphic design the designer was creating images that would be printed in tens of thousands or even millions. This accessibility and immediacy fascinated painters and sculptors. Thus artists like Andy Warhol used the notion of repeat images as their subject matter – Warhol did this most famously with his silkscreen images of Marilyn Monroe.

Pop Art itself fed back into graphic design. One of the most successful American graphics studios, Chermayeff and Geismar (founded 1960), attracted much favourable publicity for their design of Pepsi-Cola's 1959 annual report, where a bar chart showing the company's success was rendered in the form of piles of used bottle caps.

The liberalism and permissiveness of the 1960s encouraged eclecticism. The student 'revolutions' of the late 1960s in the USA, West Germany, Britain and, most famously, Paris in May 1968, generated an outpouring of magazines, pamphlets, posters and badges, and spawned two forms of new graphic style. The first was a forced marriage between political 19th-century caricature and early 20th-century Constructivist graphic design, whose progeny was rumbustious, almost like the spraycan graffiti that devastated the New York subway during the 1970s. This style predominated in the posters and leaflets rushed out daily by the students of the Beaux Arts and the

82 Ivan Chermayeff's Airports poster, designed for the Aspen
International Design Conference, 1973.

Ecole des Arts Décoratifs in Paris at the height of the May 1968 activities. The other style was more long-lasting and spread like fire, partly because it was tied in with the student drug culture and rock and pop music: it was essentially a re-working of Art Nouveau, and in particular of the drawing style of Aubrey Beardsley, whose erotic illustrations had been the rage of Britain in the 1890s. In the late 1960s, this style became known as 'psychedelic' because its complicated squiggly design and lettering was supposed to be as mind-expanding as the drugs (like marijuana and LSD) that were supposed to inspire it. The most famous of the underground magazines which espoused it were *International Times* (UK), *Yarrow Roots* (USA) and *OZ* (Australia).

Psychedelic graphic art was a reaction against conventional graphics, materialism, consumerism and corporate advertising. Young, but essentially mainstream graphics studios, such as Push Pin in the USA, caught the mood as well. One of Push Pin's founders was Milton Glaser (b. 1929). Now one of the USA's most eminent designers (he devised the wonderfully clever and much-copied 'I Love New York' sticker), he became famous for his psychedelic poster celebrating Bob Dylan.

The liberal mood of the late 1960s affected the Basle School of Design, bastion of the Swiss/International graphics style. Basle became famous all over again when graphic designer Wolfgang Weinhart (b. 1941) began teaching there in 1968, preaching that one could break the rules in graphic design. He was not, however, a putative punk artist for, at the heart of his design philosophy is a belief in clarity and order.

During the 1960s few people took much notice of Japan, but after a decade and more of postwar reconstruction and of copying and improving upon foreign designs, the Japanese business world began to foster its own design talent. Japan hosted its first World Design Conference in Tokyo in 1960; it was organized by the Japan Design Committee, whose members included three West German designers (Otl Aicher, Tomas Maldonado and Herbert Bayer), the Italian Bruno Munari (b. 1907), and, from the USA, Saul Bass. Richard S. Thornton notes in his survey, *Japanese Graphic Design* (1991), that the new Japanese design used Constructivist influences first – he cites the poster by Kohei Sugiura for the World Design Conference as an example.

83 Yusaku Kamekura design for the 1964 Tokyo Olympics – a synthesis of the
Swiss/International style with traditional Japanese iconography.
84 Masaru Katzumie led a team of graphic designers to produce the pictogram
signage for the 1964 Olympics.

Innovations in graphic design are frequently encouraged by
competitions and international events: the 1964 Tokyo Olympic
Games stimulated new graphic imagery in Japan – a contemporary
synthesis of traditional Japanese iconography and the Swiss/Inter-
national style in typography. But by no means did all the major
influences run from the West to the East. For example, as Thornton
points out, it was the pictograms designed for the Tokyo Olympics
by a team of graphic artists led by Masaru Katzumie that set the
standard for graphics at future international events. Clearly there was

cross-cultural fertilization of ideas between Aicher and Katzumie who, like Aicher, had been a member of the Japan Design Committee in 1960.

Western designers were (and remain) excited about the Japanese ability to create the most beautiful graphic patterns. Moreover, there is a conceptual component to Japanese design that stimulated the more cerebral of the Western designers but which remained beyond the grasp of most Westerners until the 1980s. The Glaser message 'I Love New York' is a positive, simple, direct idea, but in Japan the combination of text and image was working in a more complicated, metaphorical (and elusive) way. Thornton's book illustrates a poster by Akira Uno composed in 1965 for the cosmetics company Max Factor: it shows a drawing of an etiolated woman (part Beardsley, part Edvard Munch) choosing from a display of masks; the text reads, 'We are trying to pretend with another face, but it is a test to awaken your sleeping charm.'

During the 1960s and early 1970s, graphic design was effective in all fields of visual and textual communication. It also influenced the art world – the conceptual art movements of the 1970s (reappearing

85 Akira Uno, poster for Max Factor, 1965.
86 Herb Lubalin created this poster, 'Come Home to Jazz', in 1978.

87 Thomas Geismar (Chermayeff and Geismar Inc) designed this Mobil logo in 1964.

again in the 1990s as Neoconceptualism) were indebted to the lessons provided by graphic designers, especially in the art of making photographs and text work together to create multi-layers of meaning. But success tends to peak, and during the political, economic and moral trough in the West of the mid to late 1970s there was inevitably a temporary loss of confidence in graphic design.

One problem was that the Western and industrialized world was looking the same – the same architecture, the same graphic design. One cause for this sameness in graphic corporate design was perhaps predictable: the business of designing corporate images is highly technical; it demands a well-resourced, well-organized design company to implement it and clients tend to favour design consultancies who are known to be 'a safe pair of hands'. Chermayeff and Geismar have built such a reputation, attracting commissions from industry (Mobil Oil, for example), and government (the American pavilions at Expo 67 and Expo 70). A few companies have monopolized the bulk of the work.

Looking the same is not an exclusively 20th-century phenomenon – historically, successful style spreads with international trade and travel. But after 1945, because of the considerable growth in international trade and travel, and the extreme rapidity of communications, style now spreads very quickly. Moreover, the knowledge needed to implement a style also moves – via graphic design manuals, exhibitions, magazines and, most important of all, computer software.

Design historians sometimes cite the computer industry itself as an example of the greying of corporate design. In the 1950s and 1960s, when computers represented modernity and IBM was asserting itself as the market leader, its rivals naturally mimicked its graphic style.

88 KLM logo, 1964, by F.H.K. Henrion, a pioneer of corporate identity.

But the Apple Computer Company in the 1980s, seeking to differentiate itself from the middle-aged style of IBM, named its product after a fruit, and made its logo a colour-spectrum striped apple – the fruit of knowledge, a Californian-style hippy joke and a friendly piece of decoration wrapped into one pictogram. Later, other 'independent' micro-computer companies emerged, also bearing fruity names.

One of the pioneers of corporate design in Europe in the 1960s was F.H.K. Henrion (Germany, 1914–90). He established Henrion Design International in London in 1959, and one of his most famous corporate identities was for the Dutch Airline KLM. In France, the graphic design consultancy of Roger Excoffon (France, 1910–83), called U&O, had several corporate design successes founded on Excoffon's specialism in typography; his design work for Air France in the 1960s was especially praised for its clarity and elegance.

Corporate identity was generally perceived in Europe and the USA as an analytical exercise. Accordingly, many books appeared during the 1960s on the theory and practice of the new graphic 'science'. One of the most influential was by the Swiss designer Armin Hofmann (b. 1920) who published his *Graphic Design Manual: Principles and Practice*

in 1965. It remained influential into the 1970s. Through such books, however, the design 'recipes' were circulated, contributing to the problem of the ubiquity of a handful of ideas.

Some of these recipes were superficial; they were about styling tactics. In the late 1970s, in both the USA and in Britain, graphic design was re-evaluated as a tool for strategic planning. Strategic thinking was especially required in Britain because so many of its institutions – public and private – were over-staffed, suffering low morale and giving poor service and low productivity. As a result of this Britain was vulnerable to Japanese industrial competitiveness.

Japan became a model of excellence, generating interest in 'the Japanese way of doing things'. One of the strategies that appealed to the British Government, trade unions and employers was the Japanese commitment to such tactics as 'quality circles' in which teams of employees would meet each week to suggest improvements to their work and organization. Getting employees to take a pride in themselves and in their work became an important objective, and it was perceived, with much outside persuasion by young design consultancies such as Wolff Olins, that graphic design and strategies for corporate identity would help in articulating, communicating and sustaining pride, morale and the maintenance of the values of service.

One successful example of a total redesign of a corporate image (which went hand-in-hand with a reorganization of working practices) occurred in the early 1980s with British Airways. The corporate identity was carried out by Landor Associates, a San Francisco company. Landor was founded by Walter Landor (Germany, b. 1913) who had worked with Milner Gray (UK, b. 1899) and Misha Black (Russia, 1910–77) in London during the 1930s. He established his company in the USA in 1941, pioneering an analytical, research-based approach to the business of designing for large national or multi-national companies – among them were Coca-Cola and General Electric. When Landor Associates looked at British Airways (then called 'British Air') at the beginning of the 1980s, they saw crudity in the use of the Union Jack on the aircraft tail fins and a brashness in the graphics. Changing the colour scheme to a dark blue, a rich red and light grey background, and exchanging the flag for a subtle grey coat of arms and giving the airline the full title 'British Airways' immediately gave a new impression of gravitas, quality and service. The design was implemented in every aspect of the airline's

89 The design world greeted the redesign of British Airways' livery (1983) with scepticism – critics accused Landor, the designers, of nostalgia (and worse). The critics were wrong. It provided gravitas, dignity and a promise of service. Coincidentally or not, British Airways was one of the few big airlines to be in profit in the succeeding years.

90 The style, design and 'youth opinion' magazine *The Face* was the main vehicle for Neville Brody, Britain's most influential graphic designer of the 1980s. It was not only graphic design that Brody changed, but the content of its ingredients, such as photographic portraiture. The photographer here for the 'Killer' cover, March 1985, is Jamie Morgan.

91 The French graphic design collective Grapus was founded in 1970. Its
members had learned their craft producing agit prop posters for the May 1968
student revolts in Paris. Shown here is a poster advertising an exhibition of their
own work in 1982.

service, from baggage labels to 747s. Ironically, the British graphic design establishment mocked Landor's work, complaining that it looked old fashioned. But the new identity suited one of the major, profitable airlines of the 1980s.

Analytical approaches to graphic design for corporations involve delving into the working of the client company in depth, by asking many carefully structured questions and directing them at all levels of employees. Identifying goals and values, clarifying to the company what it is doing, are the prime intentions of the corporate graphics designer.

One of the most controversial uses of corporate identity analysis has been in Britain where, in 1988, Wolff Olins was commissioned by London's Metropolitan Police Force to look at their public and internal image. This bore fruit by promoting the police force in interesting ways, including a series of advertisements for newspaper, magazine and billboard hoardings that use staged social documentary photographs, hard-hitting but quite discursive texts, and some of the 'agit-prop' design ingredients of El Lissitzky.

Design in the 1980s, graphic design included, was revolutionized by microchip technology, in particular the Apple Macintosh computers and graphics software packages. The use of Quantel Paintbox computer technology has added to the flexibility and possibilities open to the contemporary designer. As the pace of communications quickened in the 1980s – and in 1991 the world watched the Gulf War as it unfolded – consumers took for granted the speed with which computers could handle information, and they were becoming accustomed to gadgetry such as portable telephones and facsimile machines. Graphic designers have responded to the spirit of the quick-information age by generating images and layouts that are multi-textured, multi-layered and fragmentary; mixing illustration, photography and computer-created imagery in a kind of high-technology chintz. The graphics world is visually very noisy.

Among the most-praised graphic designers of the late 1980s were those who specialized in magazine and poster work. They included French poster designers Grapus (founded in 1970 by members who learned their craft producing agit prop posters in May 1968), Gert Dumbar of Studio Dumbar, Holland, and Neville Brody (UK, b. 1957), who designed *The Face* magazine, and Erik Spiekermann (Germany, b. 1947), a computer typography expert.

92 April Greiman is one of the West's leading late 20th-century graphic designers. This example of her work, 'does it make sense?', comes from *Design Quarterly*, April 1986.

Perhaps the most impressive graphic designer at the start of the 1990s is April Greiman (USA, b. 1948). After studying with Wolfgang Weingart at the Basle School of Design, and working in New York and Philadelphia (1971–76), she moved to Los Angeles. The culture of California is intellectually sophisticated, but clearly not in the sense of the liberal arts attitudes found in European belles-lettres. It has been shaped by a highly educated population that is especially expert in late 20th-century science and technology, as demanded by California's major industries in computers, aerospace and defence; it is a society tempered by a warm climate, liberalism, individualism and fantasy – Hollywood. The culture shows in Greiman's work.

She was appointed in 1982 to direct the visual communication programme at the California Institute of the Arts, where she has worked extensively with video and computer technology. She has designed for Esprit, the Xerox Corporation and Benetton. Her work with the computer has led her to evolve a new kind of illusory space in two-dimensional graphics, creating the illusion with several of her designs of looking into a glass globe rather than at a flat page. She has combined Swiss order with the flexibility and inventiveness that micro-computers and their software can provide. She exemplifies how fluid influences and ideas can be in graphic design, for her work combines original vision with collaging techniques, elements of concrete poetry, the surreal and the echoes of Tschichold's New Typography.

Greiman is not alone in her novel creation of three-dimensional space; as ever, there are precedents and parallel innovations. In the

ほしいものが、ほしいわ。

93 Richard S. Thornton, in his book *Japanese Graphic Design* (1991), writes that this poster by Katsumie Asaba, 1988, was so popular that it was stolen from all its display sites. He explains that young love was not allowed public expression in Japan until the 1980s.

work of Kazumasa Nagai (Japan, b. 1929), design commentators have noted an ability to create what has been called 'cosmic', three-dimensional space on the two-dimensional plane – his posters for Asahi Breweries (1965), The Museum of Modern Art, Toyama (1981–83) and the World Design Expo of 1989 are cited as examples.

Magazine and poster design is a complex, popular and highly innovative art in the 1990s – it is also volatile and transient. Courtesy of the computer, the graphic designer can now enact on the page all the specialisms that were once delivered by individuals – can create his or her own typeface, illustrations and layout, and get the text and the images printed without involving layout artists, other illustrators, type designers or compositors. This technological revolution was encouraged by the Apple Macintosh and the first generation of graphics software packages such as Mac Write, Mac Draw and Mac

Paint. The second generation of software, including Hypercard and PageMaker, have made desktop publishing and graphic design a widely dispersed cottage industry. It has enabled very young designers to return graphic design to a quasi-craft basis (founded on high technology). Moreover, the graphic designer can take any image (subject only to the constraints of copyright) and recast it in whatever way he or she wants.

The access computer technology offers to magazine, library and museum data bases throughout the world gives the graphic designer a whole world of images and a history of styles as a resource to raid, adopt and remake. But to what end?

One trend, rooted in the 1960s, but which began to flower in the late 1980s and early 1990s in all but Islamic, African and the remaining hardline communist countries, is towards increased political devolution and regionalism. This is underscored by an ever increasing tendency of people to organize their lives through political, professional, ethnic, sub-cultural, fashion or sexual interest groups. Pluralism and fragmentation offer the high-technology cottage industry approach to graphic design a new challenge that is the antithesis to that of the mono-cultural, corporatist approach that has dominated since 1945. Corporate design is not about to disappear but its monolithic image could be paralleled by a proliferation of graphic identities and languages that are meaningful only to individual sub-groups and communities.

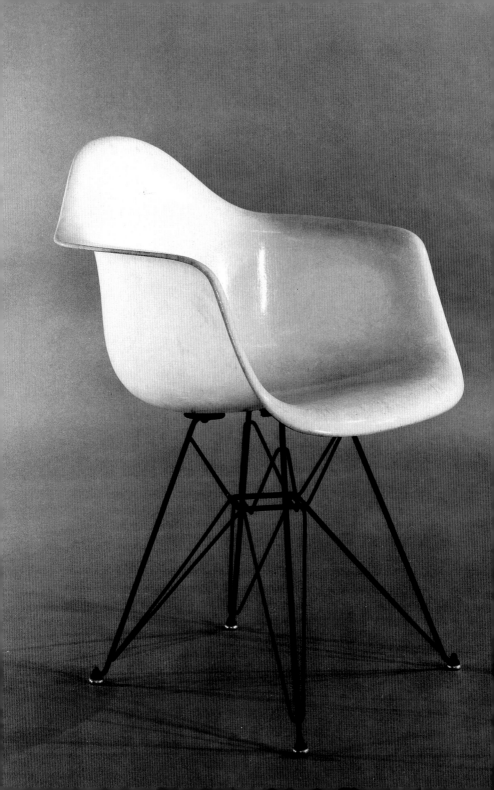

CHAPTER FIVE

Furniture Design

Furniture – and the chair especially – has been used by 20th-century architects and designers as a means of making an aesthetic, social and ideological argument.

In the 1920s, European designers such as Marcel Breuer and Ludwig Mies van der Rohe (Germany, 1886–1969), developed new, minimalist conceptions for furniture, using tubular steel and thin upholstery. Mies van der Rohe, one of the 20th century's most important architects, had a considerable influence upon furniture design and, interestingly, though he had no formal training as an architect, served as an apprentice architect and designer with Peter Behrens, who was then working as an industrial designer as well as an architect for AEG. From Behrens, he acquired a sense for classical form in design. Breuer's equally classical, simple forms for furniture became especially influential during the 1930s when, in 1933, the Chicago-based Howell Company bought some samples of his work, modified the designs, and put them into production.

The Finnish-born Alvar Aalto (1898–1976) continued the spare, linear aesthetic using laminated wood. By the late 1930s, he had extended the vocabulary of modern furniture design by tempering angularity with swooping curves, and exchanging the cold material of metal for wood. Then, due in part to new developments in technology, a new generation of American furniture designers made 'organic furniture' – notably Eero Saarinen, and Charles and Ray Kaiser Eames.

On the simple but not unwarranted popular belief that angular chairs are uncomfortable, but organic and round ones are welcoming, it would be easy to set the designer of angular forms against the designer of organic furniture – by declaring that the one was less interested in the happiness of his users than the other. But it is probable that neither camp was much interested in the assumptions of the 'ordinary consumer'. What connects all the Modernists – Mies van

117

94 Charles Eames armchair, USA, 1951.

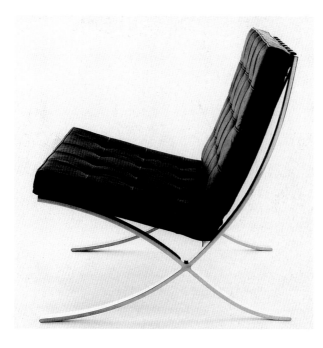

95 Ludwig Mies van der Rohe's Barcelona chair. Launched in 1929, it has a chrome-plated flat steel frame and fabric- or leather-covered horse-hair cushions for the seat and back. An improved version is now manufactured by Knoll International.

96 Eero Saarinen's design for the TWA terminal at JFK airport (1956–62) is a metaphorically rich sculptural design that took considerable courage to create because it contradicted the mores of orthodox Modernist aesthetics.

der Rohe and Charles Eames, Marcel Breuer and Eero Saarinen – is a belief in *themselves* as planners, experimenters and perfectionists. They claimed the right to pursue their ends irrespective of popular taste. Marcel Breuer (see *The Modern Chair*, 1988) wrote in 1948 that 'If human is considered identical with imperfection and imprecision, I am against it: also if it is considered identical with hiding architecture with plants, nature or romantic nonsense.' And of furniture design he said, 'There is the courage of design, together with, and in contrast to, modest responsibility towards one client.'

This apparently equivocal attitude regarding the designer's responsibility to a client or a user is one characteristic of postwar designing. Designers, especially furniture designers of the avant garde, have tended to romanticize themselves – hence such terms as 'courage' refer to the personal creativity of the designer himself, while responsibility to the client gets only the adjective 'modest'.

In the 1940s, furniture designers were excited by the possibilities offered to them by new laminates, new bending techniques, and combinations of laminated wood, metal and plastic. By making a means of moulding materials in two directions at once (thus creating

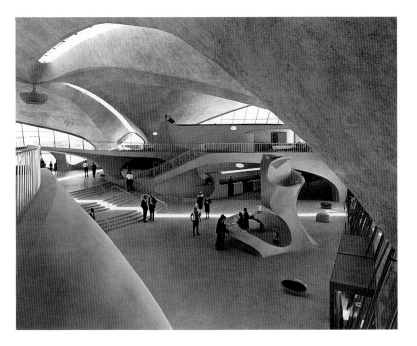

vessel as well as valley forms), modern furniture designers were able to switch from constructed assemblage to sculptural forms (see R. Craig Miller, *Design in America*, 1983). These new and rounder designs appeared also in Italy and to some extent in Britain.

Some of the most interesting furniture design in the early postwar years came from the USA, especially from the Cranbrook Academy of Art, founded in 1932 by George Booth, a newspaper baron, and Eliel Saarinen, the Finnish architect (1873–1950).

From the beginning Cranbrook had a strong arts and crafts emphasis given rigour by its intense commitment to architecture. Eero Saarinen (Finland, 1910–61), Eliel's son, became a noted architect (he designed the biomorphic TWA airline building at JFK airport in New York, 1956–62), as well as a furniture designer. Charles Eames (USA, 1907–78), appointed before the war as an instructor of design at Cranbrook, was one of only a handful of native born teachers at the college; the majority were European émigrés.

Saarinen and Eames collaborated on their design entries to the 'Organic Design in Home Furnishings Competition' held at the Museum of Modern Art, New York, 1940–41. This exhibition

established organic furniture as a style which grew out of new technologies in plastics, rubber and wood lamination. Plastics, however, did not have much influence in furniture until the late 1950s.

Wood lamination was especially useful. Strips of wood with their grains flowing in the same direction, when glued together in narrow strips, make a strong, resilient material, which can be used to create curves of much greater strength than the bentwood frames pioneered in the 19th century. Lamination was advanced by the rapid investment in research into the construction of aircraft during the war, especially propellers, and the development of synthetic bonding resins which were greatly superior to animal glues.

Rubber – especially foam and moulded rubber – altered the concept of upholstery. It could be used as an alternative to metal springing or in conjunction with it. Either way, the use of rubber enabled the creation of comfortable forms with a much narrower section than was afforded by traditional upholstery. And a narrow, slimline section suited the contemporary view of what a modern style should look like.

These technologies made the creation of the style possible in a practical sense, but what made it intellectually safe to follow the course of biomorphic furniture?

First, rounded forms look comfortable for seating. Second, with the new technology of thin materials, it was possible to achieve comfort without having to become reactionary and revert to cushions, or the floral decorated upholstery of the lower-middle classes. But third – and most important of all – was the example set by modern sculpture.

From 1914 onwards, intellectually respectable sculptors from the avant garde, such as Henri Gaudier-Brzeska, Constantin Brancusi, Jean Arp, Jacques Lipchitz, Barbara Hepworth and Henry Moore, had developed a round aesthetic. Moreover, the cutting edge of industrial design, and therefore of rationalism, was the aircraft industry – and its forms were biomorphic too. Furniture designers experimenting with biomorphic styling could point to the sculptors on the one hand and advanced technology on the other – and use both to legitimize their otherwise capricious reasoning.

In the USA, 'official' good taste – the non-proletarian American Look in furniture and furnishings – used a mixture of geometry and

sculptural forms. The two styles play off one another. Both the furniture and the layout of the furniture became abstract, sometimes highly formal and frequently two dimensional. In the Miller House (1953–57), designed by Eero Saarinen, the pictures show everything either pushed against the walls or laid low to the floor. One is conscious of horizontal and vertical planes and the effect is two dimensional, like a living billboard poster. This flatness, especially of modern Californian interior design, was later caught well in the paintings of the English artist, David Hockney, who eventually settled in Los Angeles.

That there was an American Look (never mind that it was broadly rooted in European ideas and art) was important in the 1940s and 1950s. Controversially, perhaps, Serge Guilbaut, author of *How New York Stole the Idea of Modern Art* (1983), argues that American institutions such as the CIA helped to fund exhibitions, catalogues and magazines to promote American art, such as Abstract Expressionism. Apparently the CIA was sophisticated enough to see culture as a weapon in the Cold War: *the* American painter of the New World was Jackson Pollock; *the* American sculptor of the New World was Alexander Calder; and even crafts, such as ceramics, were creating home-grown heroes of an American craft look, notably Peter Voulkos. Pollock was good because he did not paint like any of the Europeans and Calder was good because his organic sculptures were not carved or cast like those of the Europeans, but constructed. His 'stabiles', made from sheet steel, wire and wood, had both the appropriate combination of materials and the right degree of thinness and organic shaping to appeal to designers like the Eames.

The American Look in furnishings and interior design was especially significant in the offices of Corporate America. American companies such as IBM, Ford, General Motors, Coca-Cola and Du Pont (to cite a random selection) were regarded as supreme examples of business efficiency, and other companies in other countries wanted to copy their look. The characteristics of the official 'Look' were comfort, colour, brightness, order and hygiene. Surfaces were kept clear of cumbersome pattern or ornament, although the Look was tempered by simple pattern on the chair coverings or curtains or in the laminates that provided covering to the cupboard panelling. Ornamentation was provided by modern paintings, or through a reasonable number of potted plants. Overall, the style of decoration

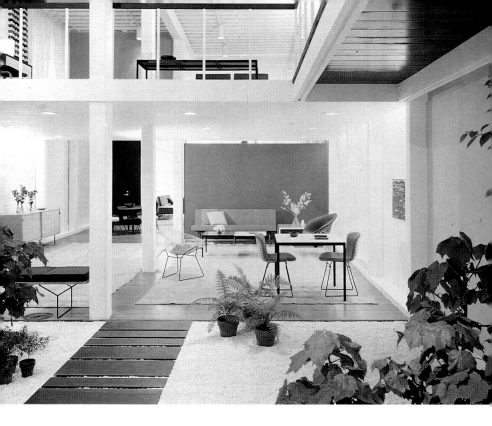

that became permitted in the interiors of the better homes, offices and reception areas might be described as 'intellectual gingham'. It was, as Alex Seago, design historian, has remarked, in particularly odd contrast to automobile design. The consumers of good taste in furnishing and architecture drove to work in automobiles that had nothing at all to do with restraint, sculpture, modernism or logic. This apparent contradiction may be read as testimony to the illogicality of consumer taste, or as an indicator of consumer control – the 1950s American consumer could choose his interior because a variety of choices existed; there was less variety available in automobiles. The technology for niche marketing in auto-manufacturing had not matured.

One of the architects of 'the gingham look' was Florence Schust Knoll (USA, b. 1917), who became responsible for design at Knoll Associates (now Knoll International). Her teachers had been Eliel Saarinen and Ludwig Mies van der Rohe. Her designs, especially her

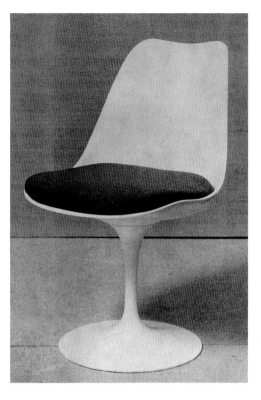

97 Knoll International was one of the leading North American arbiters of 'good taste' in both domestic and office interiors. From the late 1940s onwards Knoll revived and improved modern classics and commissioned new work from contemporary designers such as Charles and Ray Eames and Harry Bertoia.

98 Eero Saarinen, Tulip chair for Knoll International, 1956: manufactured with a fibreglass seat shell, supported by a plastic-coated cast aluminium base.

interior designs, show the influence of both – the plain geometry of cupboards, sideboards and storage cabinets co-exists with the more vessel-like forms for chairs and rounder planes for tables. Through her own sensitive re-interpretations of Bauhaus design and also by getting into production several furniture classics designed before the war – such as Mies van der Rohe's Barcelona chair (1929) and Breuer's Wassily chair (1925) – Florence Knoll played an important role in selling modern European furniture design to postwar corporate America. In her own interior designs, she used colour the way Piet Mondrian used it in his paintings – rectangular areas of primary colours and white. And, revealing another of the Cranbrook influences, Knoll was especially good at commissioning simple but elegantly patterned or textured fabrics. Charles and Ray Eames used similar mixtures of colour and textiles in their interior designs.

Among the most famous single items of American furniture design from the period 1945–60 are: Eero Saarinen and Charles Eames's

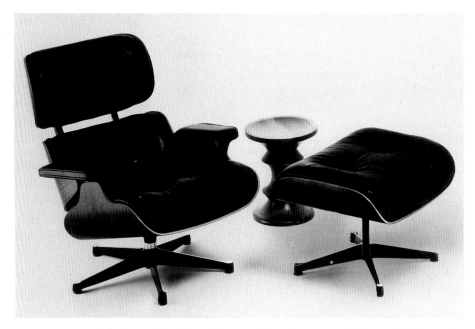

99 Charles and Ray Eames, Lounge chair and ottoman for Herman Miller, 1956.

moulded plywood armchair, upholstered in wool (1940); Eero Saarinen's Lounge chair for General Motors, tubular aluminium with brushed chrome finish, now upholstered in vinyl (1950); Eero Saarinen's Womb chair, tubular steel with wool upholstery (1946–48); Charles and Ray Eames's Fibreglass Shell armchair (1949); Eero Saarinen's Pedestal table, steel with fused plastic finish for the pedestal, marble for the top (1955–57); Charles and Ray Eames's Lounge chair and ottoman, moulded rosewood plywood and cast aluminium plus steel for the legs and supports (1956). Harry Bertoia (Italy/USA, 1915–78), a Cranbrook-trained designer turned sculptor, created one of the most famous of all postwar chairs – the welded-steel Diamond-lattice chair for Knoll International (1952).

A number of other American designers seized the chance to use the thinness and the sculptural possibilities of the vessel form permitted by new methods of steam and press moulding plywood. Ray Komai (USA, b. 1918) was one. In 1983, the Philadelphia Museum of Art, in its exhibition 'Design Since 1945', rescued from oblivion the work of an American design group called Katavolos-Littell-Kelley (1949–55) who produced the T chair (1952) in chromed steel and leather. Their

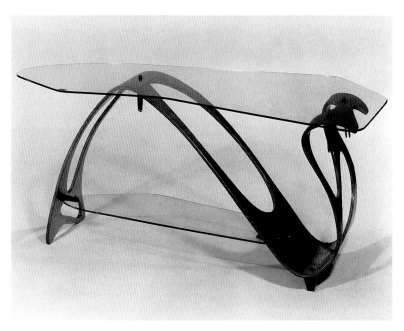

100 Carlo Mollino designed this Arabesque table in 1949.

furniture won the Association for Industrial Design award in 1952, for
the best furniture design in the USA.

The organic look varied from country to country. In Italy, the
architect and designer Carlo Mollino (1905–73) had a genius for
creating bentwood and metal furniture that was erotic. That is to say,
Mollino's interest in erotic art fed through into his designs which,
though not obviously figurative, are unambiguously related to
organic forms such as genitalia.

In Britain there was a lot of well made, modestly Modern furniture
design using multi-plywood construction. Multi-ply – dozens of
layers of wood veneer, bonded and then pressed to form a
homogeneous sheet – allowed a designer to specify thin curved legs
and back rails for chairs. This enabled the designer to create 'drawings
in space' – a popular ambition, which they shared with contemporary
sculptors. Wood predominated, but some elegant, well-propor-
tioned, apparently comfortable and durable designs in metal also
appeared in Britain soon after the war. A now classic example is the
aluminium BA3 chair (1945), designed by Ernest Race (UK, 1913–63)
using aircraft salvage.

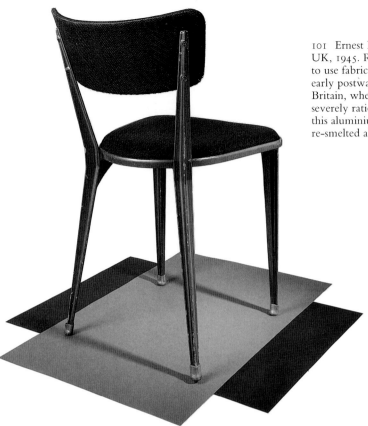

101 Ernest Race, BA chair, UK, 1945. Race was unable to use fabric or wood in the early postwar years in Britain, where materials were severely rationed. He designed this aluminium chair from re-smelted aircraft salvage.

And there was Utility furniture, a range of simple, cheap-to-make furniture designed for production during the war. Its standards improved after the war. Britain maintained rationing of food and materials until 1954 and, during the war, use had to be made of materials such as low-grade hardboard, which gave a ragged edge when sawn. When timber supplies eased in the late 1940s the Utility range was updated. The designs and specifications were extremely detailed, in order that a variety of firms, large and small, could produce the work without dispute. Though popular with some designers and architects, the stigmas of utility, bureaucracy and puritanism damned the furniture in the eyes of most consumers who, as soon as choice was available in the 1950s, threw it out.

In Denmark, Sweden, Finland, Italy and West Germany the preferred material for home furniture was wood – solid timber,

plywood, or steam-pressed multi-ply. In France in the early 1950s there was a strong revival in wicker and cane for chairs, tables and even beds. Wicker and cane is comfortable, light and durable but, although popular in Britain during the 1930s, it has seldom been regarded as appropriate for serious furniture outside of France. English reviewers at the time were perplexed by it, and their favourite adjectives were 'interesting' and 'charming'.

For a while after the war there were temporary design orthodoxies that permeated all social strata via women's magazines, the growing 'Do It Yourself' movement in Europe (the phrase itself was coined at a London trade fair in 1953) and the massive postwar public housing schemes. Free-standing cupboards, cases and chests of drawers were regarded as clumsy, space-eating and old fashioned, and the trend was for built-in or wall-hugging furnishings. The furniture industry liked this because the designs were generally unadorned boxes in concept, and cheap and easy to make. Self-proclaimed 'functionalist' designers created designs that manufacturers could produce easily on an assembly-line basis, such as the cabinet system made of PVC-coated chipboard and metal, designed by Hans Gugelot for the Wilhelm Bofinger company, Stuttgart, in 1956.

A rapid expansion in the international trade in furniture occurred after the war – manufacturers looked beyond their home markets in all but upholstered furniture (which was bulky and therefore expensive to transport). As the 1950s progressed, the leading edge in contemporary furniture design began to move from the USA to Europe, with the Danes in particular recycling the Eames/Saarinen 'vessel look' with great flair. Notably, Arne Jacobsen (Denmark, 1902–71) created for manufacturer Fritz Hansen a plywood and chromed-steel stacking chair (1951), which was essentially a useable Calder stabile; followed in 1957 by both the Swan upholstered armchair (foam rubber on a fibreglass shell supported on a chromed steel stand) and the Egg chair and ottoman. This leather-upholstered foam-rubber-covered fibreglass shell took the serious organic form about as far as it could without becoming a self-parody.

Another Dane, Hans Wegner (b. 1914), also working for Fritz Hansen, produced a popular, middle-brow piece of 'figurative' design in his Peacock chair (1947), made from ash, teak and cord, with the design taking its central decorative idea from the splayed-out tail of the male peacock in display.

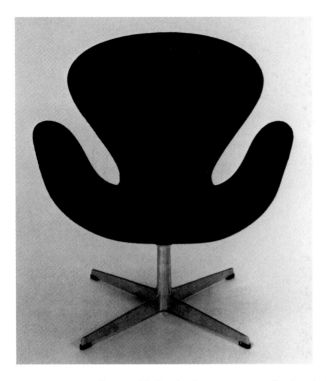

From Finland there emerged the influential designer Antti Nurmesniemi (b. 1927) who designed sleek, pared-down furniture for Artek, Lifjaama and Merivaara.

But eventually in furniture, as in so many other areas of design, the impetus for new styles came from Italy. The postwar growth of various design-led manufacturing and retailing companies in Italy provided a conduit between the designer's ideals and the market place. Among the important companies were (and are) Cassina, Driade, Kartell and Tecno.

The Italians used the medium of the magazine, especially *Domus*, to present themselves in the 1950s as the most imaginative of the world's designers. And certainly some Italian designers produced exceptional designs – Gio Ponti's Superleggera chair, made for Cassina in solid timber (ash) with a cane seat (1957), is quoted in all design books because it is such a lovely piece of furniture – but it is not *radical*; it is conservative, and based on an anonymous work by an artisan.

Less conservative was the Mezzadro chair by Achille Castiglioni (b. 1918), created in 1957. It is a little tractor seat on a sprung piece of

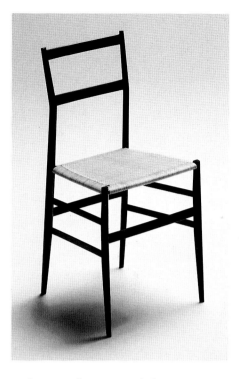

103 Gio Ponti, Superleggera chair, Italy, 1957. This ash and cane chair is a modern version of a traditional Italian design.

chromed steel which has a certain neatness and wit, making it a stylish ornament for a room. It is also a good example of the way competition between designers works. In design one finds designers from time to time making a visual statement – in order to keep themselves 'in the game'. The Mezzadro chair was, practically speaking, an absurdity, but it raised all kinds of questions: what is the relationship between design and technology, between art and design (it was based on the avant garde's favourite aesthetic tactic of recycling a found object) and, above all, what could a designer get away with? Castiglioni intended his chair to be about sculpture. In this he was following a path trodden by Gerrit Rietveld (Holland, 1888–1964) with his extraordinary Red and Blue chair (1917), the Russian Constructivists, and the postwar avant garde led by Charles and Ray Kaiser Eames.

There was a growing acceptance (among designers) that it was right for a designer to be a 'social engineer'. Interventionism is what gives a profession its power: town planners, architects and politicians, not to mention civil servants, have, through their planning and

designs, attempted to alter the behaviour of people they did not know. For designers, altering people's behaviour was a Faustian temptation.

In Italy during the 1960s for example, Ettore Sottsass designed a number of furniture pieces – mostly storage units – finished in decorative plastic laminates. The criticism of the work is more interesting than the work itself, described by Andrea Branzi as 'a line of research that undermines the traditional relationships within the house and instead proposes highly figurative objects with autonomous functions that should promote new types of behaviour in the home.'

Meanwhile, the design and architecture group in which Andrea Branzi himself figured prominently, Archizoom Associati, was generating figurative objects that were deliberately vulgar and successfully captured the aggressiveness that lurks in kitsch design. The aggression is present in the qualities that characterize kitsch, the loud colour, coarse pattern, and in the lack of reason, and absence of restraint or self-effacement.

It is when one compares the Italian avant garde in furniture of the 1960s with the Modernists of the 1920s and the 1940s that one sees that, high handed though they were, the Modernists were humanists with faith in reason and logic. By contrast, in several of its architectural and design projects or exhibitions, Archizoom and its successors revelled in exposing how rationalism, taken to extremes, led to the irrational and the illogical. They exposed and perhaps enjoyed visual disorder. They liked the rawness of Las Vegas.

But there were other Italian voices in this period whose work is the essence of reason. Rodolfo Bonetto (b. 1929) designed his ABS plastic Quattro quarti table and seating furniture (1969) whose components could be split apart into various configurations; Anna Castelli Ferrieri (b. 1920) designed her Round-up plastic storage system (1969). This intelligent design stacks cylinders on top of one another, with access through a generous sliding door in each cylinder. Joe Colombo (1930–71) was the James Dean of Italian design, inventive and daring and dying young; he produced designs that were eye-catching but functional and very satisfying in their cleverness. His nylon and polypropylene stacking chair, model 4860 (1965), produced for Kartell, is comfortable, but also architectural and rigorous in its appearance; it avoids the jelly-mould blandness that has dogged

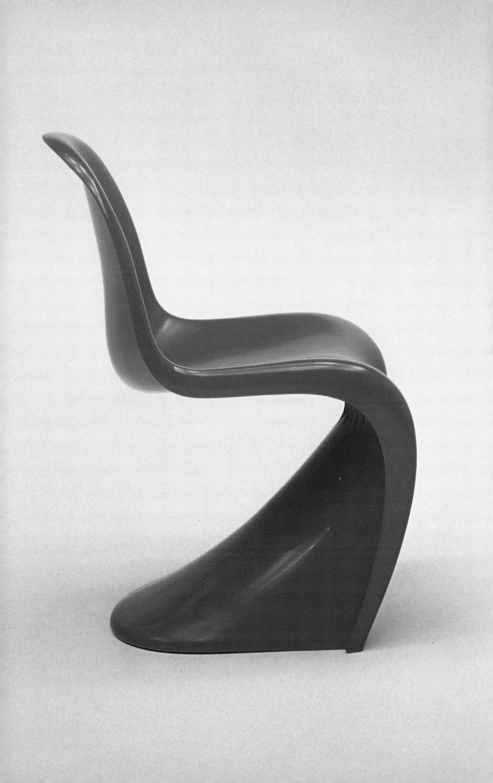

plastic furniture. Kartell (founded 1949) is one of the most important 20th-century furniture manufacturers: it has very high standards of design and has been committed to plastics throughout its history.

Some designers discovered stylistic themes through new technology, which sustained them creatively for several years. A notable example is Gaetano Pesce, who began experimenting with fabric-covered polyurethane foam furniture in the late 1960s. As his work developed in the 1970s, he created a look that may be described as that of a heavily upholstered armchair subjected to a flame thrower and then preserved at the moment between partial meltdown and total collapse.

Some chairs became icons of the 1960s: one of these was the inflatable Blow chair (1967) designed by Jonathan De Pas, Donato D'Urbino and Paolo Lomazzi. Another icon is the Sacco seat (1969), designed by Piero Gatti, Cesare Paolini and Franco Teodoro. This was a large leather bag filled with polystyrene beads – it is comfortable, and you can get away with sprawling in it if you are young, fit, slim and good looking. If not, the thing looks and feels as ill on you as you on it.

Among the other notable furniture designs from Italy in the 1960s and early 1970s is the Plia folding chair, in aluminium and plastic (1969), designed by Giancarlo Piretti (b. 1940); Ettore Sottsass's Nefertiti desk (1969); and a polythene child's chair (1961), designed by Marco Zanuso (b. 1916) and Richard Sapper (b. 1932).

Enzo Mari (Italy, b. 1932) has designed a handful of chairs, including one regarded by other designers as a potential classic – the Sof Sof chair (1971), commissioned and produced by the Italian company Driade. Its structure is composed of nine grey-lacquered tubular-iron rings that are welded together; the seat and back are two cushions of grey leather. All Mari's work is suited to mass production or for small workshop manufacture. One of the first designer/ commentators to talk about design in terms of linguistic analysis and semiology, Mari contributed an 'anti-design' statement to the Italian design exhibition held at the Museum of Modern Art, New York, in 1972 – 'The New Domestic Landscape'. He said: 'The only correct undertaking for "artists" is that of language research – that is the critical examination of the communications systems now in use.'

Communications systems and their analysis were influential in furniture design thinking in the 1970s, especially in office furniture.

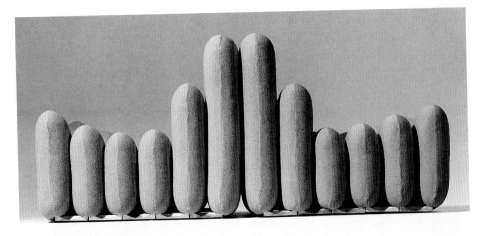

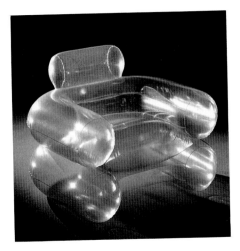

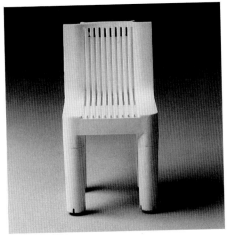

105 Joe Colombo, Additional System, Italy, 1968. Made from metal and upholstered polyurethane foam, it was one of the results of the preoccupation with systems design.
106 Three Italian designers, Jonathan De Pas, Donato D'Urbino and Paolo Lomazzi, created the PVC Blow chair in 1967.
107 The Italian company Kartell probably leads the world in well-designed, versatile and durable furniture in plastic composites. Child's stacking chair by Marco Zanuso, 1964.
108 Ettore Sottsass, Nefertiti desk, Italy, 1969 – plywood and plastic laminate.

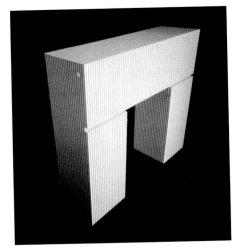

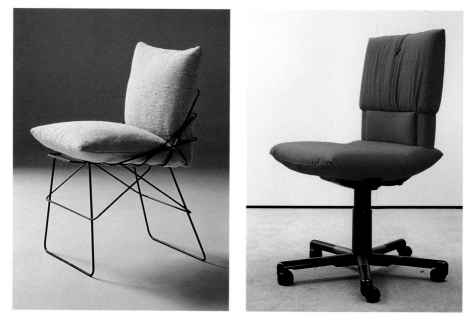

109 Enzo Mari's Sof Sof chair for Driade, Italy, 1971.
110 The Figura office chair, designed by Mario Bellini for Vitra in 1985.

Studies were made about how departments within an office interact and keep each other informed, when and where individuals do their best work and what was needed in the way of public versus private space.

In the mid 1960s, West German theorists evolved the concept of Bürolandschaft design which meant 'office landscape' – it entailed flexibility and units of furniture that could be arranged and rearranged in units, with units separated by low walls, and islands of desks rather than ranks. It required standard furniture, but such humanely planned offices were a considerable improvement upon the earlier office models of ordered ranks of desks.

In the USA, where systems furniture became popular, the language that marketed them was a revealing mixture of Hollywood glitz and slick sociology. The market leader of systems furniture was launched in 1968 by Herman Miller. They called it Action Office, and described it as the first fully-flexible, integrated-module orientated system.

During the next ten years the typist's chair was transformed into a fully-adjustable seat that could be designed in versions to suit the

134

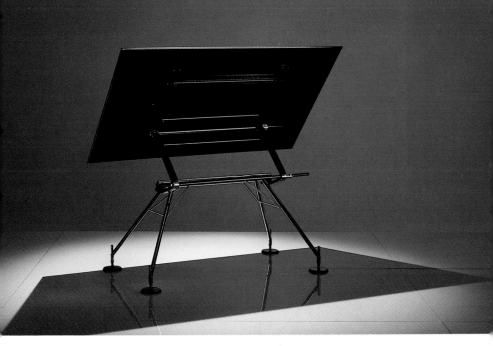

111 Sir Norman Foster, Nomos office furniture system for Tecno, UK, 1986.
The basic materials are glass and chromium-plated steel.

stations of clerks or chairpersons. One of the first of the Super-typist
chairs was designed by Emilio Ambasz (Argentina, b. 1943) and
Giancarlo Piretti, and first manufactured in 1978. Other designers
created rival chairs. Mario Bellini's Figura and Persona designs in the
early 1980s for the German company Vitra made much use of well-
rounded upholstered forms to soften the image of high technology.

During the 1980s, architects were designing office furniture because
the top end of the market could finance high quality manufacture and
intelligent modern design. The internationally recognized architect
Sir Norman Foster (UK, b. 1935) designed an office furniture system
called Nomos for the Italian company Tecno. It appeared in 1986 and
demonstrated the values Foster expresses in his architecture: the
pleasure of engineering structure and the elegance of planes traversing
wide spaces.

Foster's Nomos had finesse. Richard Sapper designed an equally
elegant system for Castelli called '9 to 5' (1986). But the marketing of
Nomos clarified a minor cultural trend that had surfaced in Western
design and applied art: the term 'ritual' became a piece of designer

135

jargon. This interest in ritual had been bumping along in the counter and minority cultural activities for some years; among the hippies and the back-to-the-earth amateur ecologists of the early 1970s. Now, the way we used furniture (or, as it transpired, coffee jugs, motor vehicles and other secular artefacts) could be seen as part of our daily cycle of rituals. Our lives were given meaning, so it was said, by the little conventions in our routines – we were as ritualistic as any native tribe whose behaviour could be observed on television documentaries.

In London, building on the work of the 1960s architectural group Archigram, there was a new group formed in 1980 called NATO (Narrative Architecture Today) at the Architectural Association in London. They stressed that design in interiors, furniture, architecture and town planning could tell stories, be symbolic and organize work or leisure in ways that were not necessarily efficient, but were intended to offer more pleasure or interest.

Less romantically, the Japanese electronics industry and motorcycle industry had learned during the late 1970s that the consumer enjoys play acting with gadgets, that the flicking of switches, turning of dials and playing of buttons is a modern ritual. The lesson was learned by others.

As it marketed Foster's Nomos in the 1980s, Tecno proclaimed: 'It cannot be said that Nomos is a thing – a collection of tables, an interior decorating system for the office or a plan for the home. It is all of these things, of course, but, first and foremost, and basically, it is a way of thinking – of creating the 'surface' function in general terms. A flat geometrical place where man has always performed his public and domestic rituals with regard to work, writing, eating, negotiation, prayer, play reading. . . . The [Nomos] exhibition puts a sampling of these solemnities on display.'

The Tecno extract also suggests how the professional designer/ architect is transformed into 'the priest' – this transformation of the designer from high-grade technician to priestly consultant and *inventor* rather than mere reporter of meaning is one of the sub-themes of the progress of design from 1945.

The idea of ritual is strong in the thinking that Bill Stumpf (USA, b. 1936) brought to his design for Herman Miller's office system, called Ethospace (1986). He did not want his system to look like a system. He dumped the office-as-machine metaphor and sought instead to create the idea of the office as a civilized society.

112 The Ethospace office system, designed by Bill Stumpf for Herman Miller, introduced 1986.

Breaks from working were encouraged; Stumpf coined the phrase 'gratuitous difficulty' to refer to the design strategy of putting things people need in places they like to use but which are not necessarily close to hand. You might, for example, place a telephone near a window away from your desk so that you get up to use the telephone and look out the window at the same time.

He made an astute observation about office work: 'The big no-no in the modern office is any form of social withdrawal'; people come in early or stay late in order to do their concentrated work. Stumpf designed Ethospace as a high quality, loose fit system, flexible enough to be cosy or corporate as the space and the user demands.

Office furniture did not and has not offered scope to the furniture designer as artist. Yet, alongside the development of the office in the 1970s and 1980s, there was a lively growth, sometimes starring the same designers, in the production of furniture as art.

During the late 1970s and throughout the 1980s, little essays of antagonism, irony and cultural elitism were produced as furniture by

137

middle-aged *enfants terribles* such Ettore Sottsass, Andrea Branzi and Alessandro Mendini (Italy, b. 1931). In 1977, Mendini founded (with Alessandro and Adriana Guerriero) Studio Alchymia, and generated a movement he called 'Banal Design'. This thesis stated that design was all about surface, and played a number of ironic games on the theme of decoration. Mendini produced chairs such as Proust's New Armchair (1978), which was crazily and brightly coloured, and shaped in such a florid manner that it looked more like an exotic but artificial flower rather than a piece of furniture. It was more than just an attack on the Modern Movement and its attitudes about plain good taste; it was, at the same time, subversive about all assumptions about taste.

Milan's furniture avant garde centred upon Memphis, the Sottsass-orientated design studio founded in Milan in 1981, attracting Matteo Thun (Austria, b. 1952) from Vienna, Daniel Weil from Argentina and George J. Sowden (b. 1942) from London. In Milan, the furniture and the objets d'art were colourful and made use of plastic laminates with computer-generated abstract patterns, but hark back to the working-class ice cream parlour décor of mid-1950s urban America.

113 Ettore Sottsass, Casablanca sideboard, 1981. This wood and plastic laminate structure became the logo of the new furniture, of Postmodernism and the Italian avant garde.

138

114 The floating forms and planes of Zaha Hadid's Projection in Red sofa,
1987–88.

In Milan, Andrea Branzi launched a collection of furniture which
he called Domestic Animals (1987), done in what he called 'the
neoprimitive style'. His furniture was an amalgam of English rustic
garden benches with industrially machined wood or metal. It brought
together an interest in ritual with the Western European and North
American fondness for certain kinds of pet animals, arguing, as other
designers had before, that furniture is animal-like; it has different
kinds of personality. He published a small book, *Domestic Animals*
(1987), in which he claimed that our modern homes were really
'uninhabitable' and that we needed to rethink our homes because we
were going to be spending more time in them; that we needed to
rethink the ritual, myth-making and magical properties that we could
derive from our surroundings. Branzi's thinking was allusive, not to
say muddled. His inability to explain successfully what he was doing
reflected the diminished impact of the Italian avant garde in the late
1980s.
 In London, the Architectural Association spawned designers such
as Nigel Coates (UK, b. 1949) and Zaha Hadid (b. 1950), a Persian
who designed striking abstract buildings and went on to produce a
range of colourful furniture that took one straight back to the idealism
of the Constructivists of the 1920s USSR. Hadid excepted, the

115 In 1987 Andrea Branzi launched a collection of furniture entitled Domestic Animals, examples of what he called 'neoprimitive style' which also embraced clothes, interior design and knick-knacks. He was seeking to establish a style that was different from the 'mono-logical' objects we find in the work place.

London furniture designers tended to enjoy recycling waste metal and wood, producing furniture that looked as if it had survived the blitz. Coates furnished his West London apartment with light fittings, mirrors and storage and seating built from discarded materials. Ron Arad (Israel, b. 1951) in 1981 took the car seats out of the Rover 2000 motor car and by giving them a welded bent-scaffolding tube frame turned them into seating units for the home or office. It was all romantic and nostalgic, like archaeology from the period of the first industrial revolution.

During the 1980s, one of Britain's most talented young designers emerged: Jasper Morrison (UK, b. 1959). Like everyone else involved in design his subsequent breakthrough into manufacture came through his exposure in the design and fashion media. The first and main arena in which the 'new furniture' operated was the magazine and the colour photograph. The colour photograph and the press media's greed for new ideas replaced the rich patron as a launching pad for new ideas.

There were attempts to give the 'new furniture' movement an intellectual base. Although words such as 'discussion' and 'debate' attended exhibitions and seminars on furniture design, such as

occurred at the 'The Modern Chair' exhibition at the ICA, London (1988), nothing very much was ever established; the discussion was always potential rather than actual. Thus it was asserted that 'the chair can legitimately be used to ask questions about our relationships with our possessions and our surroundings', but neither questions nor answers were really formulated. All that could be claimed was all that could be seen – which was that the form and material of a chair could be almost infinitely various. Indeed, in London there was a rapid retreat from discussion into romanticism, especially when artist-designers such as Tom Dixon (UK, b. 1959) and André Dubreuil (France, working in London) emerged with their elegant and fanciful metal seating. These men were, it was said, operating 'on an intuitive level.'

In America, innovative, anti-modernist, playful and intellectual furniture design was led by the architect Robert Venturi, working with Knoll International. He designed for Knoll International a range of 'Postmodern' bentwood chairs that drew on 18th-century designs by Hepplewhite and Chippendale, but also allude to Breuer and

116 Ron Arad, Big easy chair, UK, 1980s.
117 Nigel Coates, Genie stool, UK, 1988.

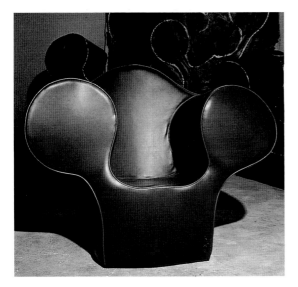

118 Robert Venturi, furniture for Knoll International, silkscreen appliqué on plywood, 1983–84.
119 Tom Dixon, S chair, UK, 1988.

Aalto. The colours reflected Memphis style and Andy Warhol screen prints. They were bits of stage sets filled with allusions to other designers and the whole burden of popular Postmodernism. Postmodernism stated that the late 20th century is an age of relative rather than absolute values; its cultures know more about other cultures, past and present, than was ever possible in the past, and that therefore modern human beings are in a constant state of ironic scepticism, through knowing so much but believing in so little . . . so why not have a laugh. Venturi's furniture was the intelligentsia's little joke for itself. Venturi was making a positive effort, not just at humour, but at providing a Modern rationale for decoration. It was an honourable failure: it failed because it was too knowing, too contrived and too unrelaxed – in a word, too academic.

But at least the mental landscape occupied by Venturi was optimistic. An altogether more bleak atmosphere pervaded the experimental work that was brought together in Düsseldorf in 1986, in an exhibition called 'Wohnen von Sinnen' (Living from the Senses). The overriding feeling created through the work, much of which was made from recycled metal, was of violence and anarchic,

142

political scepticism. This was particularly true of the work by Siegfried Michail Syniuga (Germany, b. 1951).

Syniuga made a sofa, the back of which showed two figures, the one representing the USSR sodomizing the other, the USA. In the same exhibition Herbert Jakob Weinand (Germany, b. 1953) produced a coffee table made in the form of a rocket; other designers such as Hermann Waldenburg or Bettina Wiegandt and Manuel Pfhal produced metaphors about the oppressiveness of 'the machine'.

The bleakness of the northwest European avant garde may have had some cause in the dominant political concerns felt in West Germany and in Austria. Not only young people but most politicians in these two countries were, throughout the 1980s, much exercised by the issues of nuclear weapons, foreign troops and the status of being in the front line of a future East/West war.

As well as art – and 'political' – furniture there is also studio-craft furniture – hand built – for use rather than as polemic. The 'woodcraft' movement has been especially spectacular in the USA. The founder of the American movement (which, of course, had roots in Europe) was Wharton Esherick (1887–1970), whose designs were maverick, expressionist and idiosyncratic. After 1945, Esherick's pioneering role was taken over by George Nakashima (USA, b. 1905).

120 Eva Jiricna, Ze Trolley for the Zeev Aram Collection, UK, 1989. Her designs have absolute integrity – they function well, they have finesse and durability.

121 Wharton Esherick, walnut and cherry music stand, 1960: one of the postwar icons of the North American woodcraft movement.

122 Sam Maloof, 1986 version of his armchair in black walnut.
123 Wendell Castle, Dr Caligari cabinet/grandfather clock, 1984.

The importance of Nakashima and those who followed his lead, such as Sam Maloof (b. 1916) and Tage Frid (b. 1915), lies in their interest in beauty through utility, rather than through self expression. They love wood, and Nakashima in particular is lyrical about it: 'We work with boards from the trees, to fulfil their yearning for a second life, to release their richness and beauty.' Nakashima, Maloof and Frid continue the USA's history of refined furniture making and design – the best known and most excellent work being probably that of the Shakers, the 18th-century religious community.

However, many of the post-1945 craftspeople have moved away from Shaker simplicity and sought a voluptuousness in finish. This is nowhere so well seen as in the work of Wendell Castle (USA, b. 1932), which reflects a rich mixture of interests. His career as a

146

furniture maker has included sophisticated figurative carving in wood as well as the construction of elaborate furniture pieces which are architectural, even monumental in their forms and detailing, and shot through with a sensuousness which almost achieves an incarnation of the sins of the flesh, like gluttony. Examples include his Egyptian desk (1982) in maple and ebony, and his Dr Caligari cabinet/grandfather clock (1984) in curly cherry veneer and ebony detailing. Most famous is his Ghost clock (1985), a grandfather clock 'covered' in a 'white sheet' carved from bleached mahogany – an extraordinary investment of time and skill in a one-line joke. As the postwar period has developed, the texture and refinement of craftwood furniture has been pushed to an extreme, both by the ambitions of the maker-designers, and by advances in technology. Technology keeps trying to catch up upon the virtuosity of the craftsperson.

Until the 1980s, wood was the only practical material that could be worked in solid planks but then, in the 1980s, two new materials were developed that could be sawn and planed, and which found a ready use in furniture. The first, MDF (Medium Density Fibreboard) was the first of a generation of processed-wood boards that could be

124 Frank Gehry, Little Beaver, laminated corrugated cardboard, 1980: avant-garde funiture with wit.

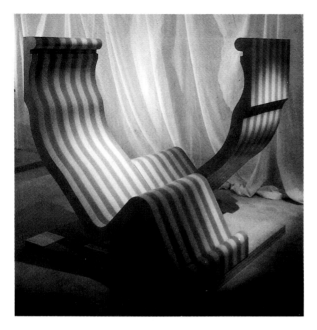

125 Stanley Tigerman designed Tête-à-Tête in 1983. Tigerman was one of several stars commissioned by Formica to design furniture in their new product ColorCore. The designs were included in a travelling show and in promotional literature to fix ColorCore as a brand name in the minds of designers and specifiers.

planed and treated like wood. It is strong, has a very smooth finish and is extremely heavy. It found favour with 'Postmodern' furniture designers who wanted the flexibility of wood without the grain and finish of wood.

The second material was ColorCore, launched by Formica Ltd in 1982. This plastic was coloured right through and came, not in thin sheets, but in thick planks which could be cut like wood. As a part of its campaign to show the decorative potential of this new building material, Formica commissioned artists, craftspeople, designers and architects to design and make furniture and jewelry. These artefacts were then toured in travelling exhibitions around the world. The first was called 'Surface and Ornament' (1983). One of its stars was the architect Stanley Tigerman (USA, b. 1930), who designed furniture. The second, 'Material Evidence' (1984), demonstrated new colour techniques in handmade furniture. And one of its exhibitors was Wendell Castle; this was a gentle irony – the hi-tech designer material of the 1980s being put through its paces by a virtuoso performer in art craftsmanship.

Of course, the majority of furniture design owed little to any of these experiments. As ever, the bulk of the furniture manufactured and bought was either reproduction or comfortable, compromised,

chintz-covered and upholstered modern. But there was also a minority of domestic furniture that was well designed, new, optimistic and usually utilitarian.

Sometimes utility has become the dominant theme. In Norway, the Westnofa furniture company has become well known for its range of furniture designed with the twin concepts of health and comfort in mind. Westnofa made its name with the Balans variable seat (1980) designed by Peter Opsvik (Norway, b. 1939). You kneel into it rather than sit on it, and it is designed to prevent backache. A whole and sometimes eccentric-looking range of posture furniture has been seeded by this design.

The most famous furniture designer of the 1980s was the Frenchman Philippe Starck (b. 1949). Starck came to public renown through being commissioned by French President Mitterrand to design the furnishings for Mitterrand's private apartment in the Elysée palace. In the midst of colourful Postmodernism, with its references to Neoclassicism and Las Vegas vulgarity, Starck's designs were simple, neat and chic. Although Modern, they were also nostalgic for the Art-Moderne look of the French 1930s. His preferred material was metal. His most famous designs remain those produced in the 1980s for the Italian company Driade – the Von Vogelsang chair (1984) and the Titos Apostos folding table (1985) are 'classics' of his

126 Peter Opsvik, Balans variable seat, Norway, 1980.

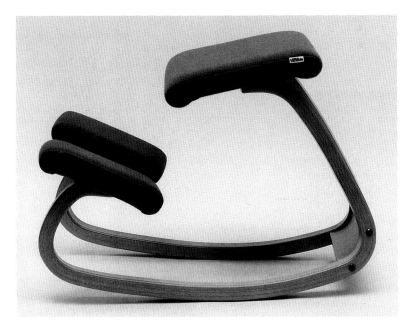

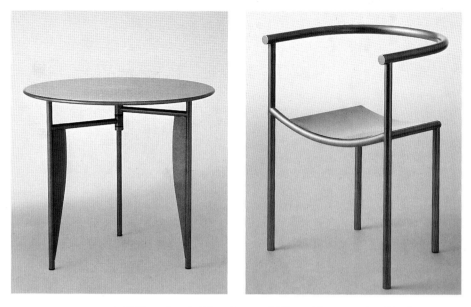

127, 128 Philippe Starck, Titos Apostos folding table, 1985; Von Vogelsang chair, 1984. Starck's furniture designs for Driade helped to popularize metal furniture as domestic furnishing.
129 Shiro Kuramata, How High the Moon, Japan, 1986.

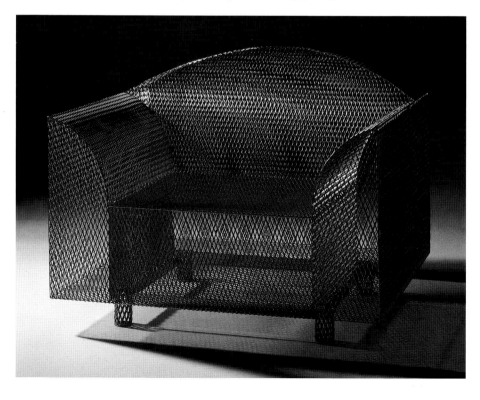

style. Since the mid 1980s Starck's work has embraced interior and product design as well as architecture. He is quoted as saying: 'I work instinctively, and above all fast. I can design a good piece of furniture in fifteen minutes.' In the early 1990s, he was designing buildings in Japan.

Also in Japan, a designer had emerged who was a master of using metal in furniture and in interior design: Shiro Kuramata (b. 1934). His work often uses the lattice effects that are possible in metal to create optical games, and several of his chairs are designed as things to contemplate – in the tradition of Japanese gardens or ceramics. For Western critics, Kuramata revitalized the issue of furniture design communicating not only through its design but through the quality of its craftsmanship – the importance of craft that had become ignored in European experiments.

Furniture can be made in low-technology workshops, and it is not dependent upon clever electronics or sophisticated engineering. It has become, since 1945, an ideal medium for designers to make their visual statements and construct their individual manifestos. In furniture there is a ping-pong game played out between absurd and useful design, and this game is one way in which the design profession explores itself: the designing, re-designing and re-re-designing of the chair is the design profession's equivalent of publishing a short scientific paper asking 'What if?'

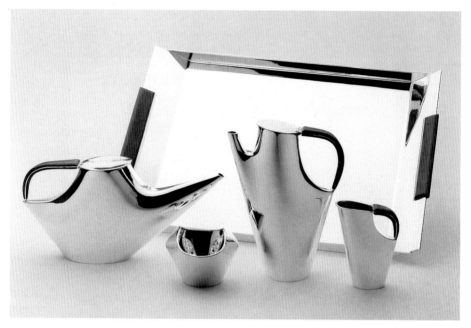

130 Lino Sabattini's Como tea and coffee service, silver plate, 1957. Sabattini, one of Italy's leading silversmiths, has far outpaced in inventiveness and fantasy those Postmodern architects who turned to tableware and other domestic design during the 1980s.

Domestic Ware

The kitchen of the Western or Westernized consumer features an abundance of clever but rather bland electrical tools. Their blandness is no criticism, although some consumers favour retro designs – coffee pots, coffee mills, kettles, clothes irons and cooking stoves are instances where, in the 1980s, some designers preferred to copy 1950s or even 19th-century styling. The Sanyo company of Japan, for example, began marketing at the end of the 1980s a range of electrical goods that mimic early American postwar styling.

In the main, however, food mixers, jug kettles, microwaves, kitchen scales and the rest of the gadgetry are simply sanitized and sheathed. The designs are in neither good nor bad taste; they are on the edge of visibility, and their existence is to provide a background comfort of utility, not the foreground stimulus of an aesthetic conversation piece.

If one looks at the development of tableware in Westernized countries since 1945, one may wonder what it is that some consumers found or still find attractive about the avant garde in cutlery and metal tableware (coffee pots, water pitchers, cruets and jugs). For, between the early 1950s and the mid 1970s, the design of cutlery for one sector of the market became not only more sculptural, but possibly less comfortable to use. In the leading edge of tableware the style developed from 'free flow' through to 'soft squat'.

The 'free flow' style of the 1950s (see Michael Collins, *Towards Post-Modernism*, 1987) was prominent in Scandinavian, northwest European and North American metal tableware. Free flow was a marriage between the organic style prominent in furniture and some sculpture of the period, and functional streamlining of the kind seen in metal-skinned jet aircraft. A startling example of the style is in the work of the Italian silversmith Lino Sabattini (Italy, b. 1925). In his book, Collins shows a photograph of Sabattini's Como tea and coffee service (1957), the forms of which are like super-elegant versions of the

nozzles found on automobile petrol pumps. Sabattini, an acknowledged Italian master designer, has not switched styles. His designs have become even more extreme in their version of streamlined gothic.

In the 1950s the 'free flow' style popular in Europe and North America was tempered in Britain by linearity. However, Britain's leading postwar silversmith, Gerald Benney (UK, b. 1930 – he was awarded the title of Royal Designer for Industry in 1971) produced influential designs that were refined and Modernist. Benney's clean forms, although straight sided, had rounded corners. The spouts and handles, on the other hand, are sharp.

In Benney's work, as generally in the better domestic tableware of the 1950s and in the civic architecture such as the Royal Festival Hall (London, 1951), there was a lexicon of forms and shapes that became the basis of the vocabulary of Britain's courteous brand of Modernism. Architecture apart, design in Britain in the 1950s was not driven by ideology; it was not, as it became later, about irony or subversion or 'comment'. It represented a pragmatic attempt at producing civilized design that looked right for a new and increasingly optimistic era.

Unfortunately, when stainless-steel ware 'caught on' in the 1960s and was manufactured for the home and commercial catering use, all the refinement of the new vocabulary for metal was lost. Mass-

131 Robert Welch, stainless-steel teapot for Old Hall, UK, 1962.

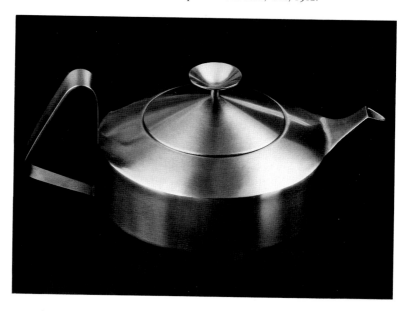

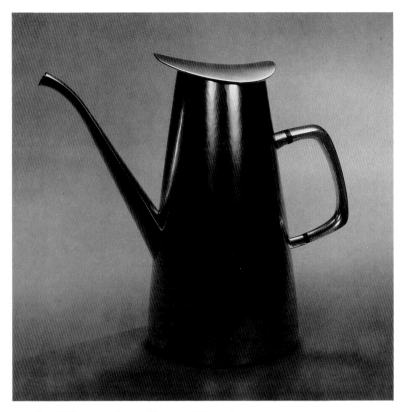

132 Gerald Benney, silver coffee pot, UK, 1958.

manufactured British metalware tended to be simple in form but crude and let down by poor detailing.

In Scandinavia, designer/silversmiths such as Henning Koppel (Denmark, 1918–81) and Sigvard Bernadotte (Sweden, b. 1907) were producing ewers, ice buckets, coffee jugs and other vessels in silver, often with ebony or ivory handles. Soren Georg Jensen (Denmark, b. 1917), sculptor and son of the silversmith Georg Jensen (1866–1935), designed in 1951 a sterling silver condiment set that appeared to take its shapes from industrial architecture but, refined, simplified and polished in silver, became miniature sculptures. Among the most famous designs are the silver fish dishes by Henning Koppel which, though very simplified into submarine forms, have enough reference to the generalized form of a fish to be both figurative and abstract at

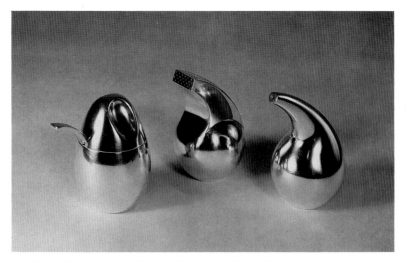

133 Soren Georg Jensen, silver condiment set, Denmark, 1951.

the same time. In this work Koppel was adding to, rather than breaking with, a decorative tradition.

Tableware, especially that produced in traditional materials such as silver, silver plate or china, does not easily shake off its design history. The twin aspects exhibited by postwar avant garde tableware design in the 1950s – of rounded, simplified forms and a predilection for quasi-sculpture – were not postwar inventions. The roots of both aspects go back to the Deutscher Werkbund (1907–34), the Viennese Secession (founded 1898) and the Wiener Werkstätte (founded 1903). These organizations had, in their turn, been fired by ideas about form versus decoration by the late 19th-century English Arts and Crafts Movement, as well as the early 20th-century developments in both Art Nouveau and Classicism in Scottish architecture and design – the work of Charles Rennie Mackintosh (1868–1928), for example.

Beyond them, the sculptural tradition in tableware extends through a variety of rich figurative and allegorical examples. Perhaps the most famous table sculpture in the West is Benvenuto Cellini's gold salt cellar of 1540 for Francis I (now in the Kunsthistorisches Museum, Vienna).

The historical shift in tableware, especially the essentially decorative or sculptural pieces such as serving plates, tureens or cruets, has been away from figurative sculpture towards abstraction. This is in part because complicated, fabricated, figurative works are expensive

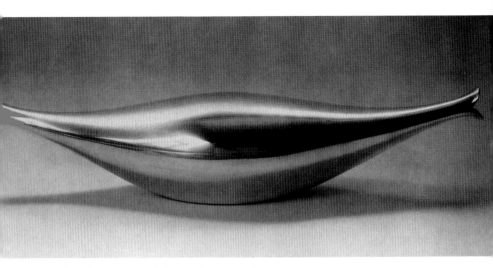

134 Henning Koppel, covered silver dish, Denmark, 1954.

to produce, but mainly because there is no contemporary need for allegorical or symbolic narrative design in the average home – television, newspapers and magazines, as well as kitchen trivia, such as decorative cookie jars and jokey mugs, fulfil that kind of role.

None the less, the fashion for Postmodernism in the 1980s – for bringing metaphor and simile into design – encouraged a partial, somewhat thin revival in figurative or narrative tableware.

The Italian manufacturer Alessi (founded 1922) began commissioning famous architects and product designers to create expensive tableware for the young, professional classes to buy. In 1983, Alessi produced a silver coffee set designed by Richard Meier (USA, b. 1934), architect; Aldo Rossi (Italy, b. 1931), another architect, designed La Conica stainless-steel espresso coffee makers (1984). The designers of the 1950s had located their designs in the current architectural and art styles of the times; Postmodernist designers of the early 1980s incorporated ironic or reverential quotations from historical masterpieces in architecture, design and art. Several of the Alessi products made knowing reference to other work. Rossi's La Conica, for example, quotes from the forms of the Campanile in St Mark's Square, Venice.

The 1950s saw a gradual assimilation of precious and non-precious materials in good-quality, middle-market tableware manufacture. For example, David Mellor (UK, b. 1930) produced his Pride cutlery

in 1954, in silver-plated metal with the knives having white/off-white striped celluloid (xylonite) handles. Other designers, too, were using the precious/non-precious material combination. Also in 1954, the American designer Nord Bowlen (USA, b. 1909) produced his Contrast cutlery, which was sterling silver with black injection-moulded nylon handles. Apparently it was not commercially successful, whereas Mellor's Pride has achieved both commercial and aesthetic success.

But in a sense Pride (arguably the most beautiful of postwar British tableware designs) was, like Contrast, a cul de sac. Both designs were elegant, clean and modern, with their roots in 18th-century English silverware. The truly Modern design emerged from Scandinavia, especially Sweden. Peter Anker, writing in *Scandinavian Modern Design 1880–1980* (1982), said 'Sweden is the country in which the idea of "more beautiful things for everyday use", materialized first and went furthest.' The ambition of Swedish (and other Scandinavian designers) was to make quality a goal for mass production. And Anker suggests that among Sweden's exemplary achievements in design for mass production are Stig Lindberg's (Sweden, 1916–82) ceramics, textiles and tableware for Gustavsberg; and the polished steel cutlery of Sigurd Persson (Sweden, b. 1914).

Persson's cutlery is made from stainless steel and the knives are made as a single piece. Thus they were cheap to manufacture. Stylistically, Persson's design is sculptural – the knife blades, the spoons and the fork prongs are generous and the handles are squat. For mainstream taste in both northwest Europe and North America, the Persson design (and similar designs from his Scandinavian peers) was very radical.

Certainly the material – stainless steel – was given an enhanced reputation by being introduced into the market-place via sophisticated design. Sophistication meant taking the free-flow, organic styling and single-piece manufacture to its extreme. The extreme was being reached by Arne Jacobsen (Denmark, 1902–71) in 1957, with cutlery where the functional end of a spoon, fork or knife was only just differentiated from the handle. Such design paralleled, and was perhaps influenced by, designs produced for the plastics industry, which favoured absolute simplicity of form. (Persson's stainless Jet Line cutlery of 1959 deliberately associates itself with aircraft cutlery and jet travel – perceived as both glamorous and progressive.)

135 David Mellor, Pride cutlery, UK, 1954. Probably still the best design for cutlery to have emerged from the UK since 1945: silverplate with knife handles in white striped celluloid.

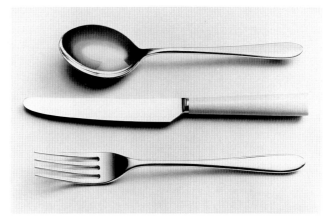

136 Sigurd Persson, Jet Line cutlery, Sweden, 1959. Designed for use on Scandinavian Airlines and made of stainless steel.

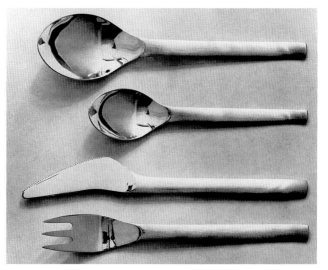

137 Arne Jacobsen, stainless-steel cutlery, Denmark, 1957. The reductionist styling must make for ease of production.

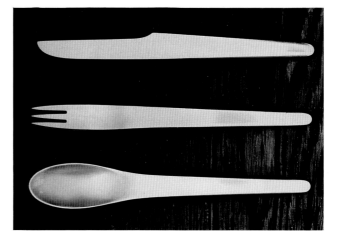

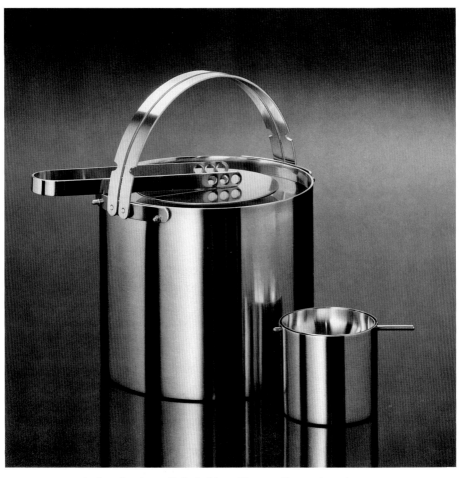

138 Arne Jacobsen, Cylinda Line tableware, Denmark, 1967.

Who bought such wares? Why did they find them attractive? What was their influence? Why were these forms among those which were regarded as the apotheosis of good design? Herbert Gans, an American sociologist, raised these questions in the context of the seminal 'Design Since 1945' exhibition (Philadelphia Museum of Art, 1983). He restricted his speculation to the consumers of the USA, arguing that 'good design' appealed particularly to a new class of professional person in what he called the 'knowledge and service sectors' – which include design, art, communications, academia. This

class, he ventures, sees itself as being enlightened and forward looking; it also sees itself as enlightening and reformist. Thus it wants objects that reflect these attitudes, objects which show they have a very high degree of new design (new reformist) thinking about them. Utilitarian function is much less important. The symbolism inherent in the 'good design' identified by Gans has been an important feature of upper-middle-class consumerism since 1945, in all aspects of homemaking.

What is by some perceived as reformist can, through some adaptation, become a convention for others. Thus, by the 1970s, Main Street stores in North America and Europe sold canteens of stainless-steel cutlery which have their roots in the shapes of the 1950s. They are easy to manufacture, easy to keep clean, and have an informality of styling that suits a changing pattern of family life – especially in northern countries, where people tend not to sit down together for formal meals.

Some designers of cutlery have treated function in a more or less perfunctory manner but there have been serious attempts at ergonomic design in this field. The Ergonomi Design Gruppen of Sweden (founded 1979) drew together men and women who had entered design in the early 1960s and who were interested in human factors in design. EDG has concentrated on designing cutlery for people with disabilities or for elderly people with limited strength in their hands and wrists. A good example of the ergonomic genre were the Ergonova kitchen tools (1979) designed by Annika Gudmundsson (Sweden, b. 1951): the various scoops are designed to hold hot food safely and in generous proportions; the handles are angled and shaped with reference to the basic physics of levers and fulcrums which enable a person with weak hands or wrists to lift food from one vessel to another with safety and efficiency.

For the larger part of the 1980s, architecture provided the leads for stylistic developments in product design, whilst the broader (and some times contradictory) philosophies and literatures of Postmodernism provided an intellectual framework. The products designed by Alessi's star architects in the 1980s included tableware. Alessi and other companies, such as Swid Powell (USA, established 1982), found that the constituency of consumers identified by Herbert Gans – the reformist professionals of the communication and knowledge industries – had greatly increased in numbers and in

wealth. Postmodernist stylists, such as the architects Michael Graves and Richard Meier, or designers such as Richard Sapper, were creating narrative objects. The kettles produced in the 1980s by Sapper and Graves were full of little images for members of the 'chattering classes' to discuss. Sapper's kettle had references to steam engines, while Graves's had a plastic whistling bird on the spout; these were among the very few overtly expressive objects for the kitchen.

Avant garde tableware of the 1980s was distinguished from that of the 1950s and 1960s by rediscovered possibilities of pattern and colour. The architect Robert Venturi, whose riotous furniture is discussed in Chapter 5, also designed for Alessi – he produced a stainless-steel mechanically engraved tray with galvanic gold plating. Together with a new tolerance for decoration and ornament, especially in things for the home, there came further advances in computer-controlled machines which could create decoration with a finesse hitherto associated with hand craft.

The mechanical or computer application of decoration helped to make decoration intellectually respectable as a design component for a generation of architect/designers who had grown up with the teachings of Modern plain design. Decoration could again be seen as progressive, because it could be both designed with and applied by the latest technology. This reinforced the self-image of the postwar designer as a professional distanced from any form of handicraft. Among the designers who led the way in mechanically applied finesse in the 1980s were Ettore Sottsass, George Sowden and Matteo Thun.

However, designing for handicraft technology is intellectually respectable if it is a matter of getting some one else to make a 'one off' polemical piece, or a batch-produced design for collectors and museums, or where one was designing for second or third world economies. The rehabilitation of decoration as a progressive component in design was made complete with initiatives such as The Golden Eye studio and information centre in India, organized by an Indian designer, Rajiv Sethi. He secured funding for Western designers, including Ettore Sottsass and the German architect Frei Otto, to create designs for tableware that could be produced by Indian craftsmen. Emilio Ambasz's *International Design Yearbook 1986/1987* shows cutlery designed by Otto using damascened steel. This is a process which originated in Damascus; it gives a watery pattern to steel (not unlike the effect of marbling that is sometimes used as a

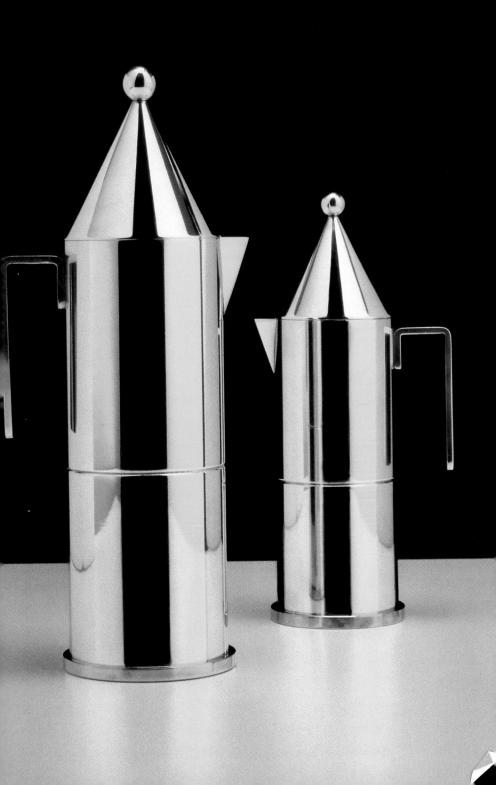

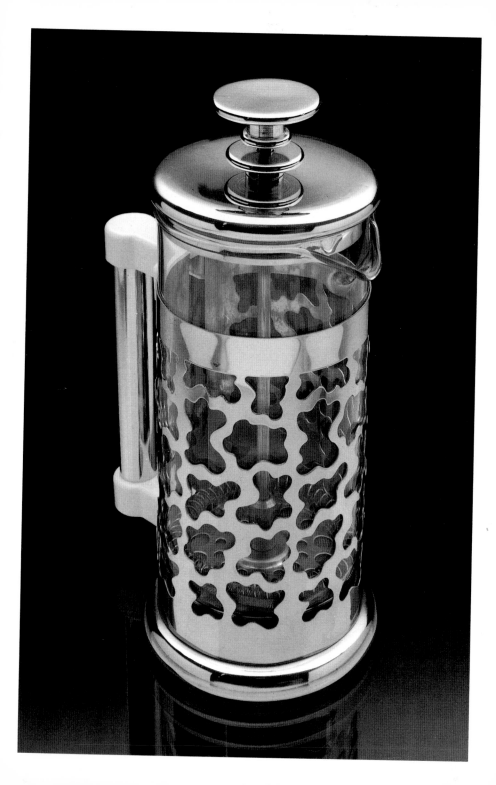

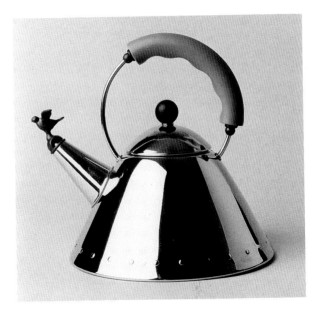

140 George Sowden designed this stainless steel coffee pot for Bodum, Switzerland, in 1987. The decoration, which is deceptively complex, is cut by machine.

141 Michael Graves, architect, designed this kettle for Alessi in 1986. It is one of the most famous pieces of giftware of the decade, and its knowing cuteness made it a commercial success with the young, professional middle classes. The plastic bird on the spout whistles as the steam passes through.

decorative device for the endpapers of books). Indian craftsmen, like others across the world, used the technique for embellishing sword blades; Otto persuaded them of its possibilities for cutlery.

In Japan, designers have embraced intellectually both the spirit of technology and the spirit of handicraft, especially with regard to tools for the home, including cutlery (even though Japan has only recently started using Western-style cutlery). The word 'spirit' is used advisedly, for, as Sîan Evans makes clear in her book *Contemporary Japanese Design* (1991), the Japanese Shinto belief in the spirit of inanimate objects still has power as a metaphor. Evans remarks, 'Tools are still perceived to have personalities of their own. Any self-respecting chef will carefully select a personal set of handmade *schocho* (culinary knives) from traditional manufacturers, weighing, balancing and testing them to make sure that he feels happy with them.' This care and respect for the feel of tools has been carried over into mass-produced tools – both mechanical and electrical.

However, equally important, as Evans relates, is the Japanese design strategy of making tools look professional. Science and technology are the most respected cultural institutions in Japan. The innovative use of an old material (such as using a form of ceramic as a cutting material to replace metal in knives or scissors) will attract consumers, as will any design that echoes its professional counterpart.

In most consumer societies, a gulf remains between materials and tools that are suitable for informal day-to-day use and materials that are judged appropriate for more serious (some will say 'ritualistic') occasions, such as entertaining guests with a meal. Not even the Gans constituency of forward-looking affluent consumers has taken plastic to their dinner tables. In the home, except in the casings of a number of gadgets and tools, plastic is a material for the kitchen and for informal family use, such as plates and cups for young children, or for light snacks or picnics. Jeremy Myerson and Sylvia Katz, authors of the *Conran Guides to Design*, suggest that because kitchen tools have to be practical, the kitchen has not attracted the expressive, high-profile designs associated with some tableware or furniture. But is it true, as they suggest, that high-profile designers have ignored the kitchen because most product designers are men with little knowledge of, or real interest in, kitchens? It could be argued that the well-off, educated middle classes who may buy avant garde tableware do not entertain in the kitchen, and therefore have no need of status-bearing, discursive or polemical objects in the kitchen.

After the First World War, North Americans became accustomed to plastic as an alternative material to metal, wood, glass or ceramic for casings and containers. And in this first 'age of plastic', which lasted until the late 1940s, American designers generated a wealth of innovative and frequently pretty artefacts. In 1939, the Cynaamid company (USA) introduced Melamine commercially. This material feels as if it has the density of ceramic, yet it is light, durable and can be brightly coloured. Russell Wright (USA, 1904–76) designed his Residential dinner service in melamine (1952) – a commercial success which prompted other manufacturers to enter the market. Light, strong and colourful, plastic found favour with designers, who used it to produce some of the most elegant early postwar tableware for the American mass market.

Melamine was taken up by designers and manufacturers in other countries, and was the basis of one of the first postwar 'classics' of design in plastic – the Margrethe mixing bowls designed for Rosti (Denmark) in 1950 by Acton Bjorn and Sigvard Bernadotte.

Italian designers and manufacturers exploited melamine and other plastics. Plastics were not new to Italy – there was a substantial industry built up in the early 1930s which then ran into difficulties in the late 1930s, when the Italian economy ran into chaos. Research,

142 Jean-Paul Vitrac, disposable picnic set manufactured by Diam in polystyrene, France, 1971.

however, continued, and yielded several inventions, including that of polypropylene (1954) by Giulio Natta of the Milan Polytechnic.

After the Second World War, American aid, a rapidly developing petro-chemical industry, and the emergence of many new small businesses contributed to the growth of the Italian plastics industry.

The founder of Kartell (Italy's foremost postwar manufacturer of plastic artefacts), Giulio Castelli, had trained under Giulio Natta. He started Kartell in 1949, and in 1953 began producing household goods designed by Gino Columbini (Italy, b. 1915). Columbini's brightly coloured kitchen tools – colanders, cruets, fruit squeezers and spatulas – set a standard of design which saw plastic as a versatile material from which to make forms. The emphasis is on the form.

The design development of wholly plastic utensils has been driven by the manufacturers' recognition that in order to raise the status of plastic as a material they had to introduce a sense of high quality into the form and function of their wares. The design spirit of the 1950s helped this process, because the preferences by designers and artists for form rather than surface favoured design in plastics. Apart from decorative plastic laminates as developed, for example, by Formica, the surface of plastic forms was difficult to decorate except with the use of decals (transfers), or by perforation and embossing.

In 1957, Kartell was joined by a rival company – Danese – which also hired good designers to produce a range of plastic utensils. The first designer was Bruno Munari, and he was joined in the early 1970s by Enzo Mari.

The interest in systems furniture that was developed in the 1960s affected other areas of design. During the 1970s, French, Scandinavian, Italian, German and North American designers were working with melamine, polyethelene and ABS plastics to create series of containers, 'dinner services', picnic wares and wares for institutions (such as schools, hospitals and hotels) – systems that interlocked, stacked up or fitted, like airline packaged meals, into one another. These systems had the function of being space saving, but their design also showed again that plastics looked good as forms, as an integrated alphabet of shapes. A good example of this is the melamine MAX 1 stacking dinner service, designed in 1972 by Lella and Massimo Vignelli (Italy/USA, b. 1931) for Heller Design.

But it was not only the 'good taste' designers who exploited plastic. In the anonymous manufacturing world of blue-collar and working-

143 Enzo Mari, Tongareva melamine bowls, Italy, 1969.

144 Massimo and Lella Vignelli, stacking dinnerware in melamine for Heller, 1972.

class design, plastic quickly took over from aluminium and plaster casts as a material for cheap ornament. Cruets had come a long way from Cellini. By the early 1950s, a mini-industry had sprung up, especially in North America, producing cruets, clocks, food containers, children's lunch boxes and children's tableware in the form of cartoon and TV characters. And, of course, there were plastic cookie jars in animal and human forms, which were later collected by that curiosity of 20th-century art, Andy Warhol, and thereby transformed from one-dollar kitsch into several-thousand-dollar ironic commentaries (in the art auctions following his death in 1987).

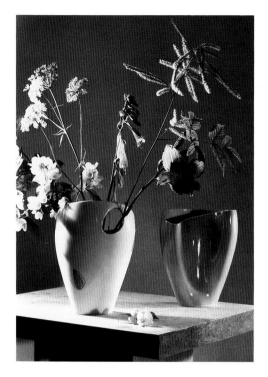

Perhaps one reason Warhol saw fit to collect cookie jars and, in a sense, elevate them to art (no doubt a temporary elevation) is that such trivial plastic objects are a new 20th-century 'tradition'. Such trivia is the nearest plastic comes to having folk roots, and at the low-technology level at which they were manufactured, they were almost craft objects.

The traditional materials of tableware – glass and pottery – have folk roots, craft roots and an exalted history as art as well. But whereas in textiles (see Chapter 7), a vital injection of ideas and creativity has come from the studio craft sector, there has been less exchange between studio ceramics and glass and their opposite numbers in industry. This is partly because the studio craft movement in ceramics and glass has tended to reject finesse, to opt instead for exaggerated and ostensibly crude forms, textures and decorations. Although ceramics manufacturers, such as the German company Rosenthal, have commissioned a wide range of designers to produce modern wares (especially in the area of giftware), the emphasis has been on clean forms in restrained surfaces.

The exception to this general principle occurred in Scandinavia where the links between industry and craft ceramics and glass remained strong until the early 1970s.

The strength of the craft aesthetic and the bridge between craft and design in Scandinavian glass and pottery was made clear in the Cooper-Hewitt Museum (New York) exhibition of 1980. A determination to maintain roots in the crafts of one's country can be interpreted as nationalism, or at least as a determination to hold on to a cultural identity (there are parallels between keeping craft alive and keeping minority languages and their literatures as living tongues – a desire that has become more fervent since 1945).

In Finland, the connection between craft and design and cultural identity was sometimes made explicit. For example, one Arttu Brummer (1891–1951) was an applied arts teacher who influenced many of the modern Finnish designers. In 1945 he produced a wheel-cut glass vase called Finlandia (1945); its reference is to Sibelius's great nationalistic symphony of the same name (1899).

146 Arttu Brummer, Finlandia vase, 1945. Moulded blown glass, wheel cut.

Nationalistic impulses tend to attach themselves to the land and to the nature of the given country. Certainly much of the glass and ceramic ware of the 1950s produced in Sweden and Finland takes its cue from the landscape. Colours tend often to reflect the snow and ice of the area. Typical of the early 1950s are tall, almost anorexic vases such as those designed and made by Toini Muona (Finland, b. 1904). The Arabia ceramics works in Helsinki commissioned a number of craftspeople-designers to produce domestic art objects for the home, predominantly semi-abstract sculptural vessels with undertones of 'nature'.

Sweden and Denmark too produced quantities of this domestic ornament, which also influenced the design of tableware as produced by such designers as Gertrud Vasegard (Denmark, b. 1913). Vasegard translated the studio craft aesthetic into production designs. Her tea service, produced by Bing and Grondahl in Copenhagen in 1957, is one of the major pieces of postwar domestic design, in that it captures exquisitely the synthesis between the high industrial quality of factory manufacture and the finesse of hand craft. This synthesis characterizes the quality of Scandinavian domestic design until the early 1970s, at which point there was a gradual splitting away from craft by designers, as a younger generation moved into the profession, fired not by the human certainties of the past, but the dynamics of technology's present.

None the less, in the design and commercial manufacturing of glass and ceramics the trend has been to follow, rather than lead, on style. There has also been a continuing, indeed burgeoning, production of traditional styles and patterns. This latter development may give grounds for complaint among modern designers but it is partly a consequence of the fact that the ceramics industry *qua* industry is a mature one. It has an industrial, factory-based tradition going back two hundred years (or centuries more, according to how one defines 'factory production'). Within this tradition, just about every variation on form and decoration has been developed and marketed. For most modern stylistic innovation in ceramic tableware there is a precedent in the archives of Wedgwood (founded 1759), or Royal Copenhagen (founded 1774), or Minton (founded 1796), or Rosenthal (founded 1879). For example, the Modernist simplicity of form favoured by the 20th-century Werkbunds, the Bauhaus and the postwar internationalist designers is all laid out in Wedgwood's late-

147 Timo Sarpaneva, covered cooking pot, cast iron and wood, Finland, 1959. The pot has a simple detachable handle for carrying it or removing the lid. Nuances of craft and nature – so strong in this work – have been rejected in late 20th-century Scandinavian design.

18th-century matte-black basalt ware. In glassware, the weight of historical precedent is even greater.

However, the living tradition of design for ceramics and glass has been added to since 1945 by some considerable designers – notably Tapio Wirkkala (Finland, 1915–85), Paolo Venini (Italy, 1895–1959), Martin Hunt (UK, b. 1932), who established the partnership Queensberry Hunt with David Queensberry (UK, b. 1930), former Professor of Ceramics at the Royal College of Art, London; Timo Sarpaneva (Finland, b. 1926), Wilhelm Wagenfeld (Germany, b. 1900), and Susie Cooper (UK, b. 1902).

After the Second World War, ceramic and glass companies emerged which sold themselves on 'design' – Rosenthal founded its Studio-Line in 1954, commissioning Raymond Loewy to produce a coffee service. Called Form 2000, it almost caricatures the Anglo-American idea of elongated elegance. Despite the company's

148 Finnish designer
Tapio Wirkkala's
Porcelaine noire teapot
for Rosenthal,
Germany, 1960.

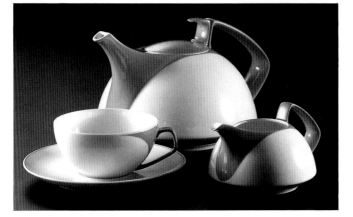

149 Walter Gropius,
TAC I porcelain teaset
for Rosenthal,
Germany, 1959.

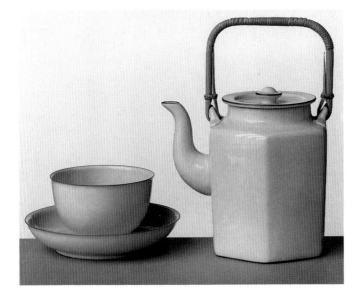

150 Gertrud
Vasegard, tea service
for Bing & Grondahl,
Copenhagen, 1957: a
very good example of
a synthesis between
hand craft and design
for manufacture.

151 Queensberry Hunt, Trend tableware, designed in the UK for Thomas China, Germany, 1981: one of the most successful ranges of tableware in Europe. The banding is achieved through alternate thicknesses of the glaze and is only possible in porcelain.

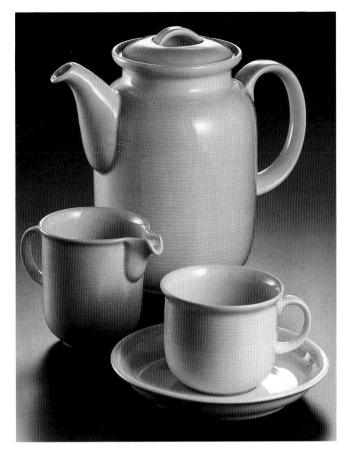

152 Rosenthal is one of the world's leading manufacturers of high-class ceramic table- and giftware; it has made particular use of named or 'star' designers, as in this Raymond Loewy and Richard Latham Form 2000 coffee set, 1954.

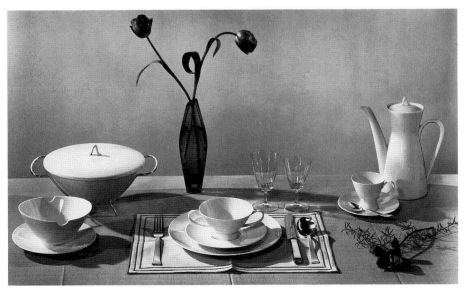

employment of well-known designers – Walter Gropius designed their TAC I TEA set (1962), for example – Rosenthal's management has consistently displayed a talent for taking the edge off the avant garde; it is conscious of its place in the superior giftware market. Thus the work of the American Dorothy Hafner, which is vibrant yet raw in its decoration, has been, when adopted for Rosenthal's production in the later 1980s, slightly but perceptibly sanitized.

The sanitization of ideas that surfaced first in art and craft has been a feature of postwar factory design and production in glass and ceramics since 1945, resulting in, for example, a surfeit of giftware knick knacks in the form of organic sculptures – much of it sub-Henry Moore.

The majority of consumers are relatively conservative in the choice of tableware for the dining room, but in the kitchen design is being driven by technology in ways probably unforeseen in 1945. The great difference between the kitchen wares of the 1940s and those of the end of the 20th century concerns the development of heat-resistant products. By the end of the 1980s, electric kettles were commonly made from polymers, not metal, and the introduction of microwave ovens radically altered design assumptions about cooking utensils.

The combination of the freezer, the microwave oven and transparent plastic packaging has begun to change the demand for cooking utensils in the home. To paraphrase Ezio Manzini from *The Material of Invention* (1986): with microwave cooking, heat is no longer conducted from the surface of the pot to the contents within, but is generated within the food itself. Therefore the task of the container is to contain the food and allow the microwaves to pass undisturbed to the food. As Manzini relates, the very packaging can be designed to do this task – making superfluous the casserole dish, the baking tray and the other metal, ceramic and glass (Pyrex, for example) containers designed for the oven. Undoubtedly it would be possible to dispense also with plates and cutlery in the home – as fast-food retailing in the high street has already done – but the consumer does not yet want this, and perhaps never will.

In ironic parallel with the freezer/microwave revolution there is a growing demand in the USA and Europe for dough-kneading machines, pasta makers and other devices, as consumers begin to want to 'make their own food'.

Kitchens are often defined by their owners. In a paper presented at the Stuttgart Design Centre in 1987, the German design critic, Dr

Katrin Pallowski, detailed her research into West German taste in home interiors. She had discovered that of the small number of people (mainly designers) who liked bare, minimalist home interiors, all had traditional kitchens with old-fashioned tools hanging off the wall or from the ceiling; yet the great majority of German consumers had cluttered, cosy homes, except for their kitchens – which tended towards being white, streamlined and technical.

Whether such distinctions hold from nation to nation, what the relationship is between high-tech in the bedroom and low-tech in the kitchen, and how it fits in with the status, occupation, income and education of the individual consumer are questions that are not yet integrated into design history or criticism. Such information does exist, and forms part of the basic (but still secret) intelligence of market research companies, who sell the information to clients who want to know what to sell and who to sell it to.

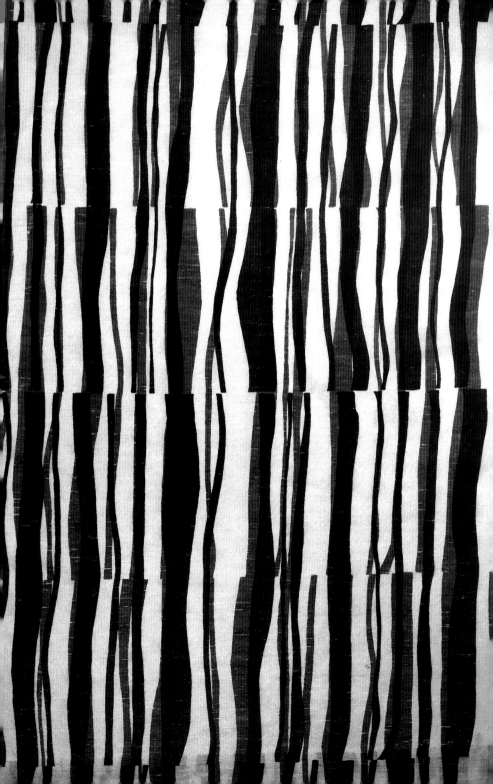

Textile Design

Historically, the relationship between studio craft (or handbuilt applied art) and design has been significant in the design of decorative furnishings. Indeed, before the late 18th century, designing and making overlapped considerably in decorative furnishings, although it is salutary to note that a division of design from manufacturing in the textiles industry can be seen as early as the 12th century in Europe. None the less, the relationship between hand craft and design is still important, for although most contemporary decorative ware is mass-produced, many of its designers have had some craft training or background, or continue to design and make limited production work while designing for larger manufacturers.

Advances in materials technology have widened the decorative possibilities, and although within the arts and crafts movements there are many practitioners who abhor new materials, there are others who have embraced them. The 1980s saw the blurring, in some areas of design, of the distinction between art, design, craft and technology. In textiles especially, it becomes quite difficult to establish who began which innovation, as different groups of people were experimenting and researching in parallel. In Italy during the 1970s, the design studios of Archizoom and the others were experimenting with structure in clothing and in the decorative surface. Meanwhile, in the USA, a large 'art' movement called 'Fiber Art' was in full flood, whose craft-based practitioners were also, in their way, experimenting with constructions and tensile structures. In Japan, during the 1970s, designers began looking afresh at traditional garments and traditional weaving. Materials scientists were developing new fibres and new chemical processes for treating cloth. In Britain, at the same time, a counter-culture in street fashion was producing anti-design, with teenagers taking design into their own hands and slashing at it with razors; and college art courses training hundreds of textile and fashion designers who were not interested in traditional tailoring or in

179

153 Marianne Strengell, drapery fabric, c. 1955–60.

the finesse of craft weaving but wanted to collage, montage, burn, scrape, weld and meld materials viciously.

Since 1945 (and indeed before it) textiles has been an important area of exchange between craft and design, and during the period of Modernism or Internationalism that accompanied the public architecture of the first boom years following the Second World War, textiles provided colour and variation in texture.

The Cranbrook Academy of Art was especially influential in American textile design during the 1940s and 1950s. And through its former students, such as the internationally known craftsman, designer and businessman Jack Lenor Larsen, Cranbrook's influence continues. Stylistically, this influence owes much to the Scandinavian roots of its textiles department. It was established by Loja Saarinen, wife of the Finnish architect of Cranbrook, Eliel Saarinen. She built up the reputation of Cranbrook as a centre of textile excellence through her own studio work and the quality of the teachers she appointed as weaving instructors. Of these appointments, the most important was that of Marianne Strengell (Sweden, b. 1909). Strengell, who had trained in Finland, exhibited internationally during the 1930s and became an instructor at Cranbrook in 1937, taking over as head of textiles in 1942.

Throughout the 1950s and early 1960s, she worked with a number of important clients, including Raymond Loewy, Knoll Associates, General Motors and the architectural firm Skidmore, Owings and Merrill. In encouraging both design and making, Strengell got her students to consider seven aspects that shape any design/craft commission: materials, price, climate, labour, equipment, architectural placement and personalities.

As well as weaving and designing for woven textiles, Strengell reintroduced to Cranbrook practical courses in designing and making printed fabrics. Under her influence, most of the designs that were produced by Cranbrook teachers and students were abstract patterns, using a subdued but not uncolourful palette. Primaries such as red and blue would be used but with the edge taken off – very much in the manner that Scandinavia still uses colour today on the exterior of its buildings.

In 1944, a graduate of the textiles department, Robert D. Sailors, also began teaching in it. He also favoured abstract design but his main influence upon postwar textile design in the USA was his exploration

154 Weavers at work on the large loom, Loja Saarinen's weaving studio, Cranbrook Academy, 1935.

155 Robert D. Sailors, drapery textile, 1953. A graduate of Cranbrook, Sailors explored texture and colour through combining natural and artificial materials. This plainweave example has a warp of rayon, linen and cotton, with a weft of rayon and lurex.

156 Ed Rossbach, like Sailors a graduate of Cranbrook Academy, also experimented with structures and materials. He became one of the most influential designers and teachers of textile design in postwar America. Shown here is Bamako, 1960.

of textures achieved through the careful organization of unusual or contradictory materials. He wove any material that could be woven – industrial or natural. Sailors left Cranbrook in 1947 and set up his own company, producing both handwoven and power-loomed fabrics. However, the results of his experiments at Cranbrook bore fruit: in the 1950s his studio created a range of furnishing fabrics that had delicate, complex textures. The colours might be quiet, but the design of the structure and the combination (say of a rayon warp and a lurex weft) used the light to bring the surface alive.

Sailors influenced another Cranbrook graduate, Ed Rossbach. Rossbach also experimented with structures and the combination of unlikely materials. He became one of the most influential designers and teachers of textile design in postwar America; after his Cranbrook graduation he taught at the University of Washington, and he went on to teach and eventually become a Professor at the University of California, Berkeley. It was at Washington that Rossbach met Jack Lenor Larsen, and encouraged him to take up textiles and go to Cranbrook.

182

157 Jack Lenor Larsen has been a major figure in American textiles since the 1950s. He straddles commerce, design and craft. This fabric, called Interplay, 1960, is resistant to sun, mildew and fire.

Larsen has been a major figure in textile design for over forty years. He has retained an interest in handicraft, and has promoted art textiles, but he is also expert in power-loom weaving techniques and industrial fibres. Larsen has exerted a considerable influence on the higher end of the mass-manufactured textile market. He is one of a number of designer-craftsmen to have used the art and design of other cultures to provide source material for his collections, for example: The Andean (1956), The African (1963) and The Irish (1969). He has also worked as a consultant for the USA's Department of State on grass weaving projects in Taiwan and Vietnam. An assessment of Larsen in *High Styles* (1985), published by the Whitney Museum, New York, notes, 'In the realm of commercial fabrics, the preeminent creative personality was unquestionably Jack Lenor Larsen.' His writ has extended into the 1990s.

Cranbrook did not have a monopoly on craft-influenced textile design in the USA. One of the first American textile designers to adapt designs created through handicraft for mass production was Dorothy Liebes (1899–1972). Liebes was educated at Berkeley and

Columbia universities; in 1930, she was producing commissioned handwoven work for Californian architects; in 1940, she began designing for large-scale production. Twenty years later, with her New York studio flourishing (it opened in 1948), Liebes designed only for industrial production.

All postwar textile designers in the West owe a debt to Anni Albers (Germany, 1899–1994). Before the Second World War and her emigration from Germany to the USA, she had been the director of the weaving workshop at the Bauhaus in Dessau. A handweaver and an industrial designer, she was the first weaver to be given a solo exhibition at the Museum of Modern Art, New York (1949). She believed in industrial production supported by craft-based design, and argued in her books *On Design* (1959) and *On Weaving* (1965) that design for textiles should not be merely graphic; designers should handle the material as well, in order to understand its three-dimensional nature as structure.

Key individuals aside, the dominant foreign influence on textile design in the USA came from Scandinavia, whose influence was purveyed through travelling exhibitions, international fairs and exports. Textile designer/makers did well at the first postwar Milan Triennale in 1951. A gold medal was awarded to an Icelandic weaver, Juliana Sveinsdottir (1889–1966), who specialized in combining weaving and knitting, using natural dyed wool with undyed wool as a foil.

Denmark, Finland, Norway and Sweden worked together on the major travelling exhibition 'Design in Scandinavia', which toured in the USA and Canada between 1954 and 1957. The Lunning Prize, started in 1951, was another promotional gambit. It was awarded annually to outstanding Scandinavian designers until 1972. One of its principal achievements was to consolidate in the minds of retailers the idea of the four major countries of the north as adding up to a single design entity.

Vibeke Klint (Denmark, b. 1927) was a Lunning prize winner. In the early 1950s, her simple stripe patterns predated the compositions of North American minimalist painters by several years. She designs for industry, but is also notable for producing her own fine handwoven cloth.

The experimentation with weaving different materials together, which was so prominent at Cranbrook, was also experienced in Finland. Greta Skogster-Lehtinen (Finland, b. 1900) used paper and

158 Dorothy Liebes began her career producing handwoven fabrics for architects before establishing a New York studio designing only for mass manufacture. Shown here: window blinds, 1963, handwoven using a loop fringe technique in cotton and rayon.

159 Anni Albers, linen and cotton bedspread, 1950. Director of the weaving workshop at the Bauhaus, Dessau, she emigrated to the USA before the Second World War and became the first weaver to have a solo exhibition at the Museum of Modern Art, New York, 1949.

160, 161 Eskolin-Nurmesniemi's Pyorre design, 1964, used *right* in Helle dresses as high fashion.

birch bark to test variations of texture and colour – a response to a shortage of materials as well as the result of curiosity.

Warmth, quality and abstraction made the Scandinavian textiles appealing after the war: the dark, saturated colours were reassuring; the weaving, often hand done, was good, and the patterns either echoed or anticipated developments in international Modernism – they were meaningless, and thus travelled well.

The handwoven, natural-dye look was only one of two or three significant trends that characterized textile design in the 1950s and 1960s. Bright colour and abstract or semi-'scientific' patterns were another trend. The British textile designer Lucienne Day (b. 1917) produced her brightly coloured Calyx pattern in 1951, judged the best textile design on the American market in 1952. The postwar American textiles market was impressed with other Europeans, including Fede Cheti (Italy, 1905–78). A protégée of Gio Ponti, she designed a series of art fabrics in the 1950s, and also produced screen-

162 Natural structures: source for the Festival Pattern Group.

printed designs created by Giorgio de Chirico and Raoul Dufy.

One notable Finnish company, Printex (which then became Marimekko), began producing fabrics with large scale patterns that were boldly abstract. And Astrid Sampe (Sweden, b. 1909) won a Grand Prix at the 1954 Milan Triennale for her complex abstract print called Windy Way. The chief designer for Marimekko (1953–60) was Vuokko Eskolin-Nurmesniemi (Finland, b. 1930). She had trained originally as a potter but switched to textile design and founded her own clothing and textiles company, Vuokko, in 1964. She too won the Lunning prize, in 1964.

In the UK the most significant craft/design developments were produced by designer craftswomen such as Enid Marx (UK, b. 1902), Marianne Straub (Switzerland, b. 1909) and The Festival Pattern Group. Marx became prominent as a textile designer in the 1930s, when she designed and handprinted cottons and linens. She is not a weaver herself, but has a long interest in the crafts of weaving and

dyeing. She was a member of the Utility Furniture Design Panel during the war; designed seat fabrics for London Transport; and she was a contributor to the Festival Pattern Group in the 1950s, as was Marianne Straub. Straub, who settled in Britain in 1931, studied with a variety of people, including the doyen of the studio-craft textile movement in Europe – the weaver Ethel Mairet. Straub went on to become one of Britain's leading textile designers, as well as an influential teacher.

The Festival Pattern Group had been set up in London in 1949, as a part of the nationwide Festival of Britain (1951), held to celebrate the cultural achievements of the country and provide encouragement for the future. The Pattern Group was a thoroughly eccentric affair, and was part of an attempt to bring decoration into the modern world by giving it a rationalist and scientific foundation. A University of Cambridge scientist, Dr Helen Megaw, provided a group of designers with blueprint drawings of crystal structures of materials and liquids. These drawings were to be the source for 'abstract' pattern. Apart from providing inspiration for textile and wallpaper pattern, they influenced decoration on ceramic and metal tableware.

In Britain and in the West generally, the textiles industry underwent restructuring during the 1960s and 1970s. Mass production, especially of printed cloth, became the target, and handicraft-based factories in the USA and the UK were bought up or went bankrupt because they could not compete on price. The increase in the variety and sophistication of printed textiles during the 1960s was throughout the West. Technology was one reason; another was the parallel sophistication and availability of consumer and fashion magazines, pictorial advertising, colour printing; and the growth of museum shops with their postcards and big colour prints of the latest Pop Art. The abundance of printed, coloured ephemera in the 1960s made it seem to be a decade of light and levity.

Very small craft-textile studios were unaffected by the rationalization of industry. The relatively low capital costs involved in establishing a workshop, and the relatively small production runs required to support a one- or two-person workshop, meant that the art-school educated European or North American graduate could establish a niche for his or her work.

In the 1970s, as part of a Western 'crafts revival', there was a renewed interest throughout Europe and North America in craft

textiles. This interest took two forms: there was a continuation of the quasi-traditionalist approach to textile design and making which had blossomed in the 1920s, and again in the late 1940s and early 1950s. But, more important, there was a new generation of art school trained designers and designer-makers who wanted to experiment with textiles as design, fashion and art.

Some aspects of textile work actually became politicized; specific branches of textile design and making, such as quilting and embroidery, were taken up by the women's movements as 'their' art/design forms. In Eastern Europe, textile 'art' was one area in which women and men could express themselves more freely because it was not policed as bureaucratically as painting and sculpture. Poland's leading textile artist, Magdalena Abakanowicz, whose abstract structures became progressively more figurative and obliquely subversive, took up metal sculpture just as soon as she escaped from Poland to the USA.

163 Magdalena Abakanowicz spent much of her career as a sculptor in communist Poland creating textile structures, but she now works in the USA and uses metal. This work, 1969, is from the circle of the 'Abakans', woven in sisal on a metal support.

There is a tendency in design history to overlook the fact that in its own way the textile art, or fiber art movement as it was called in the USA, does parallel the kind of research/experimentation that is so praised in the work of the Italian studios. Fiber art parallels the Italian studio phenomenon in three ways. First, both were experimenting through hand-crafted artefacts. Second, both were to some extent politicized. And third, both were interested in the analysis of the structure of their materials. Indeed, Andrea Branzi, introducing a chapter on structure in his book *The Hot House*, pays tribute to the pioneering work of Anni Albers.

In the USA, Lenore Tawney (b. 1925) has been a creator of immensely inventive textile structure. She studied at the Illinois Institute of Technology, where she was tutored by émigrés László Moholy-Nagy and Alexander Archipenko. Her work is in the Museum of Modern Art, New York, and the American Craft Museum, New York. Structure-based experiments in textiles blossomed in the 1980s throughout the world – especially in Japan, in the constructions of Akio Hamatani (Japan, b. 1947), for example.

The political nature of the textile art movement is centred upon feminism and upon the values of handicraft itself. The political debate is diverse and subtle, but it is in part a debate about how to get taken seriously those things with which women have by tradition been associated – the everyday concerns of the home and 'home arts'. For example, embroidery can be used figuratively to create political

164 Akio Hamatani, White Arc 3, Japan, 1983.
165 1980s innovation: Hyper-Hyper, Fashion Week, London, 1989.

images but it is also, in itself, a craft requiring great care – and care is a value that is not present in much of the fashionable postwar, male-dominated painting and sculpture.

But every activity is janus-faced. In France, such crafts as embroidery were not politicized so much as brought back into the centre of high, exclusive design, by being taken up again by the big fashion houses. And the leading embroiderer/designer is a man: François Lesage (b. 1929). He heads Lesage et Cie (founded 1922), the distinguished company of French embroiderers and embellishers supplying the Parisian *couturiers*. In the 1980s, he attracted public attention with a Ming vase decoration for a Chanel dress and a sequinned copy of Van Gogh's *The Irises* for Yves Saint-Laurent. *The Irises* had just been sold for the highest auction price ever reached by a work of art; by using the image, Saint Laurent was thus making his dresses a vehicle of ironic commentary (bearing in mind the high-cost status that his own work represents).

During the 1970s, 'the dress' or 'clothing' became for some designers a vehicle for research and polemical discussion. Clothing design became self-consciously and deliberately about exploring ideas, as distinct from creating useful products. It was a distinction similar to that found in avant garde chair design where the 'chair' is a three-dimensional polemic or 'comment' rather than a commercially intended product.

In Italy, Archizoom Associati experimented with both body art and costumes. Andrea Branzi claims that he and his colleagues were interested in clothing because 'we saw it as a theoretical model for a new kind of production, given the name post-industrial by theoreticians'. Yet, as the various experiments are described, it seems that the 'post-industrial' manufacture Branzi had in mind was either handicraft or super-advanced computerized production.

Nanni Strada and Clino Castelli made a film called *The Cloak and the Skin* (1973), in which two different levels of clothing – an inner and outer layer – were featured. The outer layer was made from a single piece of quilted cloth. Its construction was based on the principles of tin can mechanics: the seams were simply placed edge to edge and overstitched. The inner skin was a body stocking, again one piece, and would be manufactured in a single operation.

Archizoom Associati's film *Dressing is Easy* shared a do-it-yourself design for a garment that did away with traditional tailoring, and set

out to show how elementary a piece of clothing could be. The basic building block was a square of cloth and a series of tucks and folds as used in origami. The purpose of these films and other ventures was to pare clothing to its essential design features, thus revealing some of the logic both of design and production. Such analysis, once stripped of its theoretical pretensions, was useful in enabling designers to rethink their attitudes towards manufacturing. It may have liberated them from feeling in thrall to the machine by encouraging them to think of simpler production methods. The exploration of simpler production methods is in itself applicable to technology, and so there is dialogue – a dialetic even – between hand craft, theory and industrial production.

Naturally in Italy, as elsewhere, technology fascinated those involved in textile and other surface decoration, not least because technology was delivering new kinds of 'active' surfaces. At first this was more a matter of creating garments with liquid crystals that lit up

166 Archizoom Associati's 1972 experiment, *Dressing is Easy*.

like festive decorations inserted in them so the wearer could wander around like a subtle Christmas tree.

The technology of active surfaces developed quickly in the 1980s. Textiles can now change colour according to the light and temperature conditions they are worn or shown in. An American designer, Jane Barnes, has woven fluorescent and light-sensitive yarns into men's shirts.

Other high-quality artificial fibres and structures have been pioneered by the chemical industry, and were first used extensively in sportswear in the 1980s. One such fibre was Lycra, which enables a garment to stretch and hug the body, but not impede the body's movements at all. In a spirit reminiscent of the mixed bark, paper and cotton experiments of the 1940s, designers of the late 1980s and early 1990s combined Lycra with yarns of different elasticity, including natural fibres. This allows for interesting sculptural structures to be created. Rosemary Moore (UK, b. 1959) issued a patent in 1984 for her invention of a tube-knitted jersey lycra fabric called Maxxam and produced it under licence in Japan, the USA, the UK and Australia. But, as Chloë Colchester makes clear in her book *The New Textiles* (1991), the most remarkable syntheses between craft and design have occurred in Japanese textiles, via the conduit of chemistry and the computer.

The fashion designer Issey Miyake (Japan, b. 1935) developed laser printing of textiles in the late 1970s, and in the early 1980s he and his master weaver, Makiko Minagawa, began visiting Japanese craft weavers and then simulating the look of hand-woven fabrics using computer-driven looms. The computer was programmed to produce random 'flaws'. Rei Kawakubo (Japan, b. 1942) designed knitwear with the request that the screws on the knitting machines be loosened in order to allow flaws into the work. 'Flaws' have long been a part of the Japanese aesthetic, reminding the viewer/user that a human mind conceived and made this thing. A flaw in an otherwise perfect piece of work enhances the perfection by providing a foil to it.

Junichi Arai (Japan, b. 1932) emerged in the 1980s as a formidably impressive craftsman and textile designer. Using both synthetic and natural yarns, he has worked closely with Issey Miyake. Colchester explains, 'Arai's designs are based on destabilizing fabrics, and releasing rather than controlling tension. He weaves loosely, with high-twist yarns to create cloth with a bouncy texture and feel which

167 Lycra, manufactured by Du Pont, can be combined with natural fibres.

168, 169 By the 1990s the
textile world looked to Japan
for beautiful and inventive
design, especially to the work
of Junichi Arai.

seems to spring with life.' Arai introduced the computer into the craft tradition. He established a company called Anthologie which used a network of small family businesses of spinners, weavers and finishers of Kiryu, a small town north of Tokyo which is the centre of traditional weaving in Japan.

The stylistic, technical and technological developments in textiles, especially as they apply to clothing, are of interest in themselves, but more important are the ends to which they are put. Architecture and product and furniture design are the 'traditional' vehicles of debate in design ideology and design ethics. This is changing. Various themes emerged in the 1980s – not just the adolescent rebellions of children who want to dress differently from their parents – but concerns about what kind of materials are ethical to wear (killing animals for their fur is cruel; some artificial textile production is unkind to the earth) and whether people should be constrained by custom or religion in what they wear and when they wear it. By the early 1990s, politics had become an overt part of the fabric of textile design.

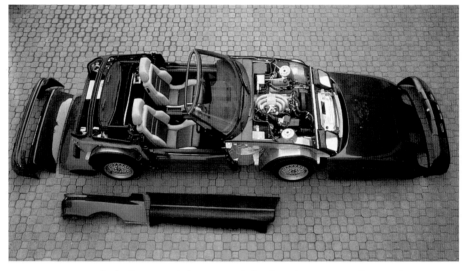

170 In the late twentieth century, design is no longer a casual enterprise; nor one that can disregard the overall environmental effects of the finished product. BMW's thinktank, BMW Technik, designed the BMW Z 1 from the mid-1980s for launch in 1991. It is a model of 'Design for disassembly', with emphasis on potential recycling of materials.

Design Futures

Misha Black, the Russian-born but essentially English designer and polemicist, wrote in 1962 that, 'The job of an industrial designer is to produce useful and agreeable objects, but he can, at the least, make them express the living, vigorous aspects of that society and not vacuously mirror its lowly common denominators.'

The comment is unfashionably patrician, but the aim – useful and agreeable objects – is reasonable and comforting. Black's desire to express the 'living, vigorous aspects of that society' has, in the context of his extensive writings (see *The Black Papers*, 1983), two aspects. First, although Black saw the designer's role as analogous to that of a servant, he also sought to include in the designer's world some of the freedoms of expression enjoyed by the artist. Second, Black was aware of the temporary nature of design – aware of its being subject to fashion. He was never comfortable with this, and seemed in his writings to yearn for absolute standards, classical principles and timelessness.

Certainly in Black's time – his career, in its maturity, went from the late 1930s to the late 1960s – one of the major spiritual or creative struggles for the designer was the reconciliation of the need to serve with the desire to give form and expression to what he or she sees, feels and thinks about the society he or she is living in. A designer is nothing without intuitions, memories, experiences and desires, and these must inform his or her work – if not, then design might as well be done by computer.

Yet the struggle between service and artistic expression is much less of an issue than it was in Black's day. Some areas of design and manufacture naturally offer more scope for artistic interpretation than others. Expressing the vitality (or adding to the vitality) of a culture is more easily done in graphic design or clothing than it is in the design of kitchen appliances. Even so, there is no logical reason why a food mixer, for example, should not be designed as a piece of useful high

applied art to be cherished and valued from one generation to the next.

In the late 1940s and throughout the 1950s, arguments about the 'right way to design' were taken seriously; Black's line that design should not be watered down by the lowest common denominators in society may be read as an expression of a belief in good taste. The roots of this desire, to impose or to insist that there is one 'good' solution in design, run deep. Specialists in the history of ideas, such as Isaiah Berlin, point out that the belief that one can give a rational reorganization to everything confusing in society is an intellectual attitude we inherit from the Greeks. This Platonic belief shaped postwar design thinking in Germany – whereas in Italy, designers have accepted and capitalized, through their design experiments, events and exhibitions, upon their belief in the dynamics of confusion and the plurality of right answers. But even in Germany and Scandinavia, 'good taste' or 'good design' is no longer a single ideology – it is accepted intellectually and intuitively that there are several right answers to any one design challenge. This plurality is liberating for the designer and the consumer.

The freedom to be 'expressive', to play the artist, is no longer a problem for designers who, by and large, whatever their speciality, can find a niche market or simply a small collection of magazine editors or museum curators who will indulge their idiosyncratic interests.

But if style and expression are no longer areas of tight constraint (there are always some constraints) the seemingly unobjectionable aim of creating 'agreeable and useful' objects has become more, not less, contentious.

What, for example, counts as an agreeable object? Specifying the content of 'agreeable' takes the thinking designer and the responsible manufacturer, retailer and consumer directly to the deeper values of society. The existence of a better informed, more morally aware public is altering the landscape of design.

In general terms, to be both useful and agreeable, an object must satisfy criteria of health and safety and the environment. A beautiful wood table, designed and manufactured with care, becomes a disagreeable object to some people if the timber was got by the destruction of non-renewable forest by labourers existing on subsistence wages. Graphic design is a particularly fraught area, since

it is usually directed in one form or another towards propaganda – it heightens some truths and silences others. The food industry has, until recently, successfully kept hidden from public view its methods of raising and killing animals.

Victor Papanek, in *Design For the Real World* (1971), suggests that words such as beautiful or ugly should be dropped from the lexicography of design and the term 'meaningful' used instead. This goes too far: it smacks of self-consciously political correctness and that is itself disagreeable. But, because of the explosion in information and the work of pressure groups and lobbyists, many more consumers see beyond the surface of design. What was once below the line in design is being revealed, not by the objects themselves, but by what we know about them through other sources.

Designers themselves have increasingly become interrogators. It was argued in Chapter 1 that the science and the art of making things explicit was a part of the designer's work. He or she has often to persuade clients to put words to ideas, intuitions, half-buried beliefs and assumptions that had hitherto remained tacit. Good designers hound their clients with questions. What do you want this for? Why do you want it? Have you thought about this aspect? Did you know that. . . .

Design as a questioning activity has developed over the decades because more often than not a designer becomes involved in more than the creation of a single useful and agreeable object. Willy nilly, he is drawn or draws himself into the overall policies of the client's company. Design is a strategic activity. Newly recognized challenges about the environment and the relationships between pollution and consumption are directing corporate designers and engineers towards designing for long-term goals in the conservation of energy and resources.

Consider, as an example, the concept of 'Design for Disassembly' and 'Design For Recycling'. Copious research has been carried out into the value of different waste materials, especially metals, and considerable thought is now being given to two aspects of design. The first involves limiting the variety of materials used in a product; the second concerns designing the product so that the materials used are easily recoverable. This second aspect is the more demanding design challenge. The ability to take products apart efficiently is fundamental to the new cause of recycling. A number of large corporations,

including General Electric (USA) and 3M (USA), have begun including Design for disassembly as a part of the design brief. This requires the designers and product engineers to avoid adhesives or screws, and adopt 'Pop-in, pop-out' fasteners. The German car manufacturer BMW is a leader in the art. The BMW Z 1 car can be disassembled in twenty minutes. However, although the description of the concept is easy, the design is not. The art of designing pop-in, pop-out products that do not fall apart until required to do so is akin to squaring circles.

Design for disassembly is an example of a developing trend in design in which the emphasis is upon the design of the object in its environment – not how it looks in a room or out on the street but in the multi-dimensional nest of causes and effects attendant upon it existing in the wider world. Real design can no longer be dashed off on the back of an envelope – not even if the envelope itself is made of recycled paper.

Chronology

1945–1957: The division of 'East' from 'West' and the cold war rivalry distorted the geography of postwar design in Europe by stifling the creativity of Russian and East European designers, whose technology was tied to the demands of the military and the state.

In some countries design innovation had barely been interrupted by the war: Cranbrook Academy in the USA was the source of inventive furniture, textiles and ceramics design throughout the 1940s and early 1950s. Meanwhile, the pioneering professional industrial designers who emerged in the 1930s, such as Raymond Loewy, Walter Dorwin Teague, and Henry Dreyfuss, continued their leadership. But even in countries such as Italy, France and the UK, which had suffered invasion or attack there was, materials permitting, a rapid flowering of prototypes, one-offs and limited production runs with promises of more to come: Italy's Carlo Mollino unveiled a new look in furniture, Christian Dior in France created the New Look in fashion and in the UK an exhibition in London called 'Britain Can Make It' (1946) showed a new look in design.

Apart from Italy, the Scandinavian countries were the most influential in terms of design aesthetics. Among design's intellectuals – at the Museum of Modern Art in New York, at the Hochschule für Gestaltung at Ulm and the Council of Industrial Design (the Design Council) in London, for example – people knew what made design good. In the marketplace, 'bad' design was popular everywhere and being discovered by the first Pop artists.

1945: The first electronic digital computer is built at the University of Pennsylvania, USA, weighing 30 tons. Wernher von Braun and other leading German rocket experts emigrate to the USA. The Braun electronics factory is rebuilt. Ernest Race, UK, designs the BA3 chair to be made from recycled aircraft salvage. Raymond Loewy does pioneering consumer electronics design with his radio for Hallicrafter.

1946: Volkswagen car plant is restarted by British Army; Marcello Nizzoli designs Elettrosumma 14 adding machine; Eero Saarinen unveils his Womb chair; the Vespa scooter is launched, designed by Corradino d'Ascanio. Le Corbusier's Unité d'Habitation in Marseilles is begun (completed 1952). The 'Britain Can Make It' exhibition opens at the Victoria and Albert Museum, London. Wurlitzer launches its 1100 juke box. Earl S. Tupper's company (Tupperware, founded 1942) expands its range of thin-walled polythene domestic containers. George Nelson creates his innovative, rational wall-storage system for Herman Miller.

1947: Scientists at the Bell Telephone laboratory develop the transistor; Edwin Land's Polaroid camera is launched; Eliot Noyes, later to shape the design policy of IBM, opens his own design office; Italian car design is put on the world stage with

203

Pininfarina's Cisitalia Coupé. Christian Dior launches his Corolle Line (nicknamed the New Look).

1948: Alec Issigonis's design for the Morris 1000 car is launched; Marcello Nizzoli's influential typewriter design – the Lexicon 80 – appears; MOMA, New York, stages the 'Low-Cost Furniture Design' competition. The work of Charles and Ray Eames and Eero Saarinen is both prominent and influential.

1949: The Peugeot Simca 6 small car is launched in France; the Porsche 356 sports car appears in West Germany; the world's first civilian jet airliner, the UK's de Havilland Comet, flies; Gio Ponti's Coffee-machine for La Pavoni becomes an icon of new design; the Kartell company is founded; the Festival of Britain Pattern Group is established; the Palatino typeface, designed by Herman Zapf, appears.

1950: Swedish industrial design emerges as a profession with designs by Sixten Sason for Electrolux, as well as his advanced, aerodynamic Saab 92 motor car. Marcello Nizzoli's award-winning portable Lettera 22 typewriter for Olivetti is launched; work is begun on Le Corbusier's chapel – Notre Dame-du-Haut, Ronchamp – (completed 1955). The first Japanese tape recorder is manufactured by TTK (Sony).

1951: The Festival of Britain gives UK architects and designers a public platform for their talents.

1952: MOMA, New York, stages the 'Olivetti: Design In Industry' exhibition. Jack Lenor Larsen, probably the USA's most influential postwar textile designer, opens his first studio. One of the furniture icons of the 1950s appears – the Diamond-lattice chair by Harry Bertoia. Zdenek Kovar's pioneering work (Czechoslovakia) in the ergonomics of hand-held tools is publicized.

1953: Gino Columbini's kitchen tools for Kartell contribute to the rapid improvement in the design of plastic ware. Cranbrook graduate R.D. Sailors gains wide publicity for his textiles that combine mixtures of natural and artificial fibres.

1954: Fritz Eichler joins the board of the Braun electronics company, where he is instrumental in establishing a productive design and research relationship with the Hochschule für Gestaltung at Ulm. The highly influential Univers family of typefaces is produced by Adrian Frutiger in Paris. Raymond Loewy's design for the Greyhound Bus Company reaches fruition. David Mellor launches his Pride cutlery. Henning Koppel shows his design for a covered silver dish – a key contribution to the Scandinavian-led trend of designing semi-craft/art tableware sculpture for the professional middle-class consumer.

1955: The sophisticated Citroën DS 19 is launched at the Turin Motor Show. The first all-transistor radio is launched by Sony; the Hochschule für Gestaltung at Ulm re-opens after a four-year gestation. Pan American World Airways buys a civilian version of the Boeing military tanker – the Boeing 707 – and Walter Dorwin Teague

designs its interior, using a full-scale mock-up and pretend 'flights' with surrogate passengers. Henry Dreyfuss publishes *Designing For People*; Saul Bass designs the poster and graphics for the film *The Man with the Golden Arm*.

1956: The Pirelli Tower, designed by Gio Ponti, is completed in Milan. Dieter Rams and Hans Gugelot's phonograph and radio is launched, nicknamed 'Snow White's Coffin'. Richard Hamilton creates his iconographic pop art collage 'Just what is it that makes today's homes so different, so appealing?'. Eero Saarinen starts designing the biomorphic TWA building at JFK airport. Calder Hall, the world's first industrial-scale atomic power station, opens in the UK. Charles and Ray Eames produce Lounge Chair and Ottoman.

1957: The USSR launches Sputnik, the world's first artificial satellite; the USA (Jack Kilby) produces the first working microchip – the semi-conductor integrated circuit. Helvetica typeface is launched. Arne Jacobsen produces his Swan chair and Gio Ponti produces his Superleggera chair. Lino Sabattini produces his Como silver tea and coffee set. Pierre Cardin launches his first women's collection.

1958–1968: *The full impact of the 'youth' revolution becomes clear in this period. In the West, ordinary people begin flying to foreign destinations on holidays; the cost of electrical gadgetry comes down quite fast and car ownership, as well as time and money for hobbies, increases dramatically. An intellectual scepticism among radical architects in Italy, departments of philosophy and sociology in West Germany, France and Britain begins to influence discussion of the purpose and quality of design. 'Consumer protection' begins to develop as a movement, inspired by books such as* The Waste Makers *by Vance Packard (USA) – an attack on low quality and profligacy in manufacturing. But improved standards of public service in design – improved transportation, signage, better houses, greater variety – are also a hallmark of the period.*

1958: Optima typeface, designed by Herman Zapf, is much praised for its readability. Philco attempts to redesign the square box television with the bug-eyed Predicta television. Cecil Beaton creates the costumes for the film *Gigi*. Lycra is invented by Du Pont. Poul Henningsen's famous PH5 light goes into production.

1959: Largely a year of compact and or miniaturized design: The British Motor Corporation launches the Morris Mini Minor, designed by Alec Issigonis. Sony launches the first transistorized television. Eliot Noyes designs the Model B electric typewriter for IBM. Sigurd Persson designs his Jet Line cutlery for Scandinavian Airlines. The Henrion Design studio is founded. Anni Albers publishes her book *On Design*.

1960: The graphic design consultancy of Chermayeff and Geismar (USA) is founded. Japan hosts the 'First World Conference on Design'. Verner Panton's influential polyester and fibreglass Stacking chair is designed (manufactured 1967–75 by Herman Miller).

1961: Archigram, a group of like-minded architects, is formed, and launches an occasional magazine. They would be most influential through their drawings, especially Plug-in City (1965). The satirical magazine *Private Eye* is launched in London.

1962: Avanti motorcar for Studebaker, designed by Raymond Loewy, is launched. The Mini skirt is introduced by André Courreges. The Total Design graphics company (Netherlands) is established. Honda begins producing lightweight trucks and passenger cars.

1964: Armin Hofmann designs the signage and logo graphics for the Swiss National Expo. Yusaku Kamekura's design for the Tokyo Olympics logo is published (in the leadup to the event Masaru Katzumie leads the graphic design team for Olympics signage). The Porsche 911 sports car comes into production. Pierre Cardin launches his Space Age collection.

1965: Ralph Nader's *Unsafe at Any Speed*, Armin Hofmann's *Graphic Design Manual: Principles and Practice* and Anni Albers's *On Weaving* are published. Two remarkably similar designs change the shape of telephones: Henry Dreyfuss's Trimline telephone for Bell; and Marco Zanuso and Richard Sapper's Grillo telephone. André Courreges launches his Space Age collection.

1966 Robert Venturi's *Complexity and Contradiction in Architecture* is published; the radical design and architecture studios Archizoom Associati and Superstudio are founded in Florence. Isamu Noguchi designs the subsequently much-imitated Akari hanging paper globe lamp.

1967: Bang and Olufsen launch the first Beosystem. Milton Glaser produces his famous Bob Dylan poster. Cylinda Line tableware by Arne Jacobsen is launched. Blow chair and Blow sofa are designed by De Pas, D'Urbino and Lomazzi for Zanotta. Expo 67 in Montreal includes Moshe Safdie's Habitat apartment block – nicknamed the 'ant hill'.

1968: The May revolution in Paris frightens de Gaulle but puts new energy into alternative graphic design. Stanley Kubrick's film *2001* offers an optimistic view of man's destiny beyond the earth; the Beatles encourage new graphics with their record sleeves and their animated film *Yellow Submarine*. Wolfgang Weinhart, typographer, begins teaching at Basle School of Design and renews its influence. Herman Miller launches 'Action Office'.

1969–1981: *Not an optimistic period – many countries in the West suffer from terrorism or political corruption, whilst the USSR and its satellites stagnate. None the less, technological and design innovation is rapid in electronics, domestic goods and automobiles. Japan comes to dominance in electronics, automobiles, motorcycles and ship building. Italy remains an engine of design invention and philosophy. The USA, the UK, Holland and West Germany*

206

experience an extensive studio-craft revival. In Britain several radical, alternative movements in 'street fashion' emerge. Remarkably little attention is paid to the 'conquest of space'; the supersonic airliner, Concorde, although a technical success, is a commercial failure.

1969: America lands two men on the moon. The Sacco chair (a pear-shaped leather sack filled with polystyrene pellets) is designed by Gatti, Paolini and Teodoro, and manufactured by Zanotta. Comme des Garçons company is formed by Rei Kawakubo. Rodolfo Bonetto introduces a range of ABS plastic furniture. Ettore Sottsass creates his Nefertiti desk and the Olivetti Valentine portable typewriter.

1970: The Grapus graphic design co-operative is founded in Paris. 'No-Stop City', an investigation into modern urban life, is created by Archizoom Associati. Achille Castiglioni designs his Primate kneeling stool.

1971: *Design For the Real World* by Victor Papanek is published. Intel produce the microprocessor. Jean-Paul Vitrac designs his disposable picnic set for Diam. Issey Miyake holds his first fashion show in New York.

1972: Mario Bellini's Divisumma 18 calculator is launched; Iain and Clive Sinclair launch the world's first pocket calculator and set a new standard for miniaturization and product styling. Jakob Jensen's Beogram 4000 for B&O is launched. Robert Venturi publishes *Learning from Las Vegas* (which becomes a 'key' text for Postmodernist architects). A 'scientific' design research department is established at the Royal College of Art, London, 'The New Domestic Landscape' exhibition (design from Italy) is staged at MOMA, New York. Otl Aicher's designs for the 72 Munich Olympics are unveiled. The Ralph Lauren (fashion) label is launched. Richard Sapper's Tizio table lamp is launched. The Honda Civic motor car is launched.

1973: Global Tools, a counter school of architecture and design is established, especially notable for Riccardo Dalisi's work with poor children in the Traiano district of Naples. Philips publishes its first house style manual.

1974: Mario Bellini designs his tape deck for Yamaha; Giorgio Giugiaro's Golf motorcar for Volkswagen is launched – it is to become Europe's most popular mass-production car. The Japanese architect Arata Isozaki comes to international prominence for his Prefectural Museum at Gunma.

1976: Studio Alchymia is established in Milan – it explores decoration and historical reference, an early example of Postmodern design. Clive Sinclair designs his Microvision pocket television. Honda launches its Accord motor car. Concorde enters commercial service with British Airways and Air France. Gaetano Pesce's Sit Down chairs are produced by Cassina.

1977: Alessandro Mendini introduces the concept of 'Banal Design'. The Pompidou Centre, Paris, opens, designed by Richard Rogers and Renzo Piano.

1978: The Sony Walkman is designed. The Fiat Ritmo is produced on an automated factory assembly line. Philip Johnson's AT&T building is begun in New York ('it marked the acceptance of Postmodernism in America's corporate style' – Deyan Sudjic).

1979: Ergonomi Design Gruppen, a co-operative dedicated to ergonomic and socially aware design is founded in Sweden. The punk pop star Sid Vicious dies. During the late 1970s punk music had inspired a subversive and anti-corporate graphic imagery that was used in short-lived underground magazines, with a particular impact in Britain, Holland and West Germany. It influences fashion, and (in the 1980s) design. Jamie Reid, art director and Malcolm McLaren, manager of the Sex Pistols, emerge as the orchestrators of punk 'style'.

1980: 'Narrative Architecture Today' is founded at the Architectural Association, London, by, among others, Nigel Coates. The Norwegian company Westnofa launches the first of a range of radically ergonomic seats – the first being Peter Opsvik's Balans seat. Frank Gehry lightens the sobriety of furniture design with his Little Beaver.

1981: The public launch of the Memphis design studio in Milan, centred upon Ettore Sottsass, is the design media event of the year. Memphis helps to shock the middle ground of design into reconsidering the possibilities of surface decoration; its leitmotif is Sottsass's Casablanca sideboard. Clive Sinclair's ZX81 personal compact computer is introduced. Daniel Weil launches his Bag radio.

1982–1992: The 1980s were notable for computers whose wide availability and relative cheapness together with sophisticated software altered the processes of design and manufacturing. This occurrence could not have been predicted in 1945. The rise and fall of 'postmodern' as a design and architectural style was swift but the rise of the 'green' designer has been steady, supported by slowly evolving government legislation making demands upon manufacturers and other polluters. Design was a fashionable profession until, as the 1980s waned, the magazine editors became bored with it. The 1980s put utopian idealism and consensus on matters such as 'good taste' out of fashion – individuality, relativism and excess seemed good enough. In the 1990s there appear to be the signs of an attack on 'liberalism' and a growing anti-science and anti-technology movement. How this will shape design is not yet clear.

1982: Ford launches the Sierra motor car, a radical design for a mass market, designed by Uwe Bahnsen. Formica launches ColorCore. The Domus Academy, Milan, begins to offer postgraduate courses in design.

1983: A scholarly review of design, the 'Design Since 1945' exhibition, opens at the Philadelphia Museum of Art. Robert Venturi designs his highly decorated Postmodern versions of Chippendale chairs (launched by Knoll International in 1984). Alessi launches Richard Meier's Postmodern silver coffee set.

1984: *The Hot House* by Andrea Branzi is published. This remains the key book on the intellectual avant garde of postwar Italian design. Apple launches the Apple Mac personal computer. Olivetti launches the M24 office/personal computer designed by Ettore Sottsass and others. Alessi launches Aldo Rossi's metaphor-laden La Conica coffee pot.

1985: Driade launches furniture designed by Philippe Starck.

1986: Several office furniture systems are launched (partly reflecting the buoyancy of the commercial property market in the West): '9-to-5' designed by Richard Sapper for Castelli; Nomos, designed by Norman Foster for Tecno; Ethospace, designed by Bill Stumpf for Herman Miller. An anti-design design exhibition – 'Wohnen von Sinnen' (Living from the Senses) is staged in Düsseldorf. Michael Graves's singing bird tea kettle is launched by Alessi. Copy Jack hand-held photocopier is launched in Japan.

1987: Inmos (UK) launches the transputer, which revolutionizes computing (yet again) by offering a computer on a single chip. Junichi Arai, Japan, joins Nuno Design in Tokyo and launches a range of contemporary furnishing fabrics – he is one of the most important textile designer/artists in Japan (and the world).

1988: Sanyo launches ROBO electronic products for kids; Canon and Nikon launch biomorphic shaped 35 mm cameras. Ezio Manzini's *The Material of Invention* is published, explaining the relationship between new technology, design and creativity.

1989: Sony launches 'My First Sony' collection of radios and personal tape-players for young children.

1991: 'Design for disassembly', actively researched in the USA and West Germany, is the key concept of BMW's Z1 motor car. 'Virtual Reality' becomes a popular media subject – will it revolutionize the way we spend our leisure or remain an effective design, prototyping and simulation tool?

1992: The publication of *Typography Now: The Next Wave* (Rick Poynor) shows how far-reaching computer technology has become in freeing the graphic designer from all constraints and offering her/him the means to design in ALL the styles history has to offer. The Fifth Generation artificial intelligence project by Japan is completed; AI remains elusive but computer 'expert systems' continue to penetrate commercial and business life and appear poised to make inroads into professions such as medicine – and design.

Select Bibliography

Albers, Anni *On Design*, 1959
Albers, Anni *On Weaving*, 1965
Aldersley-Williams, Hugh *New American Design*, 1988
Ambasz, Emilio The *International Design Yearbook 1986/87*
Anker, Peter *Scandinavian Modern Design 1880–1980*, 1982
Bagrit, Lionel *The Age of Automation*, 1964
Banham, Reyner *Design By Choice*, 1981
Bayley, Stephen and others *Twentieth Century Style and Design*, 1986
Bayley, Stephen *Harley Earl*, 1983
Bayley, Stephen *The Car Programme*, 1981
Birley, A.W. and others *Plastic Materials*, 1988
Blake, Avril *The Black Papers On Design*, 1983
Blake, Avril *Misha Black*, Design Council, London 1984
Branzi, Andrea *Domestic Animals*, 1987
Branzi, Andrea *The Hot House*, 1984
Braun, Emily *Italian Art in the 20th Century*, 1989
Brino, Giovanni *Carlo Mollino*, 1987
Butter, Reinhart and others *Product Semantics*, conference report, University of Industrial Arts, Helsinki, 1989
Caplan, Ralph *The Design of Herman Miller*, Whitney Museum, New York 1976
Carroll, J. *Interfacing Thought*, 1987
Carter, Sebastian *Twentieth Century Type Designers*, 1987
Chandraseekaran, B. 'Design Problem Solving' *Artificial Intelligence Journal*, Winter 1990
Clare, Jeremy 'Are Large Systems Safe?', *Interface* magazine, 1991
Clark, Robert & others *Design In America* exhibition catalogue, Metropolitan Museum of Art, New York 1984
Colchester, Chloë *The New Textiles: Trends and Traditions* 1991
Collins, Michael *Towards Post-Modernism*, 1987
Cross, Nigel *Engineering Design Methods*, 1989
Curtis, William & others *Le Corbusier*, Arts Council exhibition catalogue, London 1987
Dormer, Peter *The Meanings of Modern Design*, 1990
Dreyfuss, Henry *Designing For People*, 1955
Dreyfuss, Henry *The Measure of Man*, 1960
Evans, Siân *Contemporary Japanese Design*, 1991
Fiell, Charlotte and Peter *Modern Furniture Classics Since 1945*, 1991
Ford, Henry *Today and Tomorrow* 1926
Forty, Adrian *Objects of Desire: Design and Society 1750–1980*, 1986
Foster, Hal *Postmodern Culture*, 1983
Frayling, Christopher *The Royal College of Art*, 1987
Freedman, Alix M. 'Forsaking the Black Box', *Wall Street Journal*, 21 April 1987
Goranzon, B. 'The Practice and Use of Computers', *Knowledge, Skill and Artificial Intelligence*, Springer-Verlag, Berlin 1988
Gordon, J. E. *The New Science of Strong Materials*, 1976

Gordon, J.E. *Structures*, 1978
Grillo, Paul Jacques *Form, Function and Design*, 1975
Greenberg, Clement *Art and Culture*, 1961
Hardyment, Christina *From Mangle to Microwave*, 1988
Hebdidge, Dick *Hiding In The Light*, 1988
Heskett, John *Industrial Design*, 1987
Heskett, John *Philips*, 1989
Hiesinger, Kathryn and Marcus, George H. *Design Since 1945* exhibition catalogue, Philadelphia Museum of Art, Philadelphia 1983, with essays by: Max Bill, Achille Castiglioni, Bruno Danese, Niels Diffrient, Herbert J. Gans, Jack Lenor Larsen, Olivier Mourge, George Nelson, Carl Pott, Jens Quistgaard, Dieter Rams, Paul Reilly, Philip Rosenthal, Timo Sarpaneva, Ettore Sottsass, Hans J. Wegner and Marco Zanuso.
Hillier, Bevis *The Style of the Century*, 1983
Hodges, Andrew *Alan Turing*, 1983
Hofmann, Armin *Graphic Design Manual: Principles and Practice*, 1965
Hopkins, Harry *The New Look*, 1964
Horn, Richard *Fifties Style*, 1985
Jeffrey, Ian *Photography: A Concise History* 1981
Jencks, Charles *The Language of Post-Modern Architecture*, 1984
Jensen, Robert and Conway Patricia *Ornamentalism*, 1983
Katz, Sylvia *Classic Plastics*, 1988
Kicherer, Sibylle *Olivetti*, 1990
Knobel, Lance *Office Furniture*, 1987
Lacey, Robert *Ford*, 1986
Lewis, John *Typography*, 1966
Lewis, Peter *The Fifties*, 1978
Loewy, Raymond *Industrial Design*, 1988
Lucie-Smith, Edward *The History of Industrial Design*, 1983
Mack, John 'Advanced Polymer Composites', *Materials Edge* magazine, January 1988
Maldonado, Tomas and Bonsiepe, Gui 'Science and Design', *Ulm* vols 10–11, 1964
Manzini, Ezio *The Material of Invention*, (1986; 1st English ed. 1989)
Margolin, Victor *Design Discourse*, 1989
MacArthy, Fiona and others *Royal Designers On Design*, Design Council, London 1986
McCoy, Esther 'The Rationalist Period', High Styles exhibition catalogue, Whitney Museum of American Art, New York 1985
McDermott, Catherine *Street Style*, Design Council, London 1987
McFadden, David Revere *Scandinavian Modern Design* exhibition catalogue, Cooper-Hewitt Museum, New York 1982
Miller, R. Craig *Design in America*, 1983
Moles, Adrian A. 'Functionalism In Crisis', *Ulm* vols 19–20, 1967
Morrison, Jasper and Dormer, Peter *Jasper Morrison*, 1990

Myerson, Jeremy and Katz, Sylvia *Conran Design Guides*, 1990

Nader, Ralph *Unsafe at any Speed*, 1965

Naylor, Gillian *The Bauhaus Reassessed*, 1985

Nelson, George *Problems of Design*, 1957

Nelson, George *Nelson on Design*, 1979

O'Hara, Georgina *Encyclopaedia of Fashion*, 1989

Palmer, Alan *20th Century History*, 1990

Papanek, Victor *Design For The Real World*, 1985

Pawley, Martin *Buckminster Fuller*, 1990

Pawley, Martin *Theory and Design In the Second Machine Age*, 1990

Paz, Octavio *Convergences*, 1987

Pollack, Peter *A Picture History of Photography*, 1977

Potter, Norman *What Is A Designer?*, 1989

Poynor, Rick *Typography Now*, 1992

Pye, David *The Nature and Aesthetics of Design*, 1978

Radice, Barbara *Memphis*, 1986

Russell, Frank *A Century of Chair Design*, 1985

Schönberger, Angela *Raymond Loewy*, 1990

Sculley, John *Odyssey: Pepsi to Apple*, 1987

Sparke, Penny and others *Design Resource Book*, 1986

Sparke, Penny *Italian Design*, 1988

Sparke, Penny *The Plastics Age* exhibition catalogue, Victoria & Albert Museum, London 1990

Spencer, Herbert *Pioneers of Modern Typography*, 1982

Stewart, Richard *Modern Design In Metal*, 1979

Stone, Michael *Contemporary American Woodworkers*, 1986

Stumpf, William 'Are Metaphors enough to keep you warm on a cold winter's night?', lecture delivered to ICSID/IFI Congress on Design, Amsterdam 1987

Sudjic, Deyan *Cult Objects*, 1985

Sudjic, Deyan *Cult Heroes*, 1989

Sudjic, Deyan *Ron Arad*, 1989

Thornton, Richard S. *Japanese Graphic Design*, 1991

Tracy, Walter *Letters of Credit*, 1986

Van Doren, Harold *Industrial Design*, 1949

Venturi, Robert *Complexity and Contradiction in Architecture*, MOMA, New York, 1966

Venturi, Robert *Learning from Las Vegas*, 1972

Waterman, Neil 'Materials For Profit', *Engineering* magazine, London, January 1988

Wohnen von Sinnen exhibition catalogue, Düsseldorf Kunstmuseum 1986

Wozencroft, Jon *The Graphic Language of Neville Brody*, 1988

Zubroff, Shoshana *In the Age of the Smart Machine*, 1988

MAGAZINES AND JOURNALS

The following magazines are of particular interest:

Abitare, Italy: English/Italian text, architecture, interior and product design.

American Crafts, USA: Contemporary applied arts including textiles.

Architectural Record, USA: Professional architectural criticism, analysis and news.

Architectural Review, United Kingdom: Professional architectural criticism, analysis and news with regular features about furniture, lighting and related design.

Art Aurea, Germany: English/German text; contemporary applied art with some furniture and product design.

Art & Design, United Kingdom: Contemporary fine art, furniture and interior design.

l'Atelier, France: Product design, design innovations.

Axis Magazine, Japan: Furniture and product design.

BAT, France: Graphic design, video, advertising.

Blueprint, United Kingdom: Authoritative journal of architecture, with furniture and some product design.

Casa Vogue, Italy: New trends in interior design and furnishing.

Crafts, United Kingdom: Authoritative journal of contemporary applied arts.

Creative Review, United Kingdom: Graphics, advertising, film, video and animation.

Cree, France: Authoritative design and architecture magazine.

Design, United Kingdom: Authoritative magazine covering product and industrial design with some graphics, fashion and furniture.

Design History Journal, United Kingdom: Academic journal of the Design History Society.

Design Index, United Kingdom: Comprehensive listing of articles and reviews about design worldwide, issued twice a year.

Design Issues: History, Theory, Criticism, USA: Probably the leading academic journal of design history and criticism in English.

Design Week, United Kingdom: Weekly news journal of the British design profession.

Designers' Journal, United Kingdom: Interior, furniture and product design.

Domus, Italy: One of the most influential magazines about design and architecture.

Eye, United Kingdom: Authoritative magazine of contemporary graphics and its practice and theory.

Form, Sweden: Interior design.

Form and Function, Finland: Product design.

Fusion Design, Japan: Design, architecture, planning.

Industrial Design, USA: Product design.

Industrieel Ontwerpen, The Netherlands: Product design.

Interni, Italy: Mainly interior design but with some architecture and product design.

Metropolis, USA: Architecture, product, furniture and graphic design; some applied art.

Modo, Italy: Theory, analysis and news relating to design.

Progressive Architecture, USA: Serious debate about contemporary issues in architecture.

Schoner Wohnen, Germany: International coverage of architecture and design.

Skala, Norway: Architecture and design.

Tools, Denmark: Product design.

Acknowledgments

I want to thank Helen Rees and Jeremy Myerson for reading the text and for their very helpful observations.

PHOTO CREDITS

Magdalena Abakanowicz/photo A. Starewicz 163; Photo Abet Laminati 108, 113; Alessi, F.A.O., S.p.A. 139; Apple Computer UK Ltd 18; Zeev Aram 120; Archizoom Archives, Centro studi e archivio della comunicazione, dipartimento media, Università di Parma 64, 166; Courtesy of AT&T Archives 23; Bang & Olufsen A/S 55, 56; Photo Ed Barber 141; Gerald Benney 132; Photo Norinne Betjemann 20; BFI Stills, Posters and Designs 28, 79; Bing & Grøndhal, Royal Copenhagen Ltd 150; Bloomfield Hills: Collection of Cranbrook Academy of Art Museum 153, 154 (courtesy of Cranbrook Archives, photo Richard Askew), 155, 159; BMIHT/Rover Group 45, 46; BMW (GB) Ltd 170; Braun UK Ltd 25; British Airways 89; British Nuclear Fuels plc 19; Photo Thomas Brummett 122; Photo Casali, Milan, Courtesy Archivio Gio Ponti 53; Cassina S.p.A. 30, 103; Chermayeff and Geismar Inc. 82, 87; Citroën UK Ltd 44; Studio Joe Colombo 105; Colorcore 125; Riccardo Dalisi 65; Danese Milano/photo Aldo Ballo 143; Studio De Pas, D'Urbino, Lomazzi 106; Design Research Unit 70; Driade/photo Aldo Ballo 109, 127, 128; Helen Drutt Gallery, Philadelphia 121; Edra S.p.A. 114; Ekco Housewares Inc. 42; Fiell 101 (photo Fiell/P. Chave), 117 (photo Branson Coates Architecture); Fiskars UK Ltd 7; Ford Motor Company 22; Photo Mitsumasa Fujitsuka 129; General Motors Corporation 40, 47, 48; Milton Glaser 68; Grapus 91; April Greiman Inc. 92; IBM (UK) Ltd 49, 50, 77 (left); Photo Info Plan 38; © 1978 International Typeface Corporation/photo Carl Fischer 86; Hillside Gallery, division of Art Front Gallery, Tokyo 164; Georg Jensen Co., Copenhagen 133, 134, 137; Yusaku Kamekura,

Tokyo 83; Kartell S.p.A. 107; Courtesy of The Knoll Group, New York 97 (The Knoll Showrooms, San Francisco, 1957), 98, 118; Kyocera Yashica UK Ltd 67; Jack Lenor Larsen Inc., New York 157; London: Tate Gallery, 52, 53; Lycra Dupont 167; David Mellor Design 135; Herman Miller Inc. 104, 112; Howard Miller Clock Co. 35; NASA 33; New York: American Craft Museum, from the Dorothy Liebes Retrospective exhibition, 1970 158; The Brooklyn Museum. Gift of the Italian Government 100; Cooper-Hewitt Museum 39; Collection, Museum of Modern Art, New York. Gift of the manufacturer, Herman Miller Furniture Company, Zeeland, Michigan 94; Novosti Photo Library, London 21; Nuno Corporation, Tokyo 168, 169; Olivetti UK Ltd 15, 16, 17, 51, 54, 61; One Off Ltd 116; Paris: Musée Bouilhet Christofle/photo Studio Kollar 130; Sigurd Persson 136; Knud P. Petersen, Berlin 36; Philips Corporate Industrial Design 10, 11, 12, 13, 14; Polaroid UK Ltd 63; Private Eye 81; Publifoto, Milan 29; Riihimaki, Finnish Glass Museum 146; Rosenthal Design Studio 145, 148, 149, 152; W. Rosenlew Ltd 147; Ed Rossbach 156; Sanyo (UK) Ltd 58, 59, 60; Seibu Department Stores Ltd 93; Sinclair Research Ltd 26; Steven Sloman (courtesy of Alexander F. Milliken Inc.)/photo Bruce Miller 123; Sony UK Ltd 62; George Sowden 140; Space 119; Stelton A/S, Copenhagen 138; Stokke Fabrikker A/S 126; Ezra Stoller, © Esto 96; Swatch 32; © 1992 Walter Dorwin Teague Associates, Inc., New York 8, 37; Tecno UK 111; Total Design 78; Vignelli Associates/photo Aldo Ballo 144; Virtual Presence Ltd 34; Vitra 99, 110, 124; Vitrac Design Strategy 142; Vuokko Nurmesniemi Hon RDI, Helsinki 160, 161; Robert Welch/photo Enzo Ragazzine, 1973 131; Yamaha Electronics (UK) Ltd 57.

The following illustrations are from books and journals: Design, March 1952 6; Henry Dreyfuss, Designing for People, New York, 1955 9; Norman Bel Geddes, Horizons, Boston, 1932 41, Ben Selinger, Chemistry in the Marketplace, London, 1988 31.

Index

213